D1129846

waterfront retreats

waterfront retreats

Edited by Ana G. Cañizares

HDi

**HARPER
DESIGN**
international

An Imprint of HarperCollins*Publishers*

Publisher: **Paco Asensio**

Editor in Chief: **Haike Falkenberg**

Editor: **Ana G. Cañizares**

Art Director: **Mireia Casanovas Soley**

Layout: **Ignasi Gracia Blanco**

First published in 2003 by:
Harper Design International, an imprint of HarperCollins Publishers
10 East 53rd Street
New York, NY 10022

Distributed throughout the world by:
HarperCollins International
10 East 53rd Street
New York, NY 10022
Tel.: (212) 207-7000
Fax: (212) 207-7654

HarperCollins books may be purchased for educational, business, or sales
promotional use. For information, please write:
Special Markets Department
HarperCollins Publishers Inc.
10 East 53rd Street
New York, NY 10022

Library of Congress Cataloging-in-Publication Data

Waterfront retreats / edited by Ana G. Cañizares.
 p. cm.
 ISBN 0-06-053609-8 (hardcover)
 1. Seaside architecture. 2. Lakeside architecture. 3. Architecture,
Domestic. I. Cañizares, AnaCristina G.
 NA7574.W38 2003
 728'.37'09146–dc22
 2003015582
DL: B-33.579-03

Editorial project

LOFT Publications
Via Laietana, 32 4º Of. 92
08003 Barcelona. Spain
Tel.: +34 932 688 088
Fax: +34 932 687 073
e-mail: loft@loftpublications.com
www.loftpublications.com

Printed by:
Anman Gràfiques del Vallès, Spain

August 2003

Water is the essence of life. Without it, we and everything that surrounds us would cease to exist. Believed to be the mother of all forms, it continues to sustain us and keep us alive, making it the most precious natural resource on the planet. Seventy percent of the earth is covered by water, 97 percent of that is saltwater found in the oceans. Only two percent is freshwater, 70 percent of which is frozen in ice caps and glaciers, leaving a mere one percent of the world's freshwater resources available for human use.

Aside from being a physical necessity, however—given that a person can only live without water for approximately a week—water has been ascribed countless meanings over millions of years. Very quickly in human evolution, water became more than just a physical necessity. Myth, religion, and art have mystified the element of water and generated different interpretations of it all over the world. Chinese and Japanese cultures regard water as both a spiritual purifier and a functional element. For the Islamic people, it is a symbol of purity and a tool for worshipping. In Western religions it is perceived to have the power to give life as well as to destroy it. Most of these symbolic associations are universal and have penetrated all areas of life, having been perpetually applied to the objects and spaces that surround us in our incessant search for meaning.

Water has been used as an architectural element throughout time in numerous ways. The first great civilizations emerged alongside water: the great cultures of the Nile, the Tigris and Euphrates, the Indus, and the Yangtze. The Greeks and Romans displayed one of the earliest and most extraordinary metaphysical appreciations for the natural landscape. Not only did this manifest in the close relationship between their buildings and the surrounding scenery, but also in the integration of water within the actual buildings. Their respect for seaside and lakeside topography led to the beneficial architectural inclusion of scenic views, morning light, protective moorings, terrace gardens, bathing pools, constructed walkways, and porticos. Later on, in places like the Netherlands and Venice, waterfront houses started as trading establishments combining business and

residence. In medieval times, water was an indicator of magnificence and wealth, and by the 19th century the seaside became an escape from industrial surroundings and social restraints.

It is impossible to ignore the role that history and symbolism have played in the revitalizing connections between people, water and nature. As human beings, we have become conscious of our need to refer to the past in order to make sense of our existence in an increasingly complex world. Architecture intends to do just that. Materials, forms and perspectives are selected and ordered to reinterpret long-established concepts and reflect the attitudes held about the world by those who design, construct and inhabit a space.

Architects that design our living spaces today stimulate our senses, nourish our perspectives and create spaces that redirect us towards the essential things in life. *Waterfront Retreats* collects a variety of spectacular projects selected for their special relationship with water in the form of an ocean, sea, river, lake, swamp or pond. Every house reveals a unique dialogue with the landscape, whether it is designed to merge with its surroundings by integrating water into the home or conceived as a platform from which to appreciate the stunning views of a boundless blue blanket of water. In each case the architects have paid special attention to the presence of water in order to achieve a balance between building and landscape and reunite mankind with Mother Nature.

It is no wonder then that almost everyone dreams of having a house on the water. Consciously or not, we bear with us both inherent and conditioned associations that draw us toward the most vital ingredient of life. The presence of water is therapeutic, soothing and inspiring. In the chaotic and complicated world we live in, water offers us a sense of purity and space with which we can cleanse our disoriented minds. Its simplicity and beauty help us to distinguish the less important from the meaningful, and remind us that we are responsible for protecting it. Water renews our instinctive affinity with nature and brings us closer to understanding the mystery of life, and who wouldn't want to live next to that?

weiss house	Steven Harris Architects
Photos © Scott Frances/ESTO	Cabo San Lucas, MEXICO 2002

Situated 246 feet above the Pacific Ocean, this house is the southernmost private residence at the foot of the Baja Peninsula. It is a rare setting where desert meets sea, in which desert grasses, cacti, and rocky cliffs characterize the natural landscape and its sparse vegetation. A distinguished relationship between building and landscape creates an austere structure that overlooks stunning views of the ocean and surrounding terrain.

The balance between architecture and nature is evident in the overall design of the home. The building combines a variety of perspectives from excavated, cave-like rooms to spaces that seemingly float over the edge of the cliff. Through boulders and down a stairwell carved out of rock, a blind ramp leads to an unexpected view of the ocean's splendor, framed by a pavilion and a Harry Bertoia sculpture.

Composed of reinforced concrete and high strength laminated glass, the house is defined by two retaining walls that establish the public and private wings. In the private wing, illuminated stone steps link the courtyard to a pool terrace and the guest rooms on the lower level. An outdoor living room floats within a small pool, encloses the courtyard, and frames a view of the ocean. Along the private wing, floor level windows reflect sunlight off the water runnel extended along the length of the wall. The study that overlooks the pool is separated from the guest room by a sandblasted glass shower, which is sunlit through the glass-bottomed waterway above. The excavated rooms expose the carved rock and are illuminated by narrow skylights, while the living areas enjoy panoramic views of the boundless blue sea.

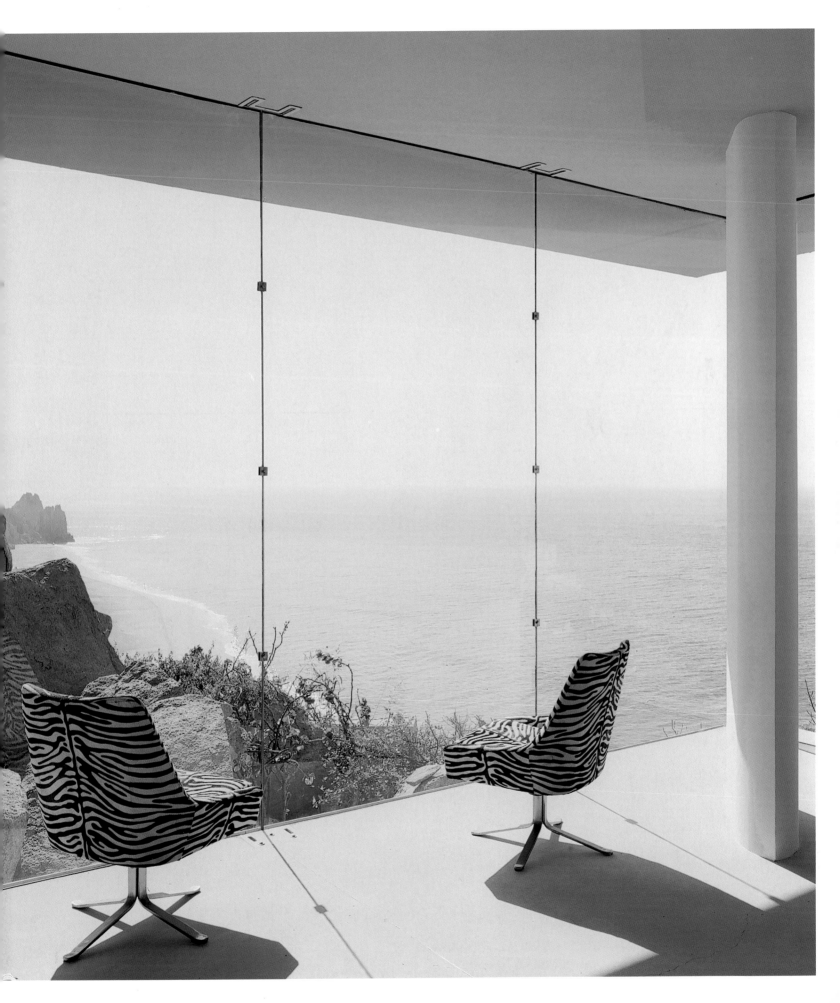

1. Carport
2. Entrance ramp
3. Courtyard

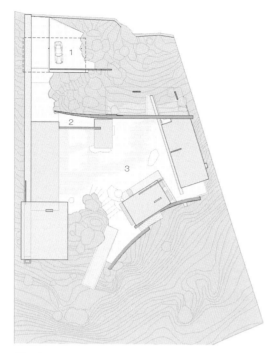

Site plan

1. Kitchen
2. Dining room
3. Living room
4. Entrance pavilion
5. Media room
6. Exercise room
7. Master bedroom
8. Outdoor living room
9. Swimming Pool

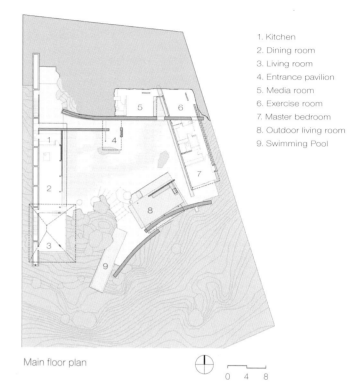

Main floor plan

0 4 8

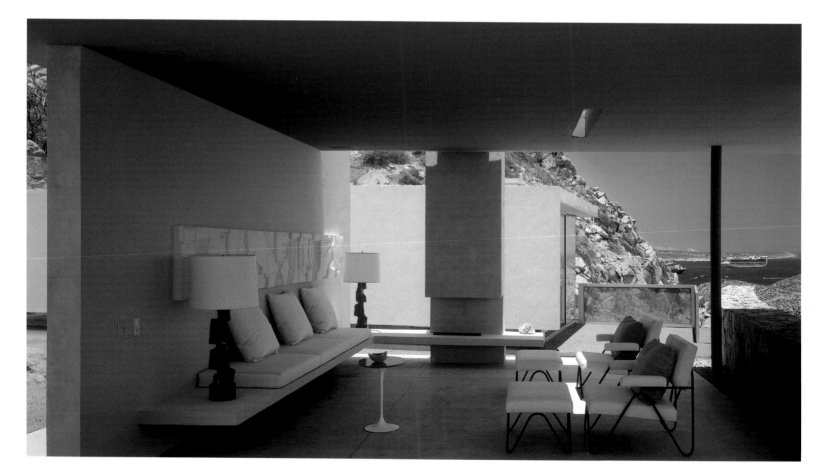

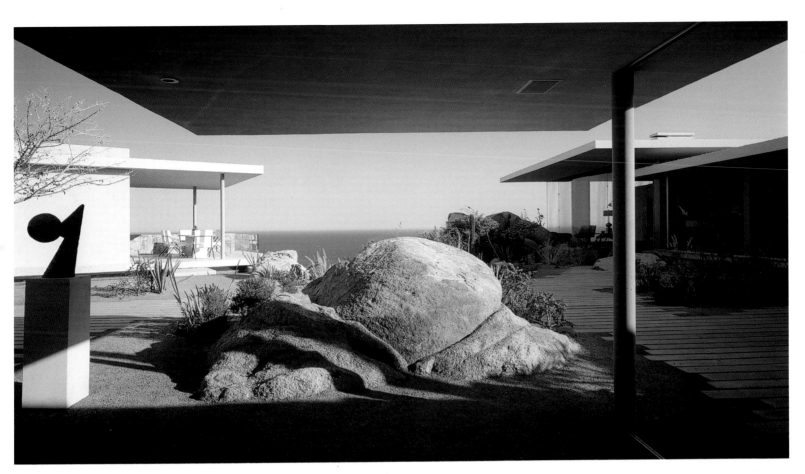

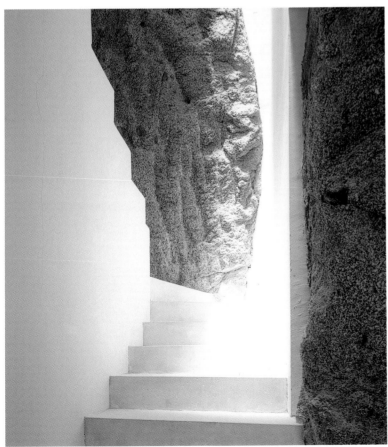

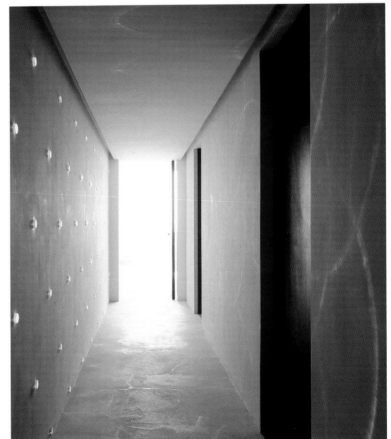

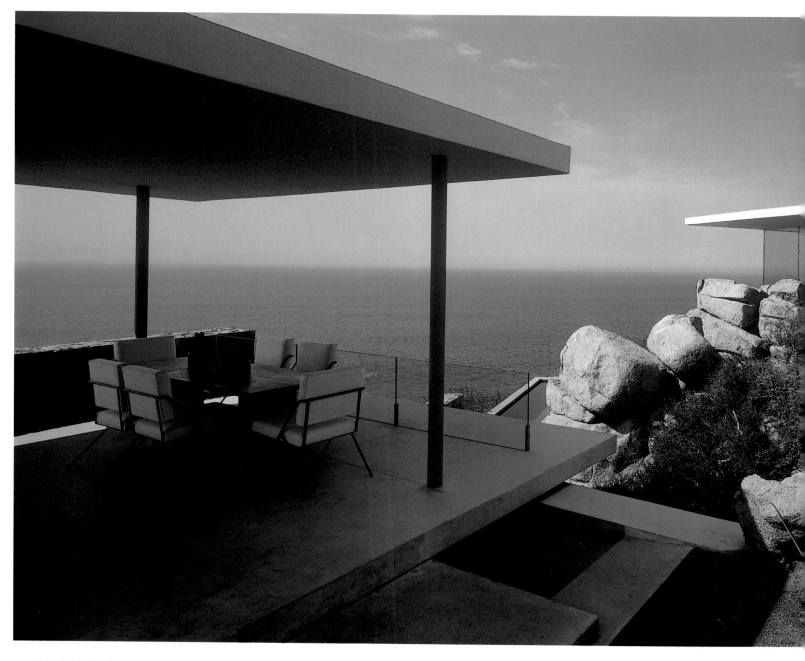

An extended roof structure protects the glass house from excessive heat and sunlight, and creates a subtle yet modern form that integrates with the surrounding landscape.

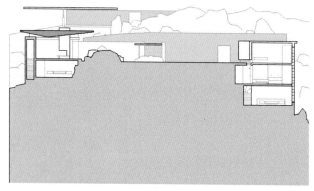

Section through courtyard

0 2 4

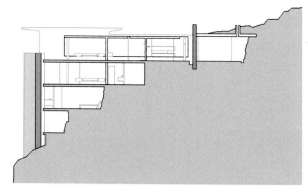

Section through east wing

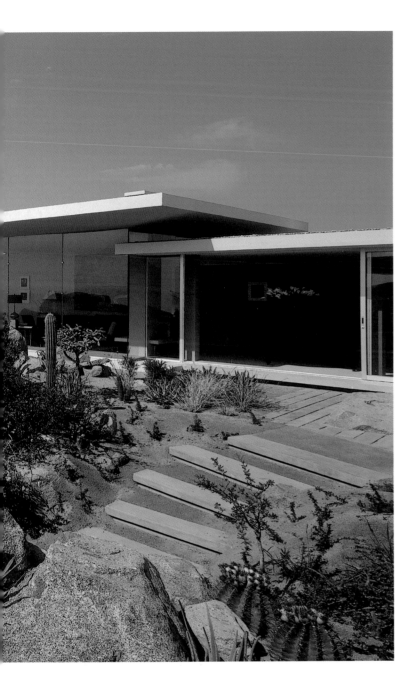

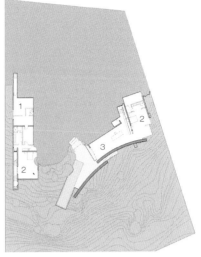

Mid-level floor plan

0 5 10

1. Service
2. Guest bedroom
3. Study

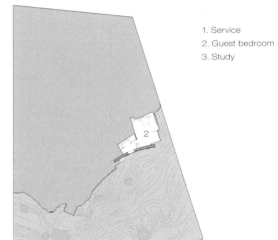

Lower floor plan

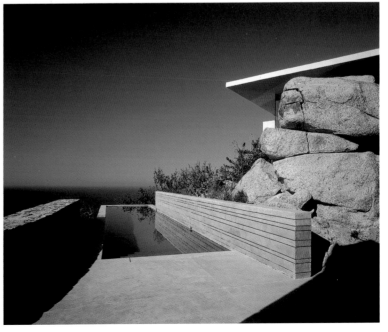

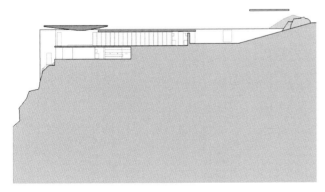

Section through west wing

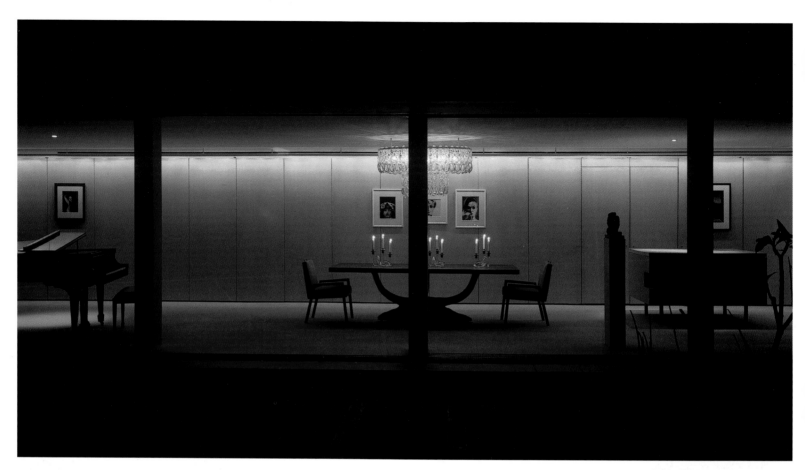

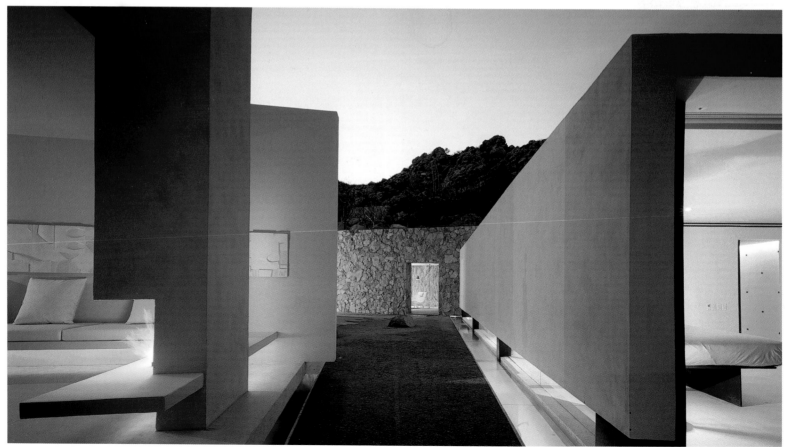

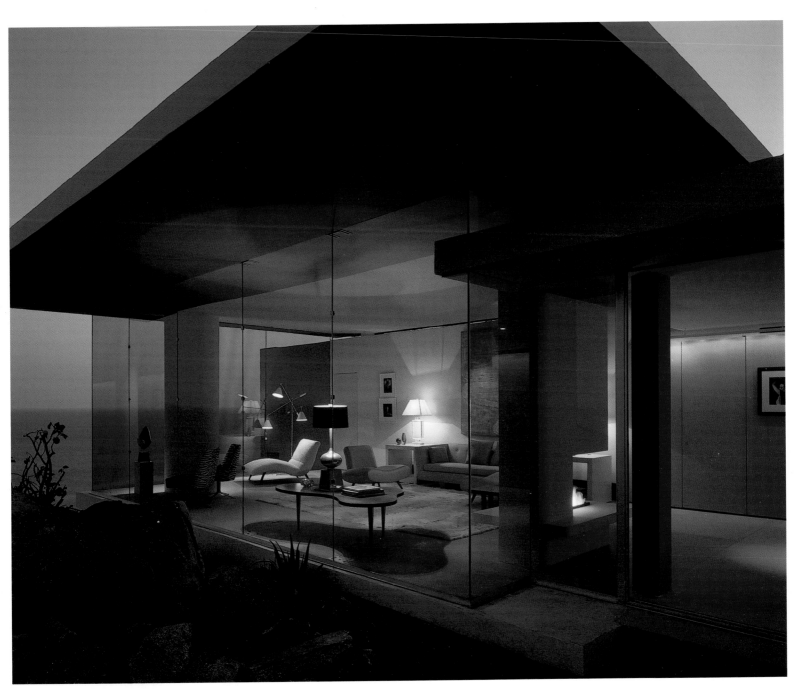

The architects believe in designing spaces that reflect and accommodate the patterns of everyday life, devoting the most attention to the areas most often used.

equis house

Barclay & Crousse

Photos © Barclay & Crousse

Cañete, PERÚ 2002

Although the Peruvian coast is home to one of the most arid deserts in the world, its climate is not extreme. The mild temperatures fluctuate between 59°F in winter and 85°F in summer, making shade the only necessary requirement in order to live comfortably. The Equis House is a perfect example of domestic architecture thoughtfully integrated into a natural and dramatic environment.

In order to achieve a balanced design respectful of the site, architects decided that the structure should occupy as much of the lot space as possible, a solid mass rooted into the land as if it had always been there. The gradual excavation of interior spaces produced ambiguous spaces with ill-defined boundaries between interior and exterior, characterized by their distinct relation to the sky or water. Conceived as an "artificial beach," a large terrace expands towards the ocean and looks towards the horizon through a long and narrow transparent pool. A sliding glass panel and projecting roof transform the living and dining areas into a spacious open-air terrace. A staircase that follows the incline of the land links the various levels of bedrooms and terraces.

The landscape also inspired the architects in designing the home. Perspectives, colors, and materials were chosen and coordinated based on their relationship to the land. Tones in ochre and sand, much like those used in pre-Columbian constructions along the Peruvian coast, were applied to the façades to avoid the weathering caused by the desert dust. These colors unite the dwelling as a whole.

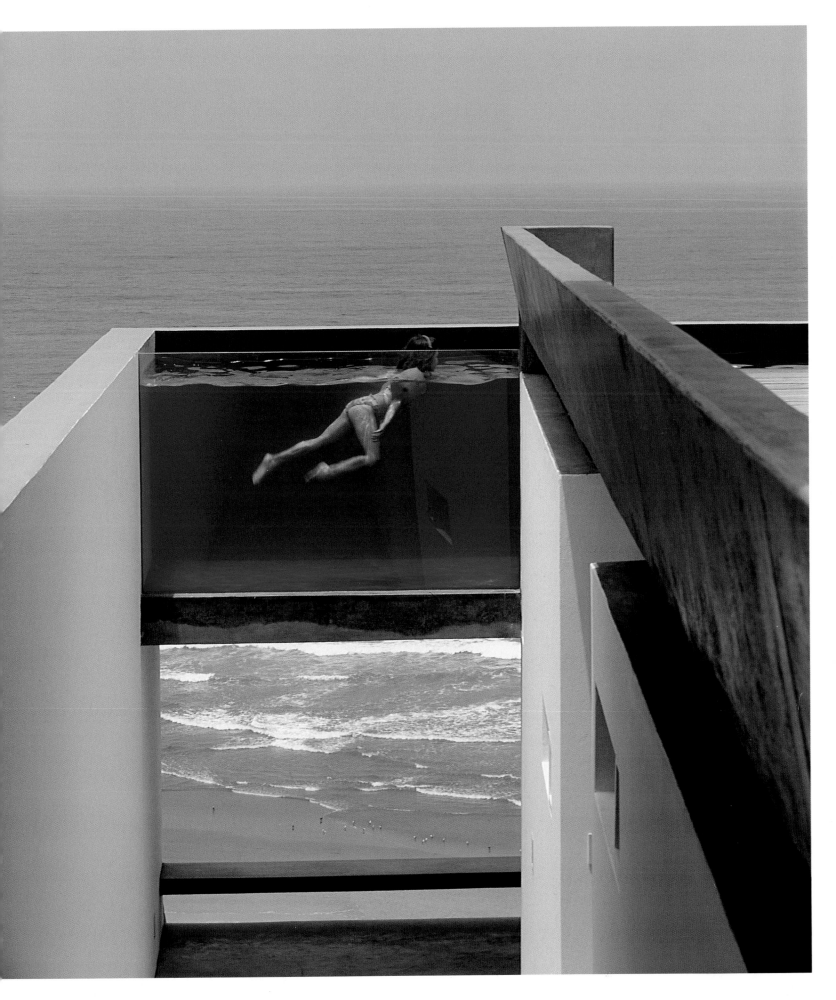

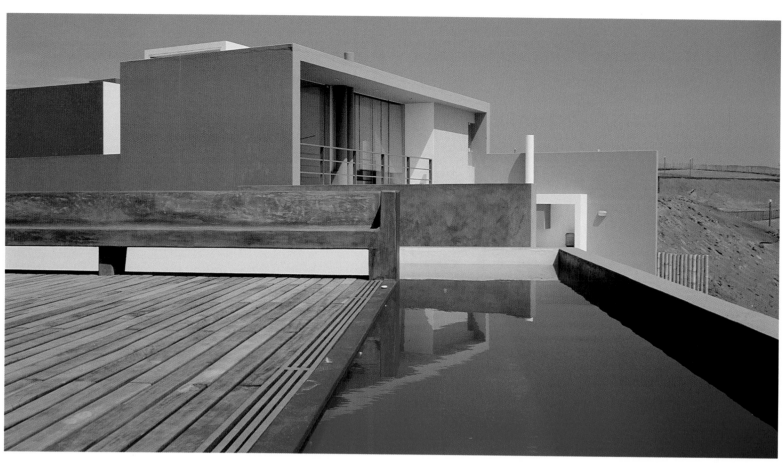

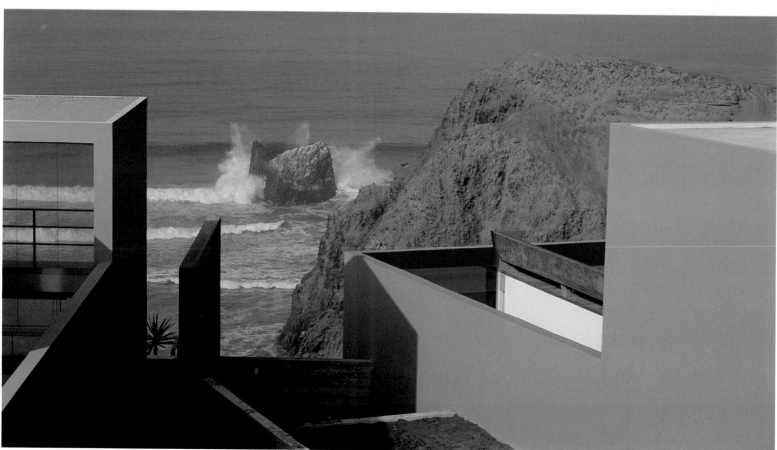

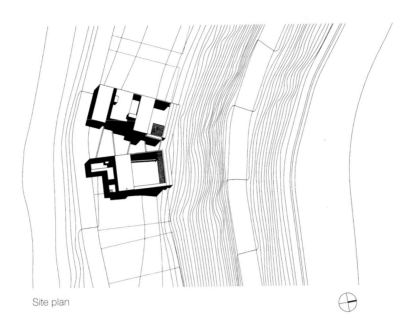

Site plan

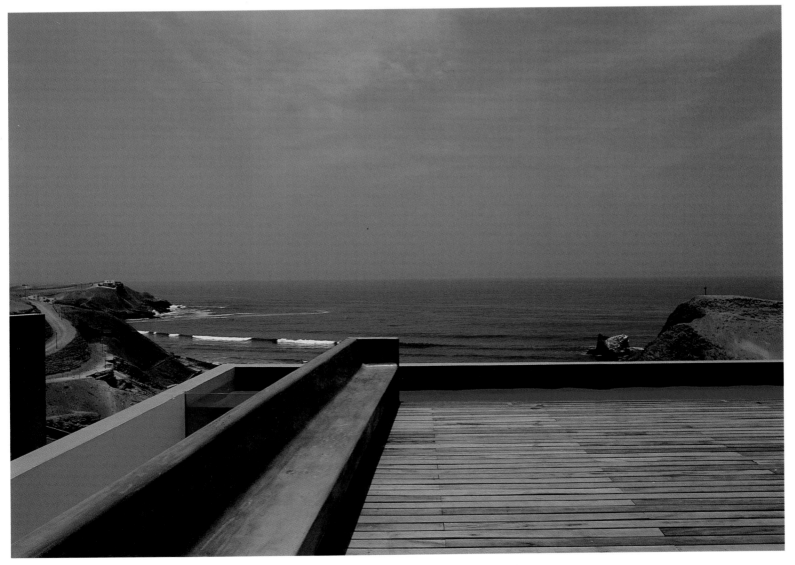

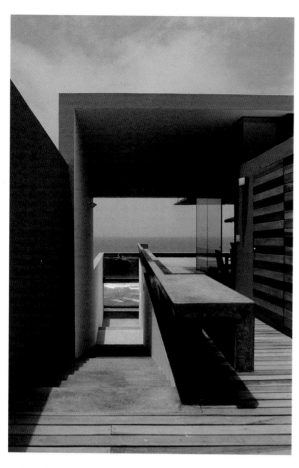

Sketch

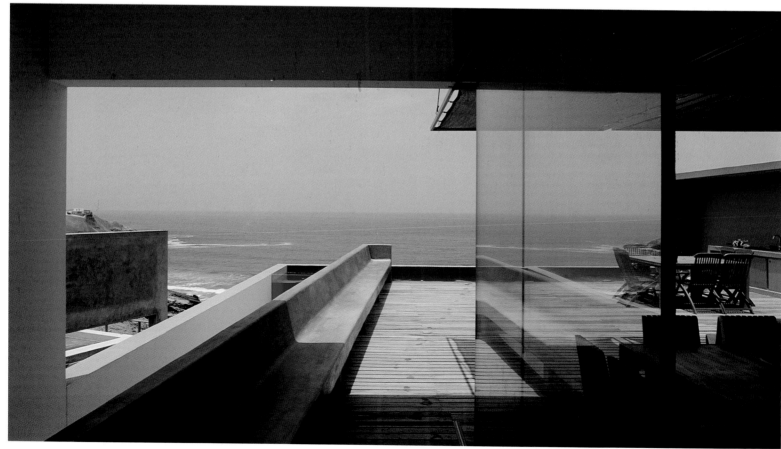

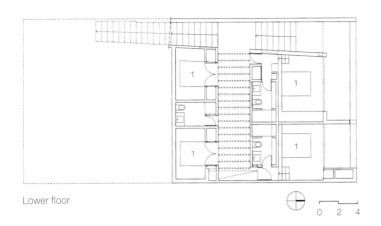

Lower floor

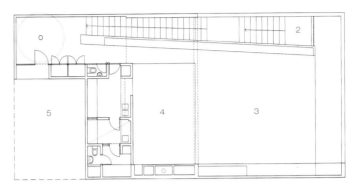

Upper floor

0 2 4

1. Bedroom
2. Entry
3. Living room
4. Dining room
5. Terrace

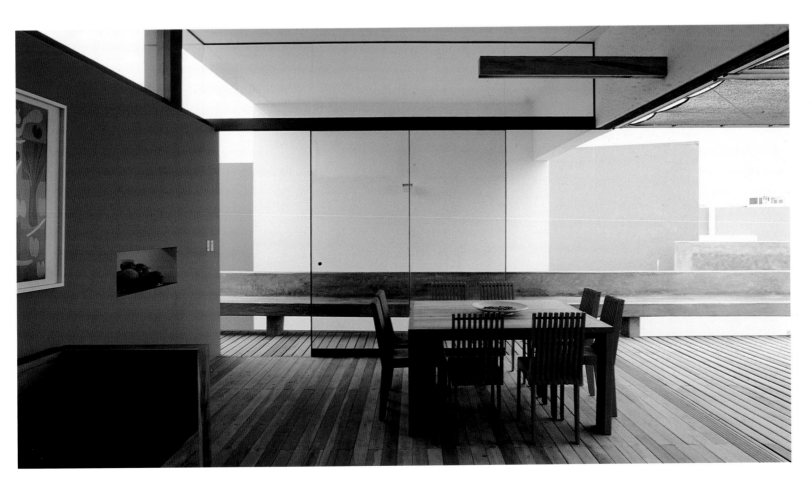

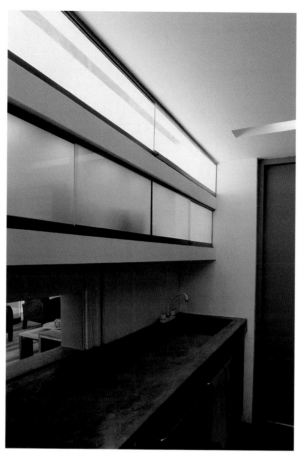

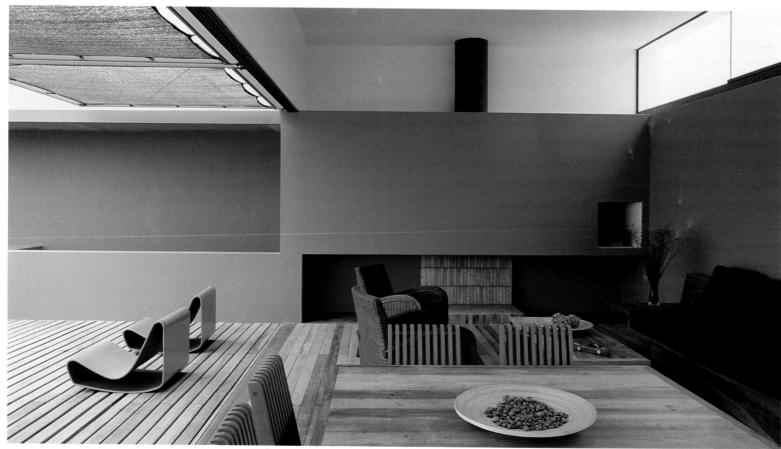

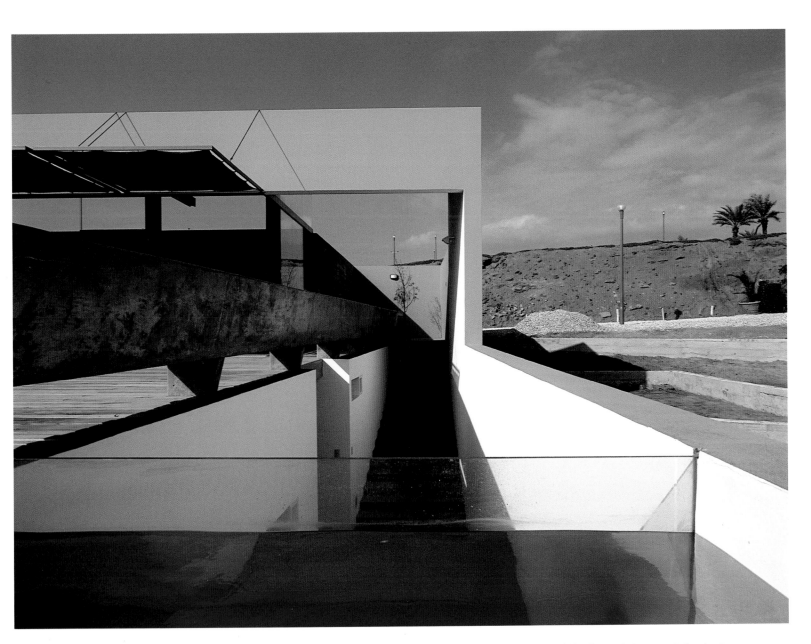

The swimming pool is much like an aquarium, its visible body of water superimposed on the view of the ocean and arid landscape that surrounds the structure.

Sketch

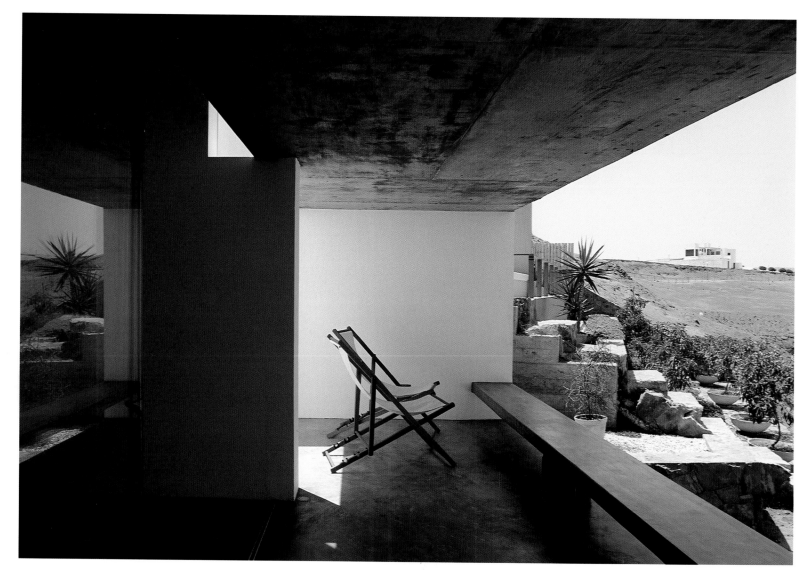

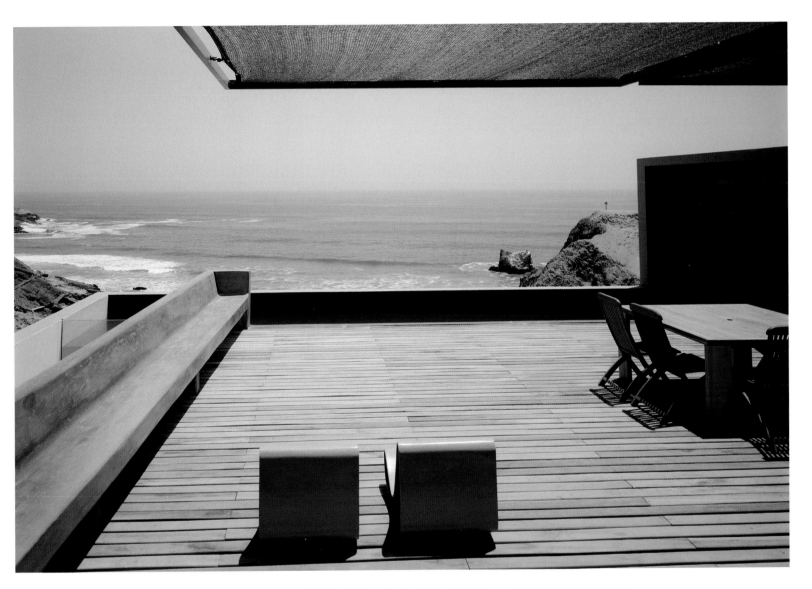

The exterior deck protects and shades the lower level, which contains the guest and children's bedrooms.

ROCHMAN RESIDENCE

Callas Shortridge Architects

Photos © Undine Pröhl

Pacific Palisades, California, USA 2001

Sitting on the edge of a downhill slope on the hills of the Pacific Palisades, this renovated late 1950s home overlooks the Santa Monica and Malibu coastlines. The initial scheme was conceived by the deceased Frank Israel, and was since developed by his former partners Barbara Callas and Steven Shortridge.

The 3,000-square-foot home, designed for a mature couple, appears as a single-story building on the street side, yet drops down two stories on the ocean side. Due to height restrictions and setback requirements, the roof was designed as a continuous horizontal parapet shared by exterior walls that lean outward from the core of the house, increasing the interior sense of space. From below, the building appears to be a two-story wedge embedded into the sloping terrain and thrusting out over the incline hillside and towards the ocean.

The entry is situated between two bisecting planes, which define three areas: the living area, private area, and semi-public study space. An orange plaster wall along the entrance defines the horizontal axis, dividing the private area downstairs and the public zone upstairs. The open-plan living spaces culminate in a 25-foot window that wraps around the corner of the living room just above the cliff, framing the views of the horizon. A cedar trellis cantilevers over the deck beyond the dining room to transform the interior space into an open-air terrace. A staircase hidden behind a plaster wall leads to the master bedroom, lower deck, outdoor garden, and landscaped pathway designed by Mia Lehrer & Associates.

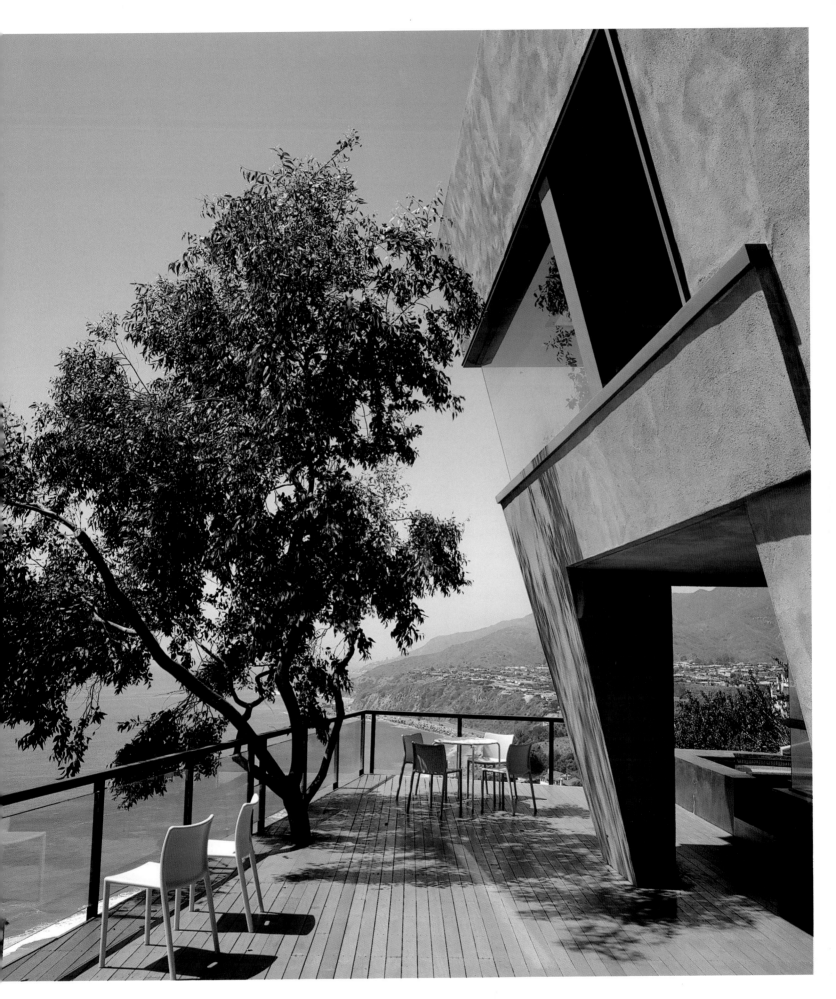

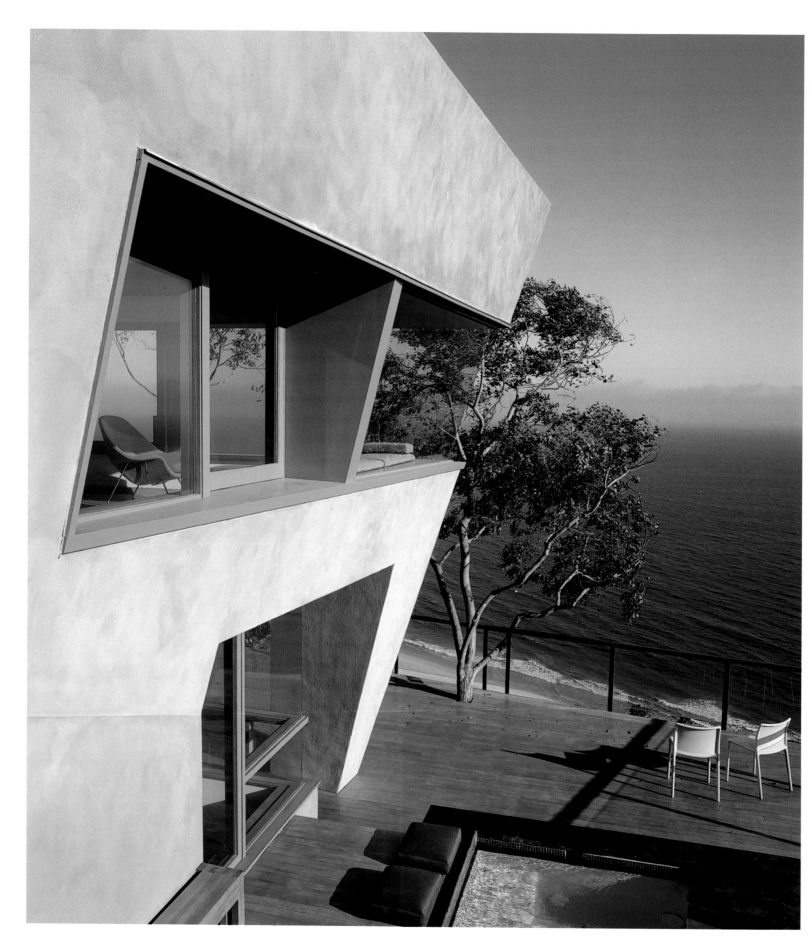

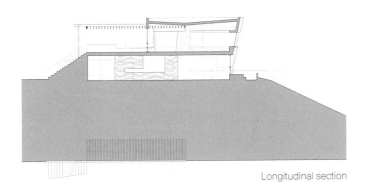

Longitudinal section

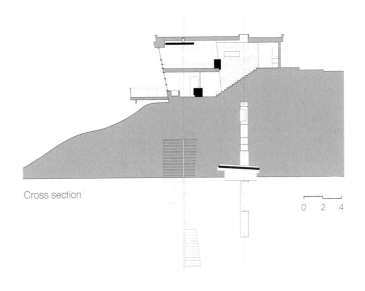

Cross section

0 2 4

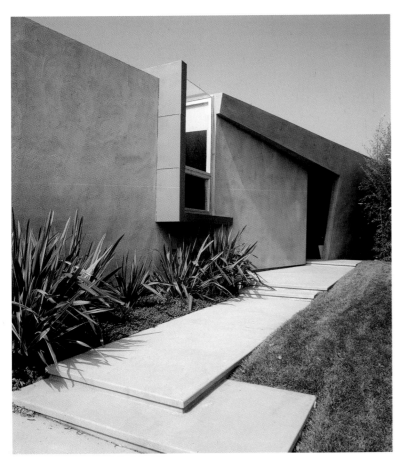

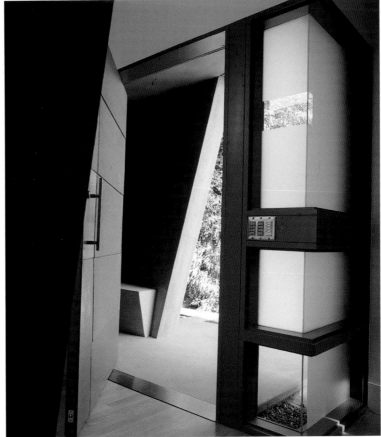

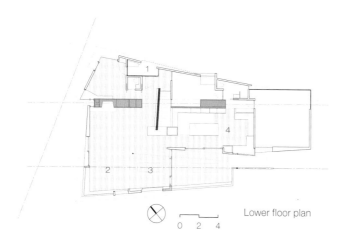

Lower floor plan

0 2 4

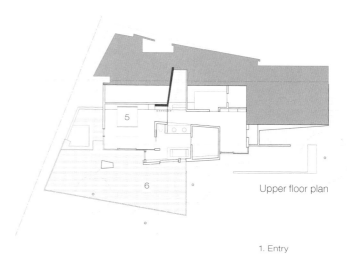

Upper floor plan

1. Entry
2. Living room
3. Dining room
4. Kitchen
5. Master bedroom
6. Terrace

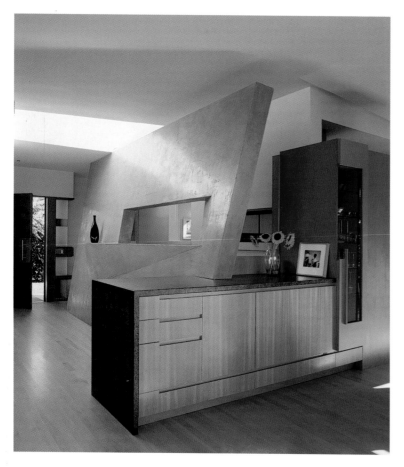

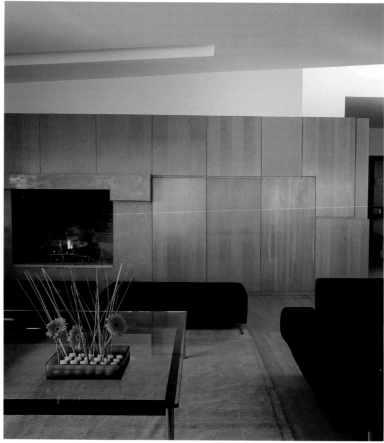

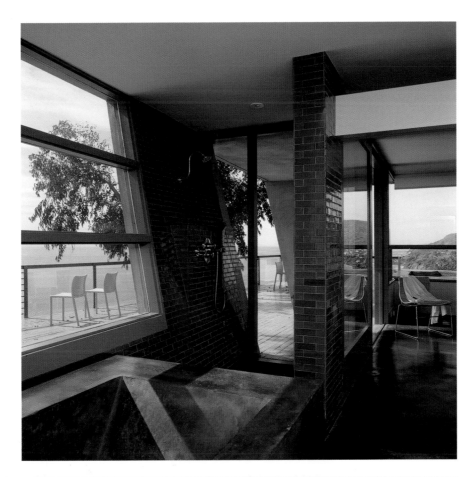

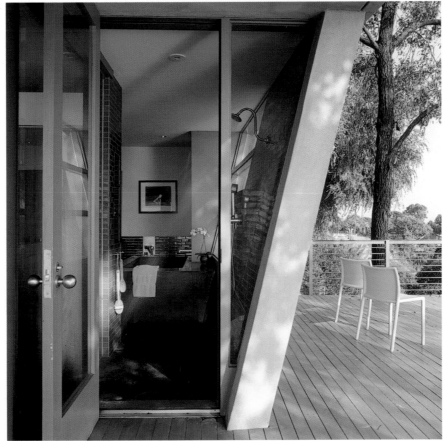

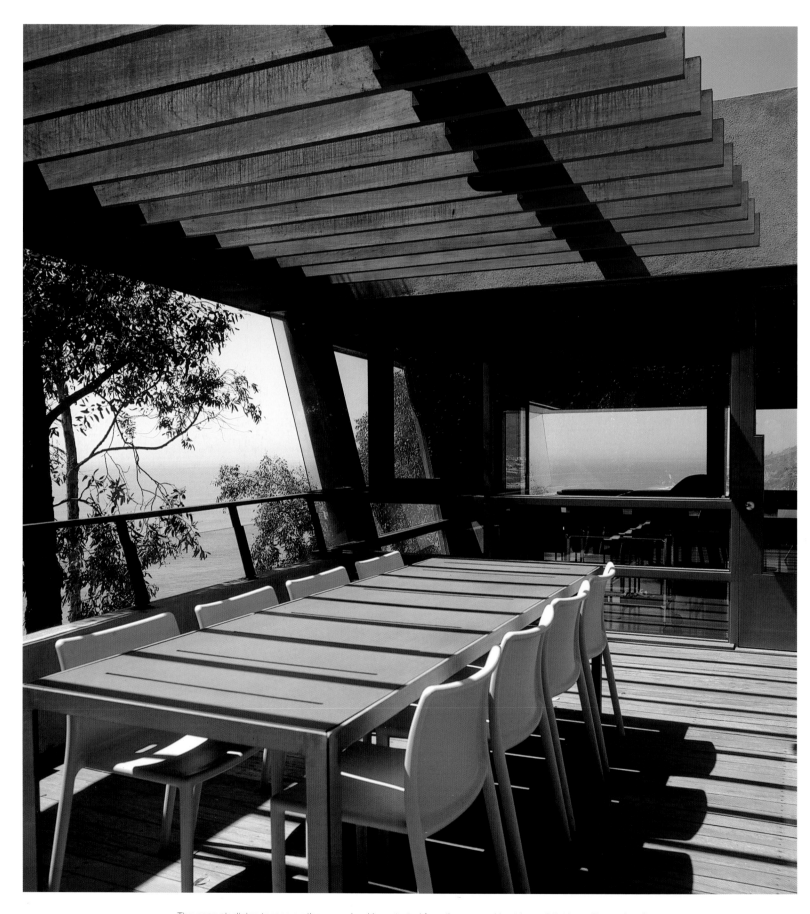

The open-air dining terrace on the upper level is protected from the sun and heat by a slatted, cantilevered roof.

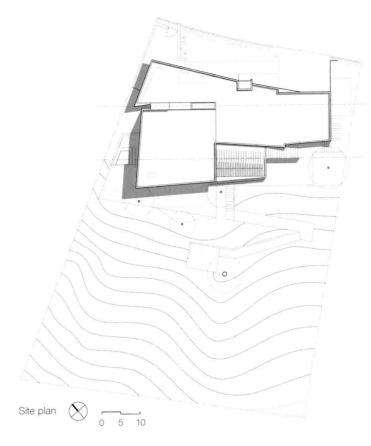

Site plan ⦻ 0 5 10

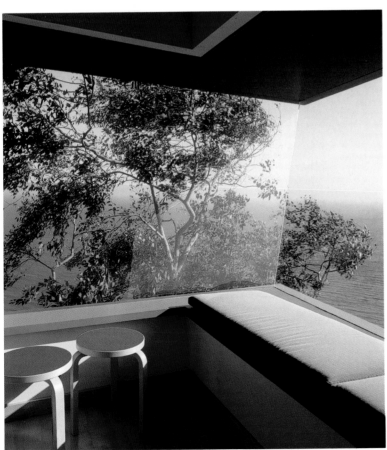 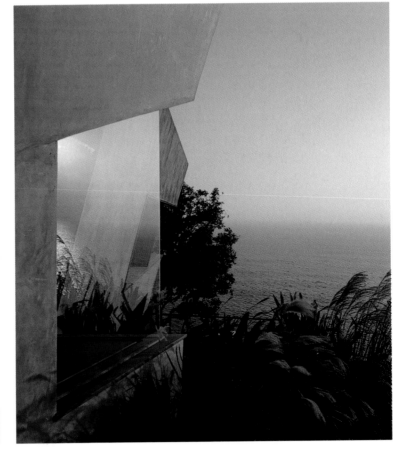

house in milos	Jean Bocabeille and Ignacio Prego
Photos © Ken Hayden	Milos, GREECE 2000

This house in Milos is located on a secluded site atop of a 164-foot cliff overlooking the Sea of Crete. An apparently random arrangement expresses flexibility and aims to curb the impact of the construction on the landscape. In designing this residence, the architects wished to avoid the building of a giant mass that would overwhelm its natural surroundings.

Each building has a specific function and displays a unique geometry that forms part of a coherent composition. The two structures situated in the center contain the living, kitchen, and dining areas, while the other volumes consist of independent rooms with private terraces. These discrete units emphasize the sensation of detachment and isolation without marring the raw beauty of the natural surroundings. This positioning allows for many different activities and infinite configurations in the constantly changing climate.

Constructed of concrete with simple Greek stone floors and limestone walls, the villa has four bedrooms linked by a communal courtyard that looks onto the sea. The openings are designed to protect the house from the sun and rain and, at the same time, reinforce the visual relationship with the landscape. The structure is a modern interpretation of the traditional white, box-like house so typical of Greece, modified to achieve a renewed sense of connection with the stunning landscape. The composition is united by the intimate paths among the various boxes and the series of terraces perched atop the rocky cliffs.

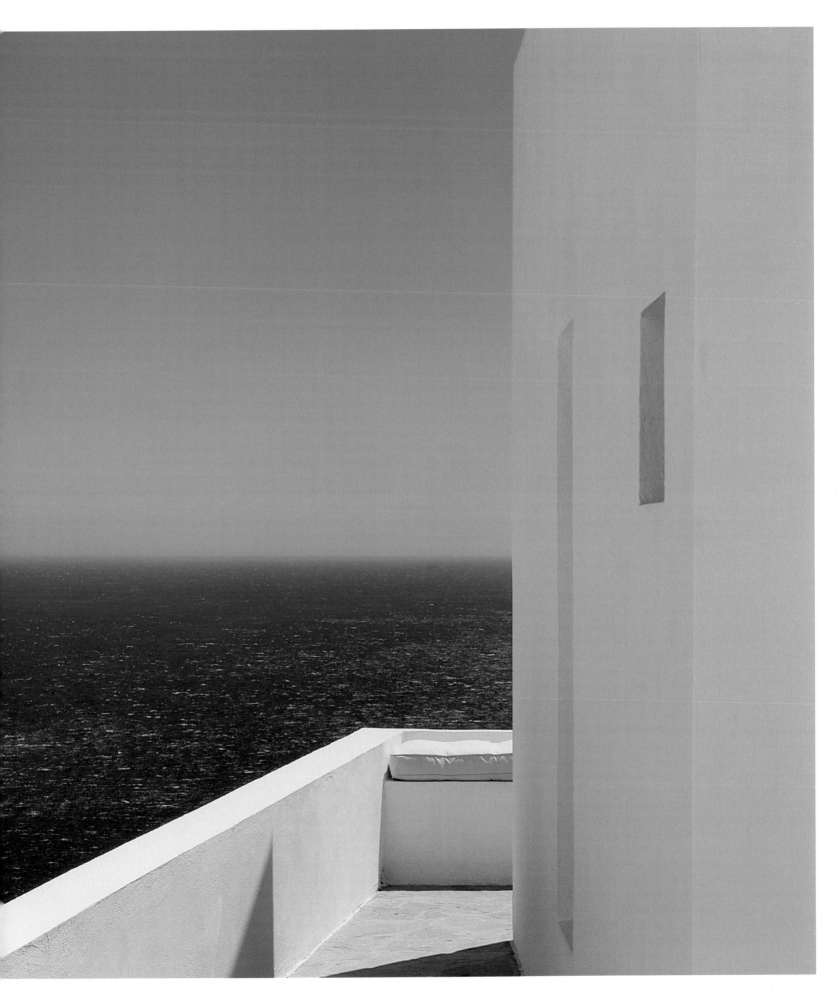

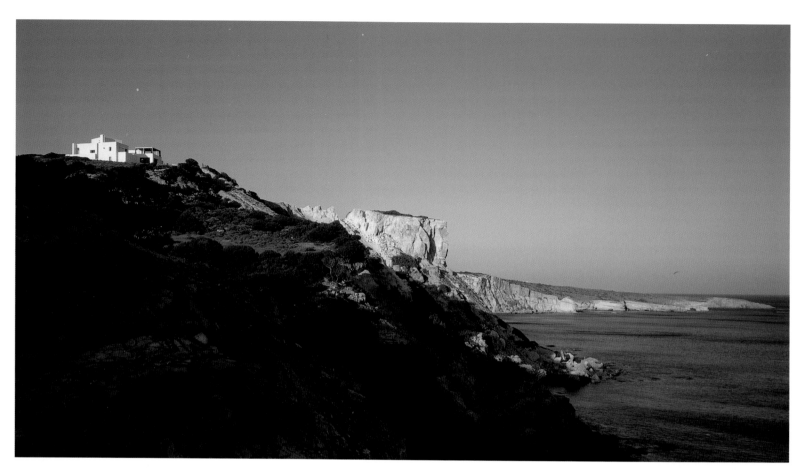

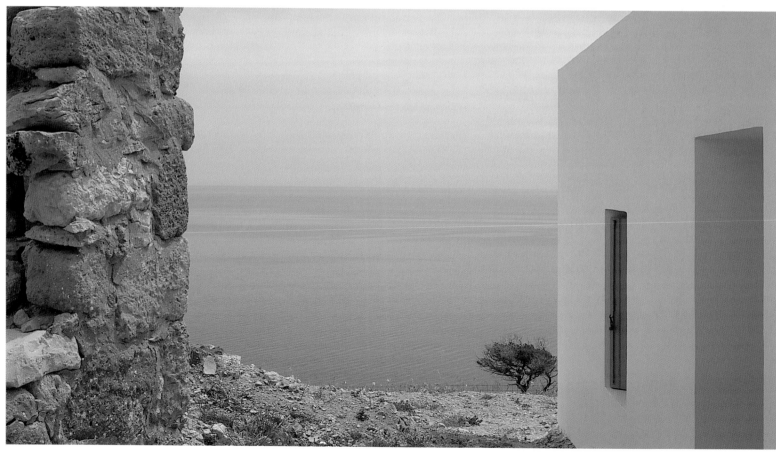

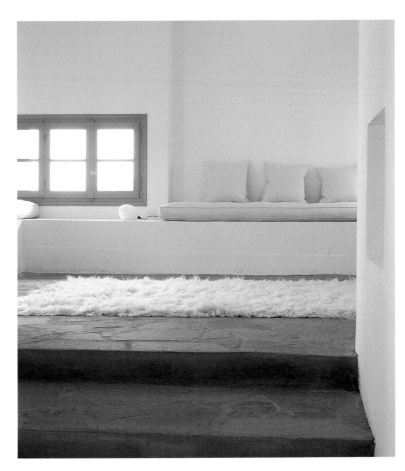

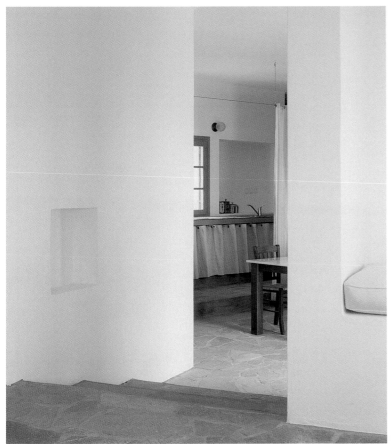

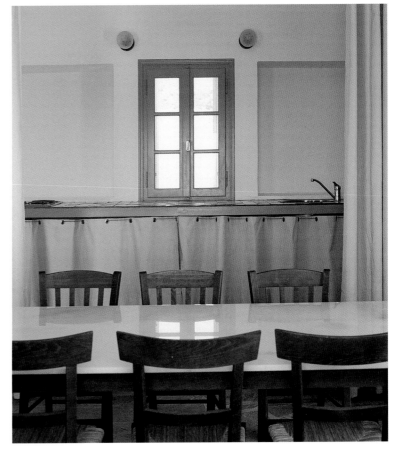

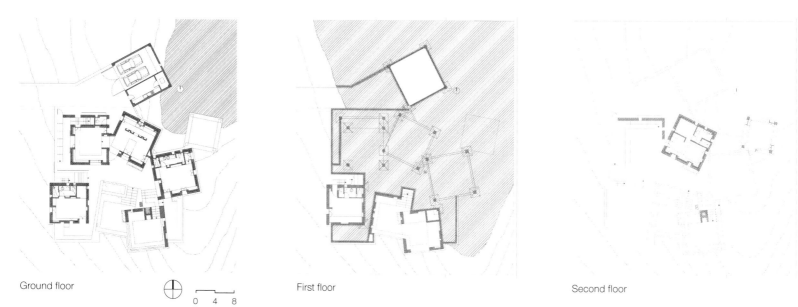

Ground floor

First floor

Second floor

0 4 8

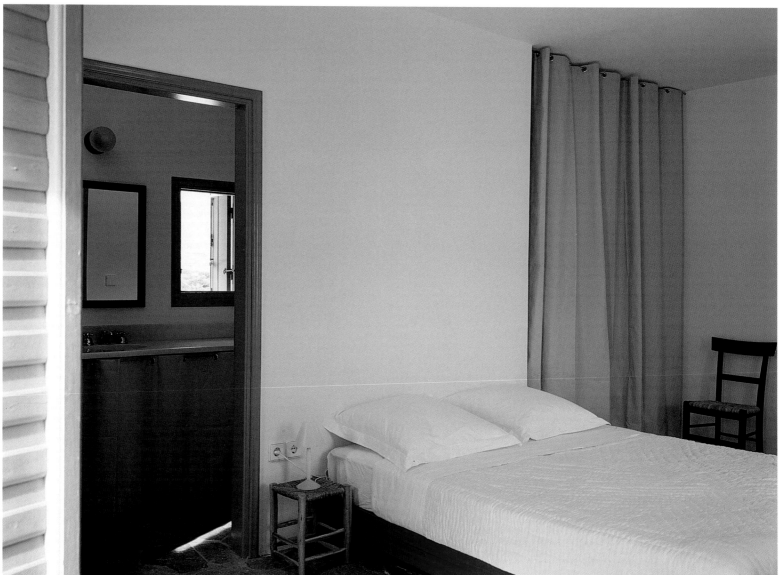

The modest interiors are furnished with simple furniture, traditional Greek floors, and white surfaces that emphasize the site's abundance of natural light.

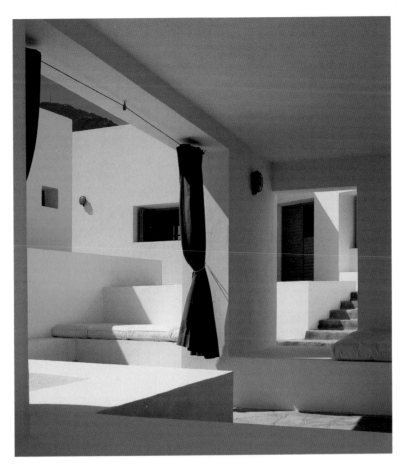

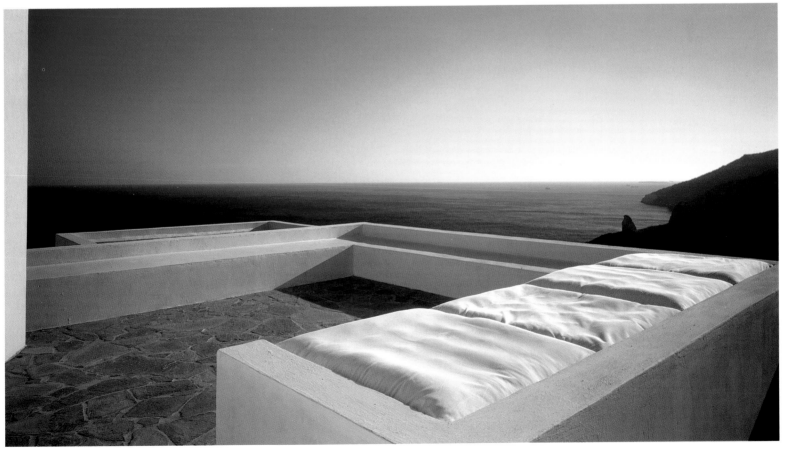

VANCOUVER house	Patkau Architects
Photos © Undine Pröhl	Vancouver, British Columbia, CANADA 2000

This 3,071-square-foot residence looks across English Bay to the North Shore Mountains that dominate the Vancouver skyline. The narrow plot of land, 33 feet wide by 155 feet deep, was limited to 26 feet in width due to required side yard setbacks. The narrow plot of land led the architects to exploit the space vertically and out towards the water, creating a spectacular home in which water is a recurring motif.

Distributed over three levels, the house contains a basement level and two floors above ground. Because the dimensions of the site made it difficult to place the swimming pool on ground level and simultaneously maintain a generous living area, the lap pool was situated on the upper level, along the west side of the house, connected at either end to the bedroom and study terraces. This floating pool seems to be superimposed on the landscape beyond, creating a seamless effect between the two bodies of water, man-made and natural. A unique perspective of the landscape as well as infinite reflections cast by the pool can be enjoyed from different vantage points.

Inside, small spaces are enlarged by virtue of generous ceilings. The living area takes in panoramic views of the bay, while the dining room enjoys a two-story space that culminates in a clerestory window made possible by the lap pool, which brings light deep into the central area of the plan. Due to the high seismic risks of the area, the house is constructed almost entirely out of reinforced concrete.

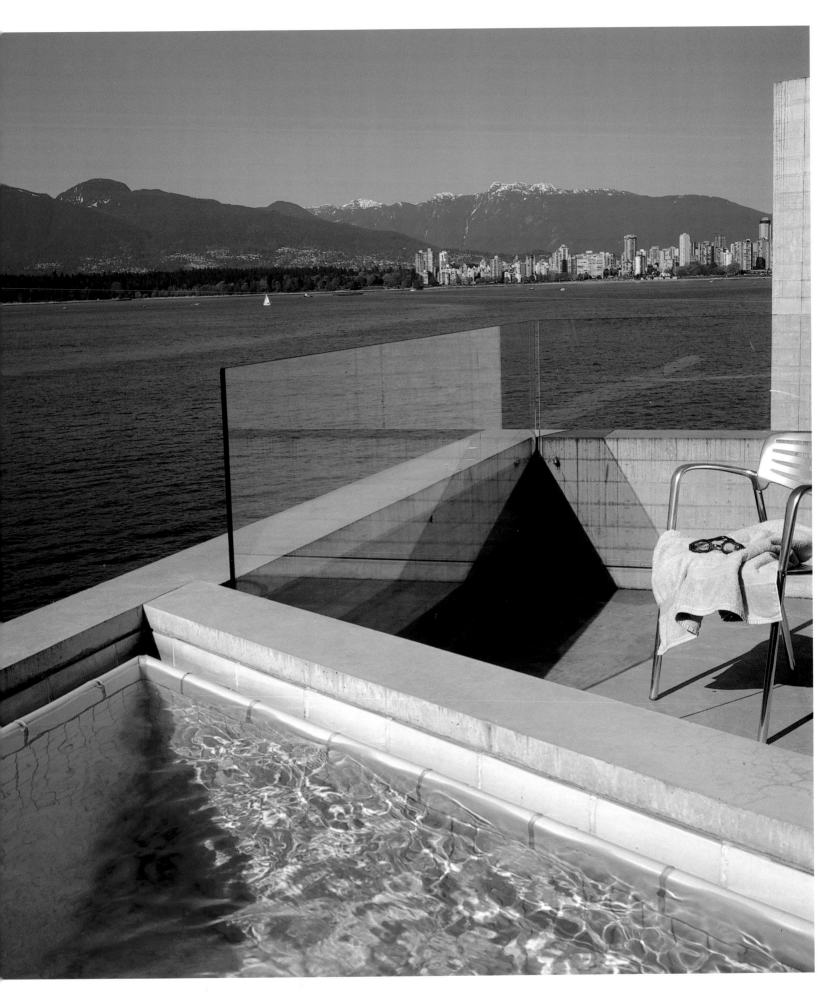

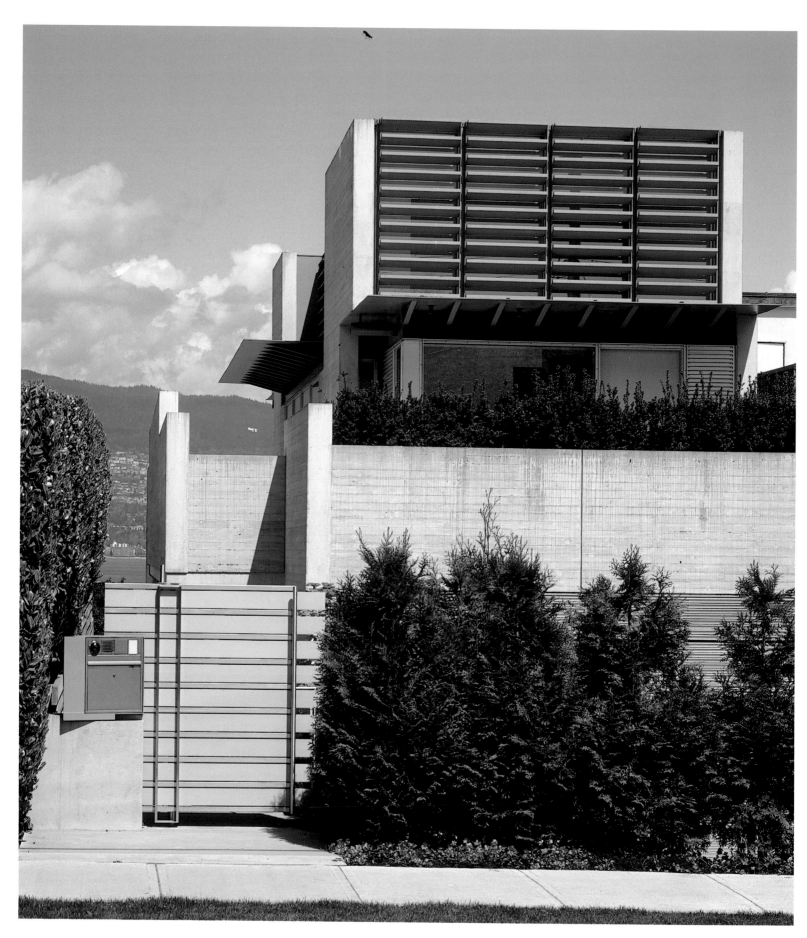

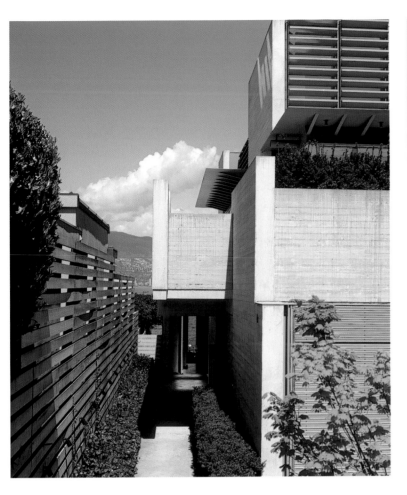

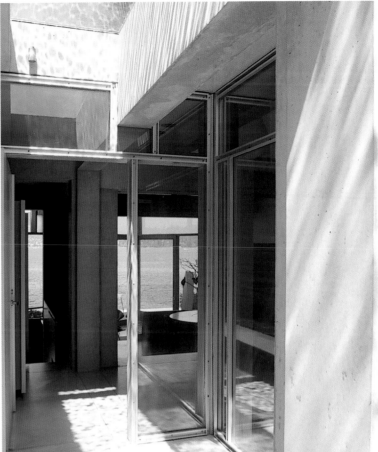

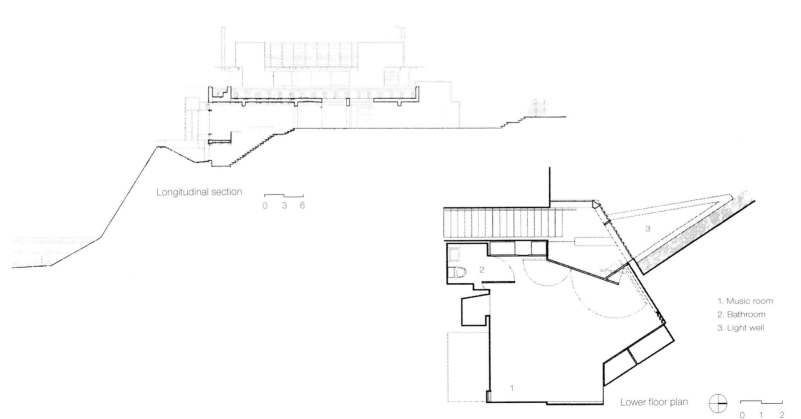

Longitudinal section

0 3 6

1. Music room
2. Bathroom
3. Light well

Lower floor plan

0 1 2

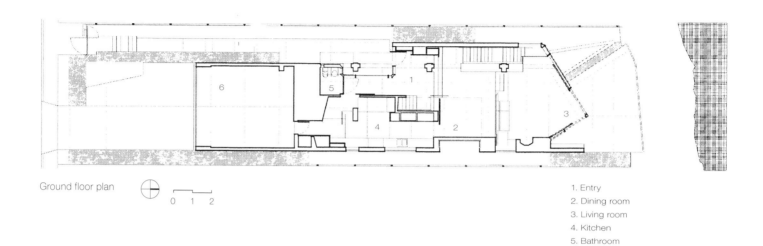

Ground floor plan

0 1 2

1. Entry
2. Dining room
3. Living room
4. Kitchen
5. Bathroom
6. Garage

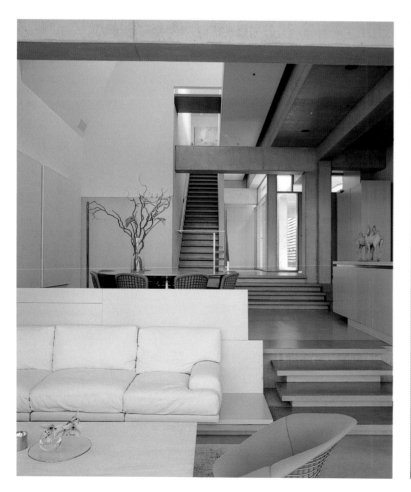

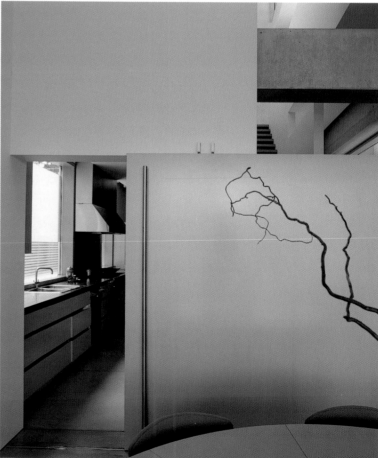

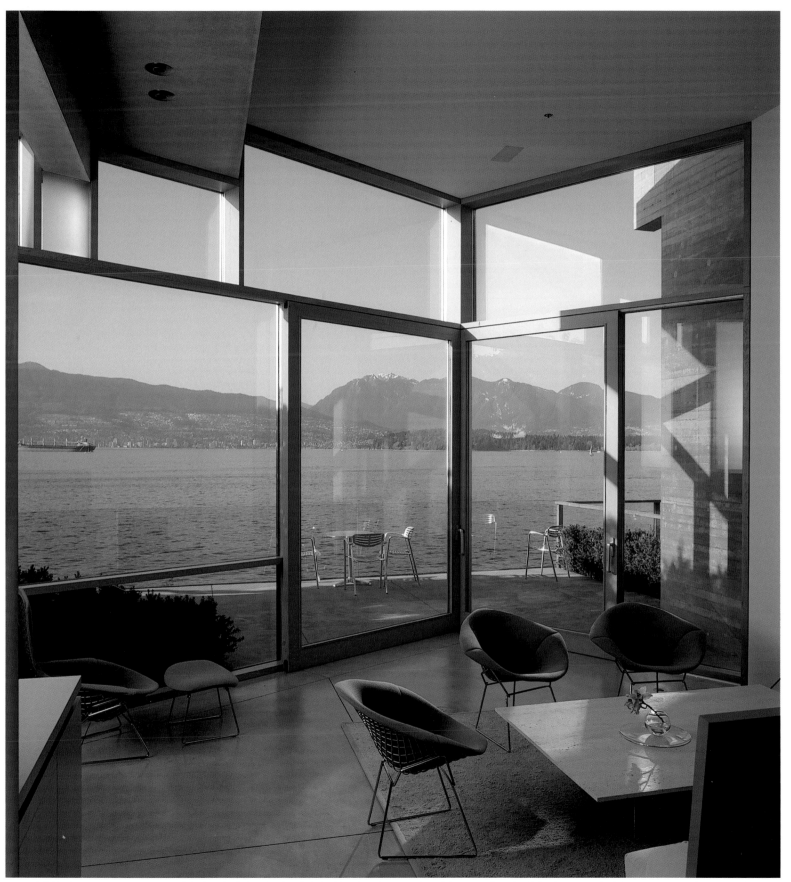

Within the structural concrete shell the interior is insulated and clad with painted gypsum board. In areas where insulation is not required the concrete remains exposed.

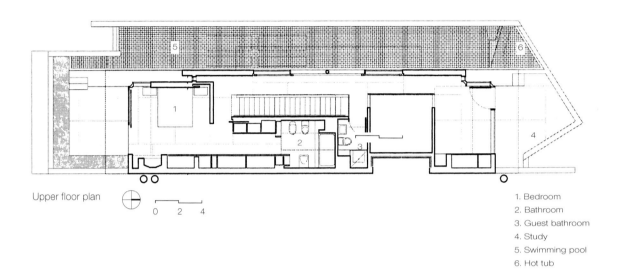

Upper floor plan

0 2 4

1. Bedroom
2. Bathroom
3. Guest bathroom
4. Study
5. Swimming pool
6. Hot tub

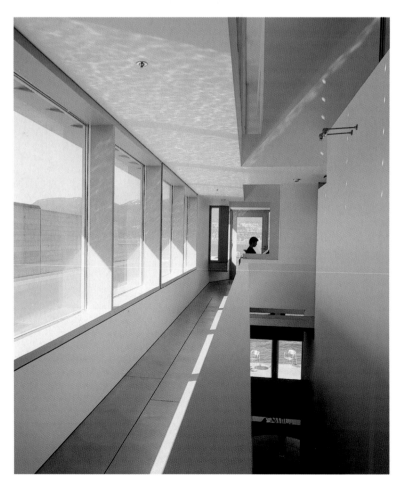

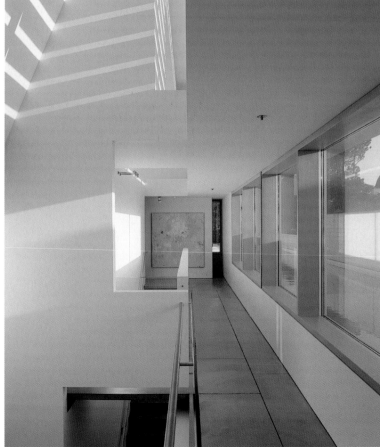

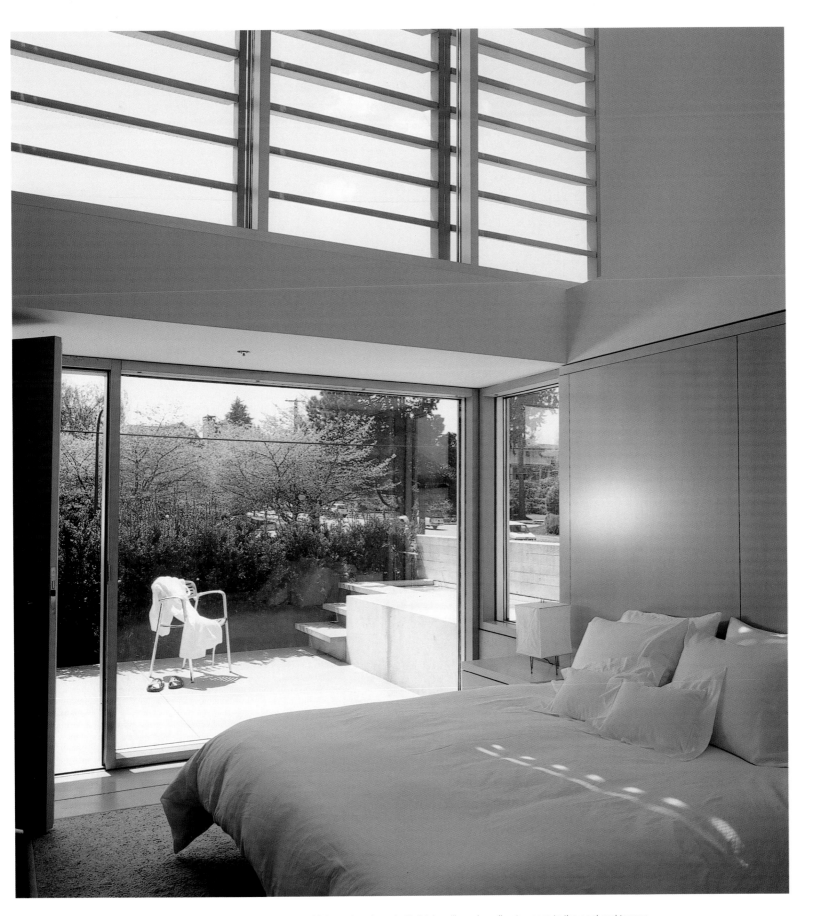

The bedroom, inundated with natural light and endowed with high ceilings, has direct access to the pool and terrace.

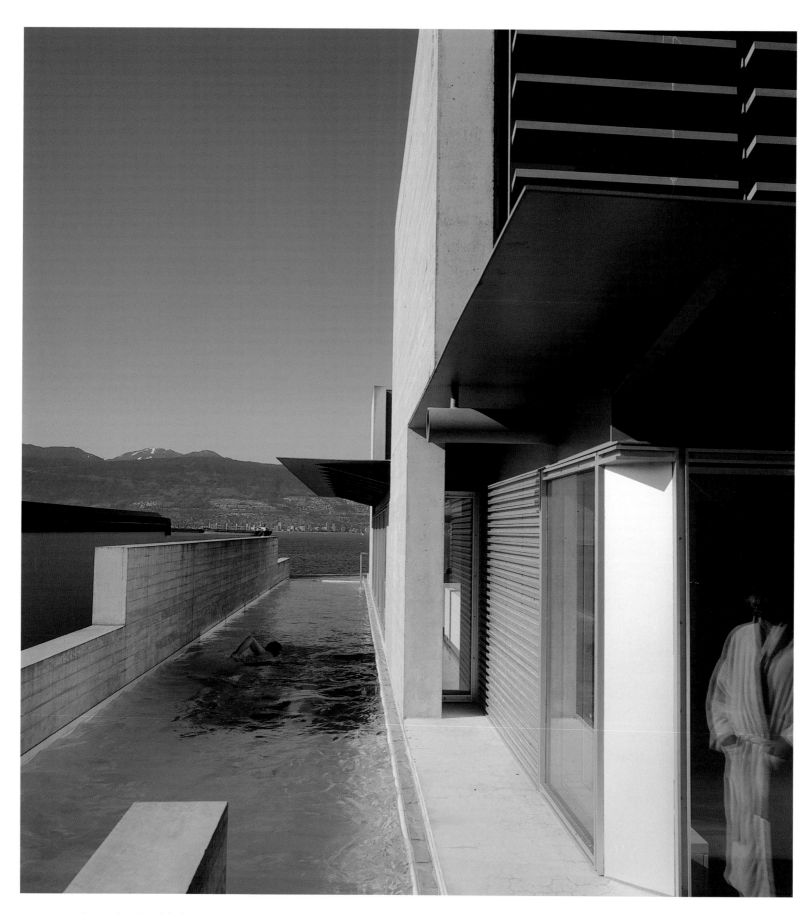

A sweeping view of the bay can be taken in while swimming laps, at the same time, the swimmer can be seen from underneath, through the glass bottom.

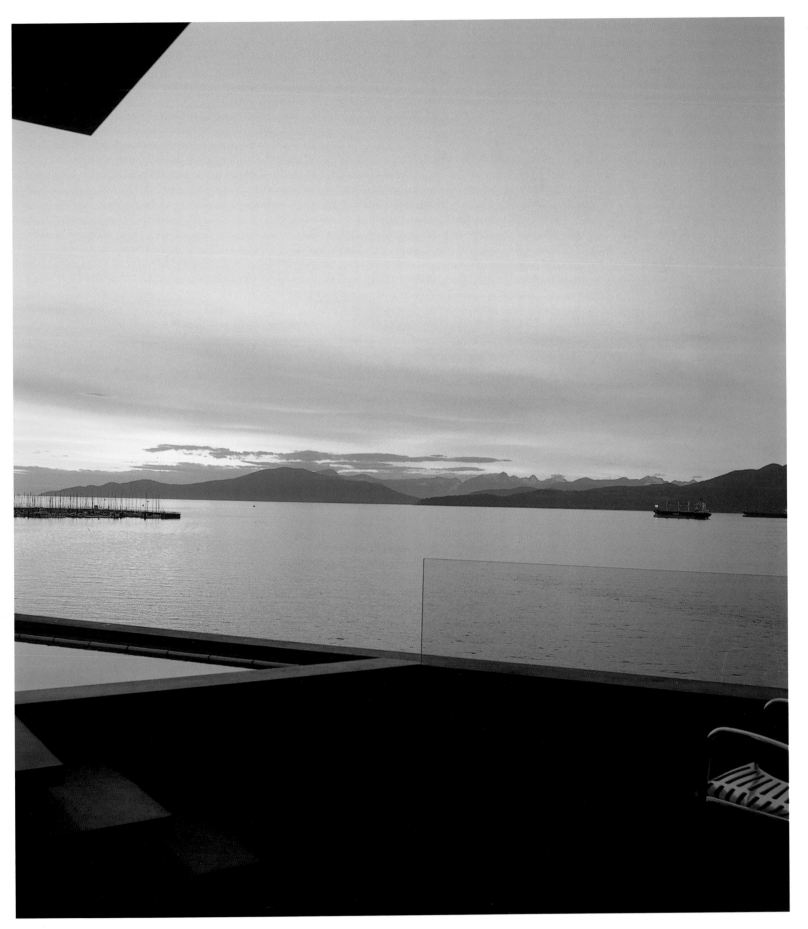

reutter house	Mathias Klotz
Photos © Nick Hufton/VIEW	Cachagua, CHILE 1998

Located 87 miles from Santiago, Chile, this house sits on a slope amidst a multitude of pine trees. Set into a 30° slope, this ocean-facing site is bordered by two streets. The project consists of two rectangular boxes that interlock and insert the living spaces into the surrounding forest. One box contains the private spaces and overlaps the other box that contains the public spaces.

Doors are replaced by sliding walls that allow the bedrooms to open completely onto the living area, thus integrating the small box into the larger box. A third mass, built of reinforced concrete, passes through the main box, representing the nucleus that contains a bedroom, laundry room, kitchen, TV room, and study distributed over three levels. To emphasize the horizontal axis of the project, a 98-foot bridge travels through the pine trees to provide street access. The roof, a large open-air terrace facing the ocean, incorporates a steel staircase that leads to a covered terrace and into the home.

The reinforced concrete basement wall supports the concrete floor and two steel-framed boxes. The larger box is finished in wood and the other in copper, echoing their natural surroundings. The construction demonstrates stability and tension both structurally and practically. The views of the ocean are optimized by terraces on each level of the residence, one of which features a swing set from which to playfully contemplate the mesmerizing view.

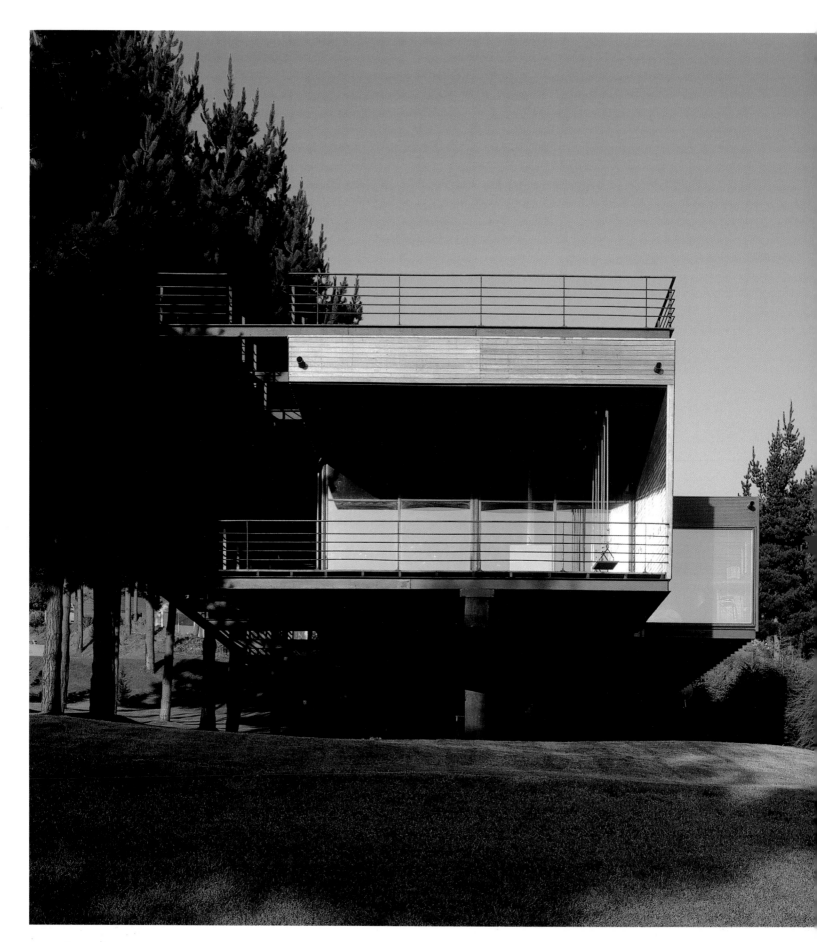

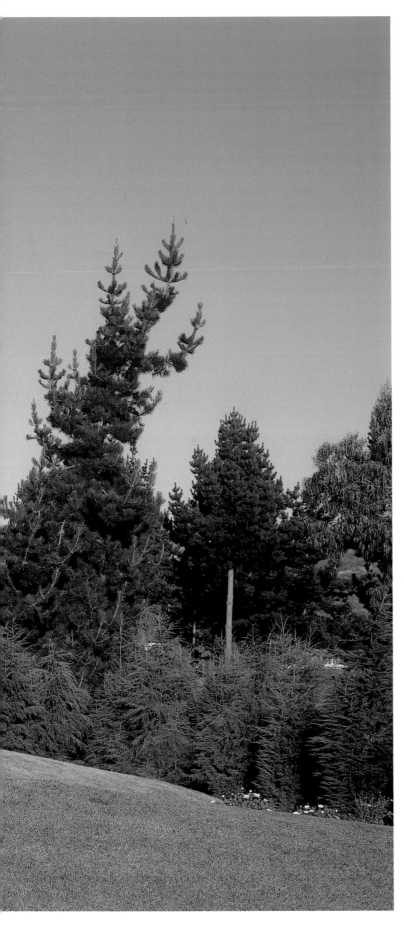
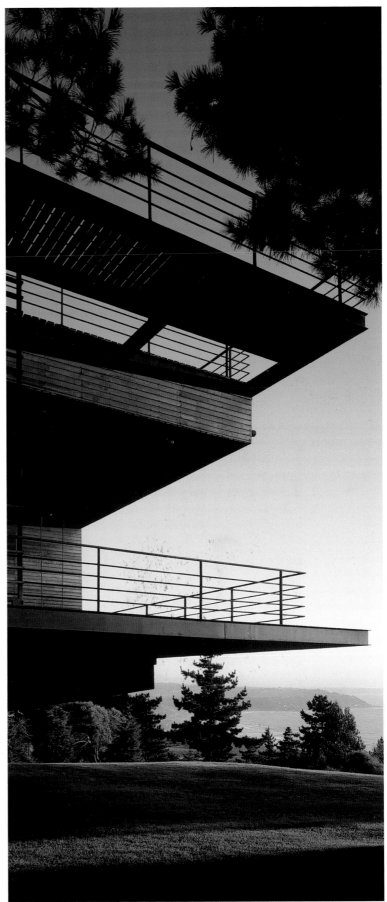

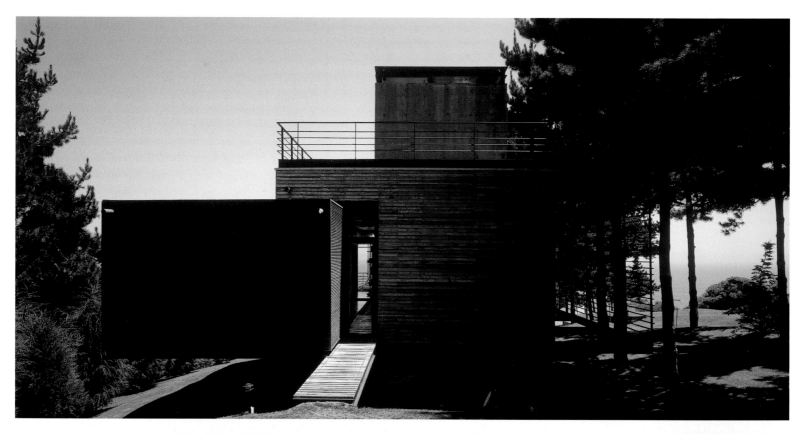

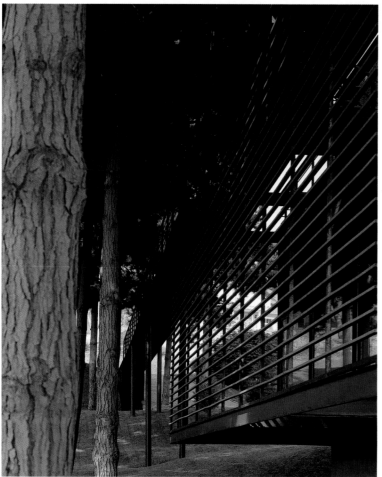

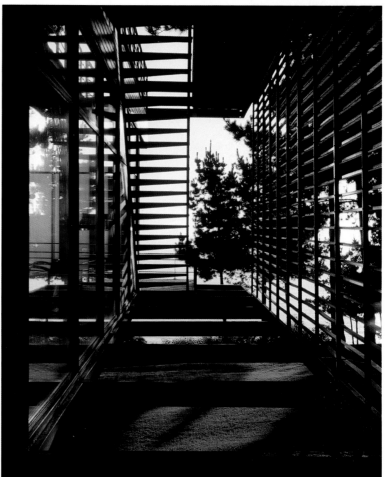

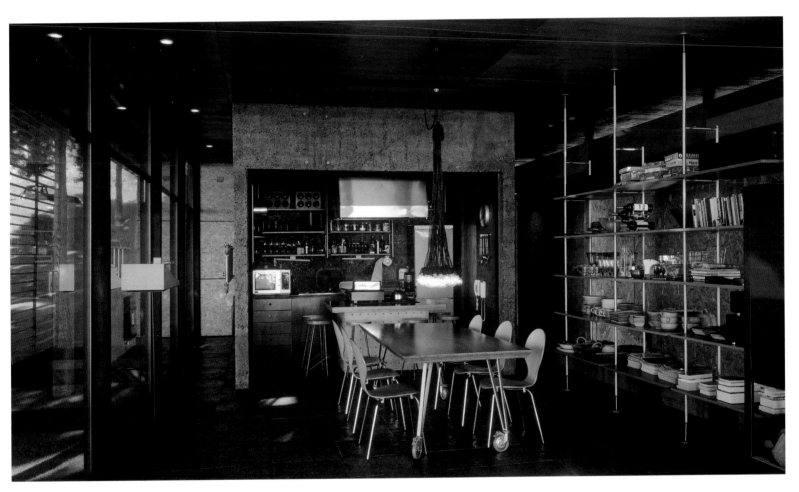

Boxes are used to shape the interior spaces as well. The kitchen is set in a concrete frame that clearly defines the dining area without the need for physical borders.

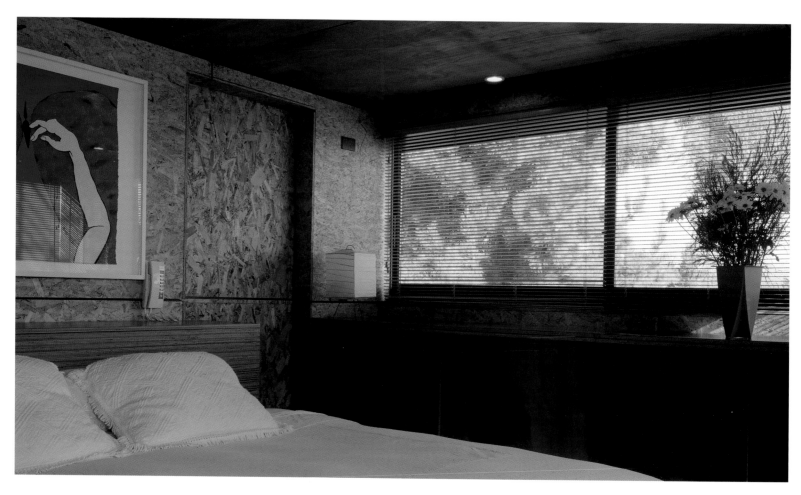

The bedroom offers a cosy, contained space that can open onto the living areas by way of large sliding panels.

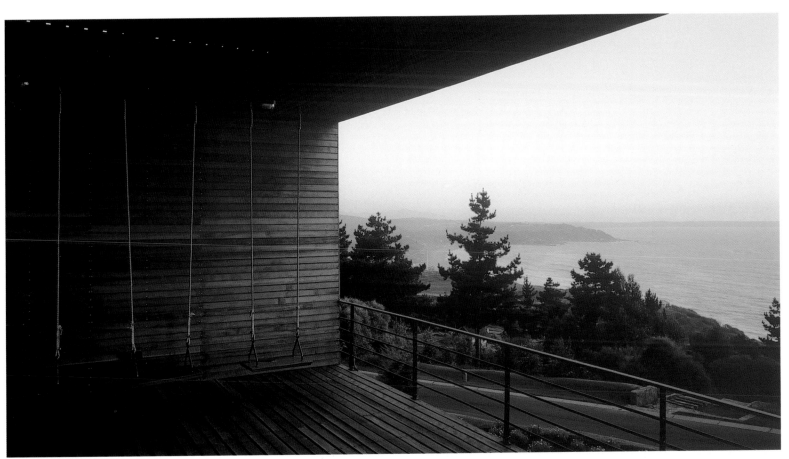

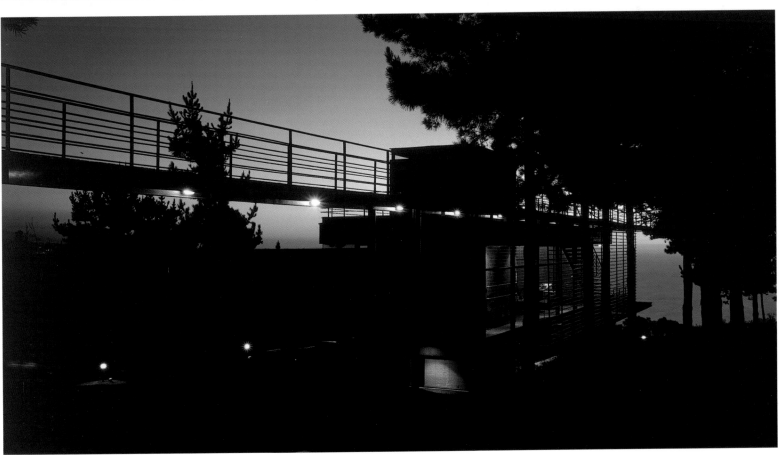

SUMMER HOUSE	Saunders & Wilhelmsen
Photos © Bent Renè Synnevag	Hardanger Fjord, NORWAY 2003

A young Canadian/Norwegian firm dedicated to experimental, environmental, and innovative design created this summer cabin set in one of Norway's most beautiful fjords. The architects created an architectural vision in line with their convictions: originality, independence, and respect for the environment. They succeeded in constructing a contemplative space that integrates with the natural surroundings and exhibits a sensitive contrast to the dramatic landscape.

The retreat is divided into two parts: a space designated for eating and sleeping and a smaller general-purpose space. A long and slender outdoor floor links the two rooms and faces the water, giving mesmerizing views of the fjord. Conceived as a retreat for the architects and their friends, the house is minimalist in more ways than one. Apart from providing only the necessary comforts, such as a bed and a kitchen, the only technology in the cabin is supported by natural gas. Using natural light by day, candles are enough light at night given that this area of Norway experiences only four hours of darkness during the summer months. All the trees on the site were left intact, and recycled newspapers were used as insulation.

Considering that in Norway all new architecture has to be at least 328 feet from the shoreline, the 262-foot distance that was conceded in this case give the project a privileged spot in the landscape. It is also situated 262 feet above sea level, and a mere 98 feet west of the cabin amidst the woods are 98-foot-high waterfalls that flow into streams, one of which passes underneath an old stone foot bridge near the cabin. The architects claim that this cabin, characterized by the dark forest in the back and the expansive light in front, has a church-like, hypnotizing, and mystical spirit.

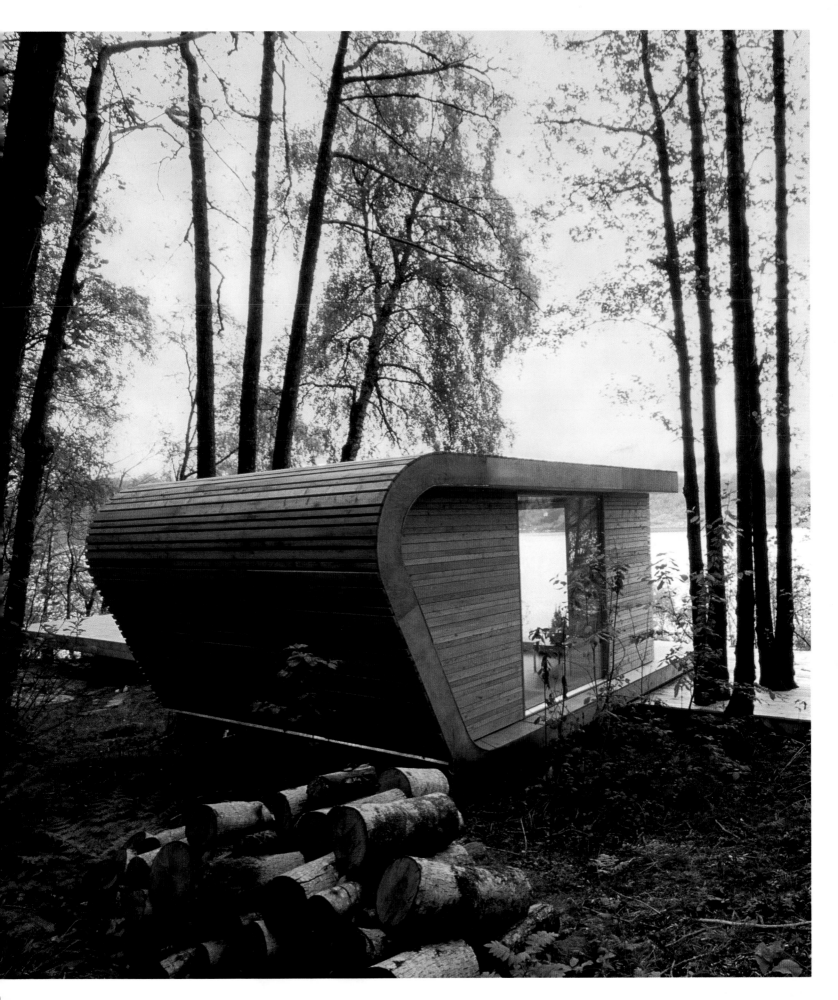

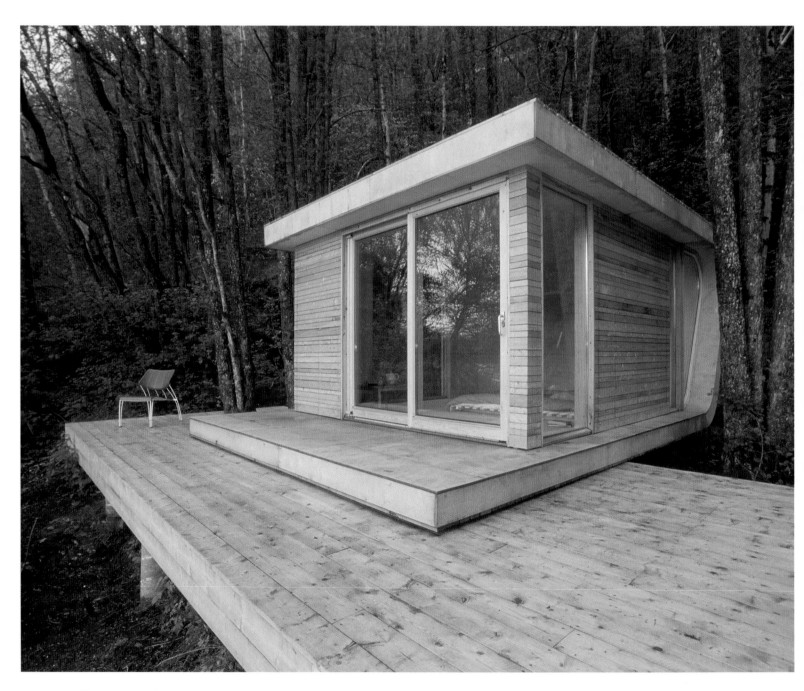

This 263-square-foot project is divided into two structures. The abstract design opens a dialogue with nature that refreshes its occupants and provides a renewed perspective on life and nature.

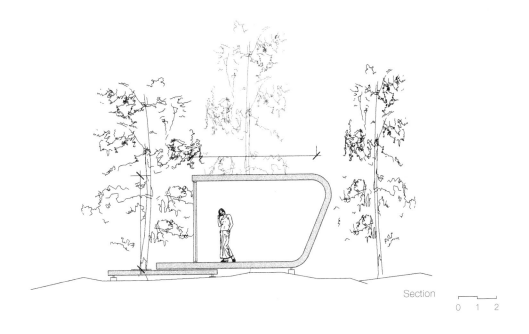

Section

0 1 2

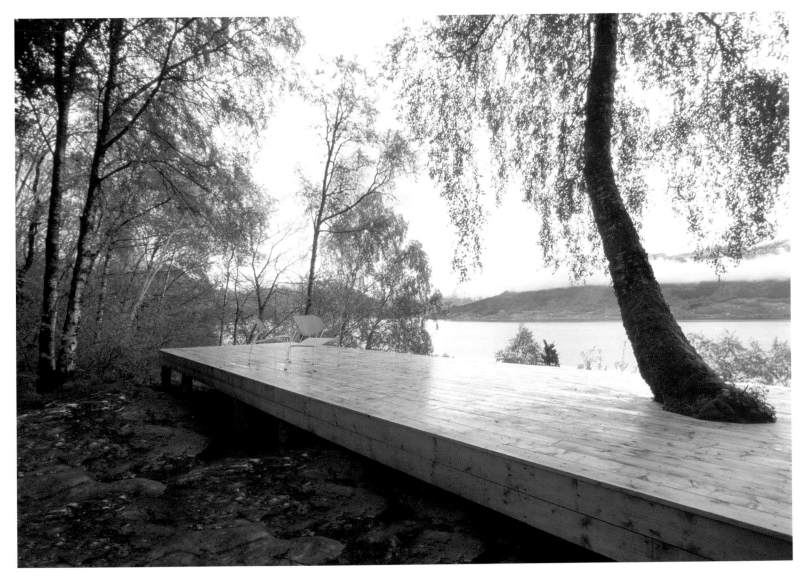

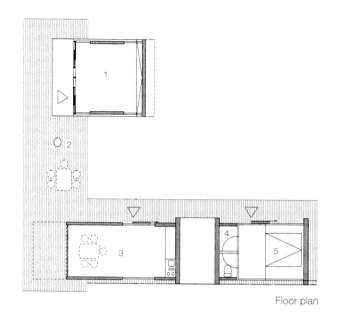

1. Studio space
2. Deck
3. Dining room/Kitchen
4. Bathroom
5. Bedroom

Floor plan

0 1 2

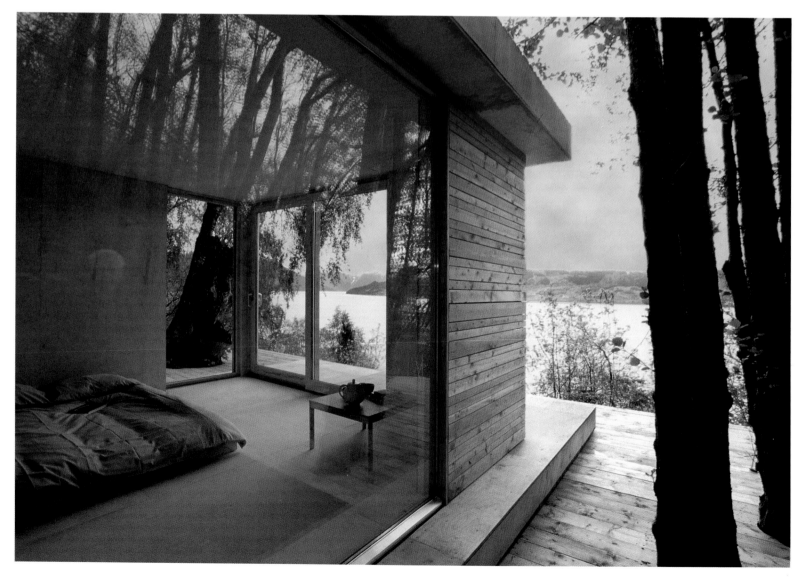

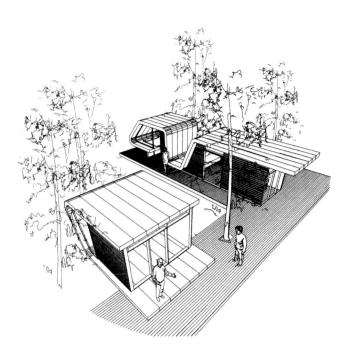

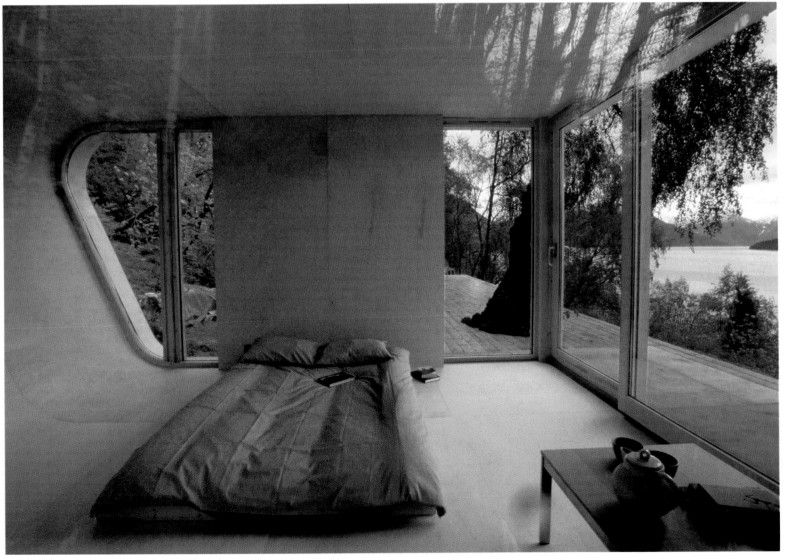

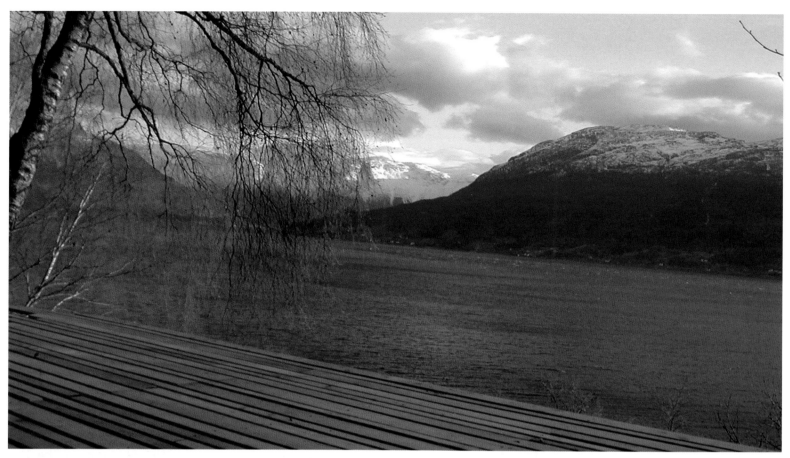

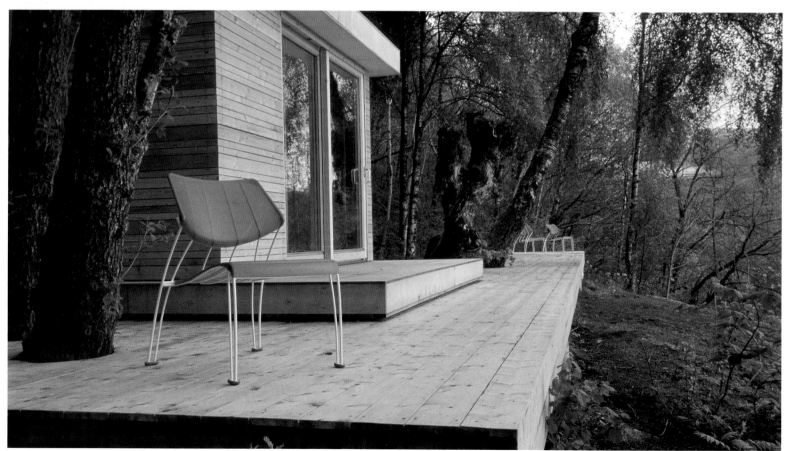

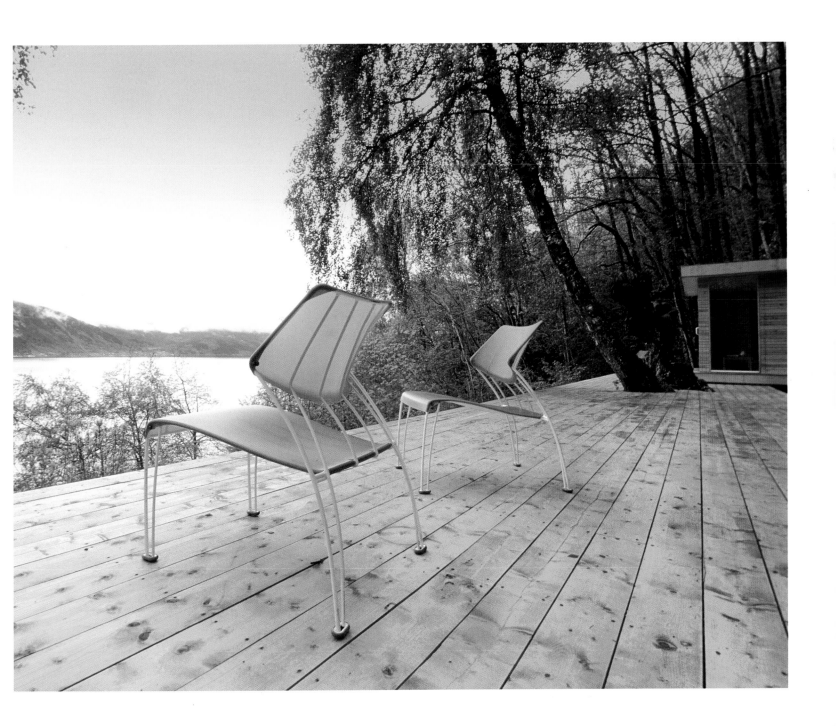

gledhill house

Tanner Architects

Photos © Richard Glover/VIEW

New South Wales, AUSTRALIA 2002

On a sheltered inlet on the eastern coast of Australia, this holiday home looks past rocky headlands and windswept bush to a small sandy beach and out to sea. Careful planning made it possible to screen out the neighbors while capturing natural light and retaining views of the natural scenery.

Designed for a family, the project was conceived as two compartments: the top level for the parents, and the bottom level for children and grandchildren during the summer months. The top floor comprises the main living space: a master bedroom with a private bathroom, a guest bedroom and bathroom, a laundry room, and a two-car garage. The lower level consists of three bedrooms, a bathroom, and a central family room that opens onto a terrace with garden access.

A masonry base supports a steel frame that floats over the site. A tilted roof and high-level windows in the main living space give shade in the summer and sunlight during the winter. On the east wing, a generous covered deck overlooks the inlet and ocean. To the west a sheltered courtyard bordered by pale river stones and flagged in white cement is accented by a large frangipani tree and perfumed with white blossoms in summer. The planar forms of the decks and roofs give strength and simplicity to the design, which emphasizes the use of metal, glass, masonry, tiled floors, and stone surfaces. The materials and finish employed were chosen for their resistance to ocean exposure. A fine example of contemporary design, this house takes full advantage of the magnificent views and open-plan lifestyle so characteristic of Australia's coast.

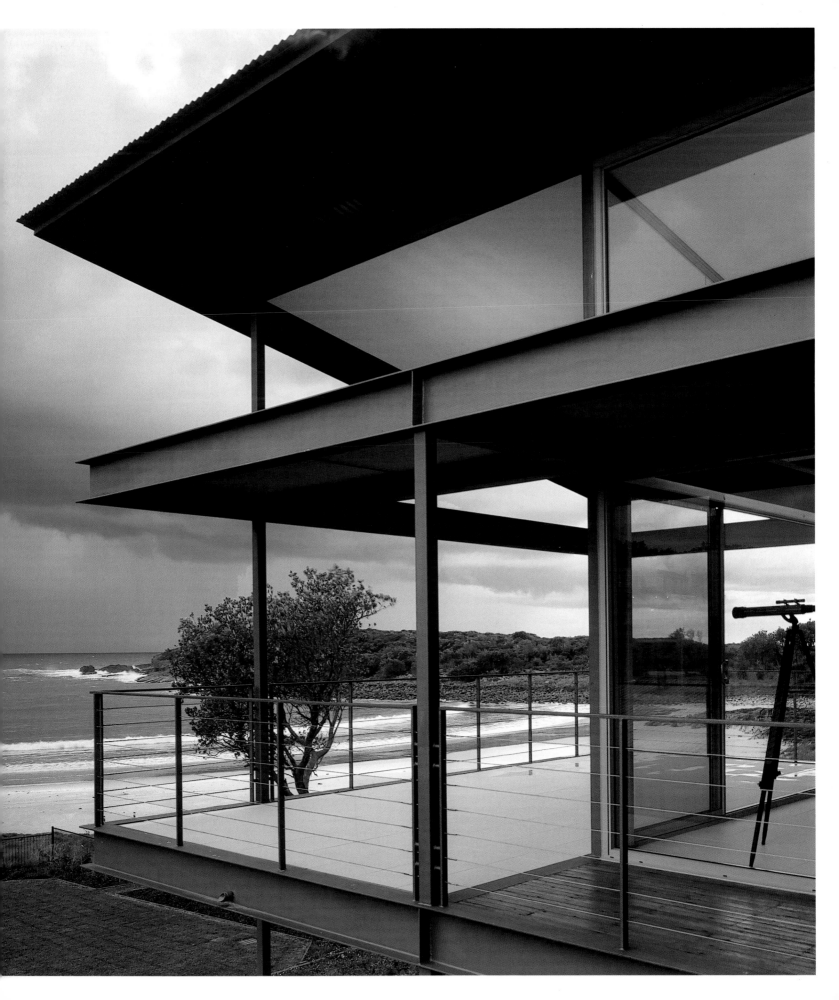

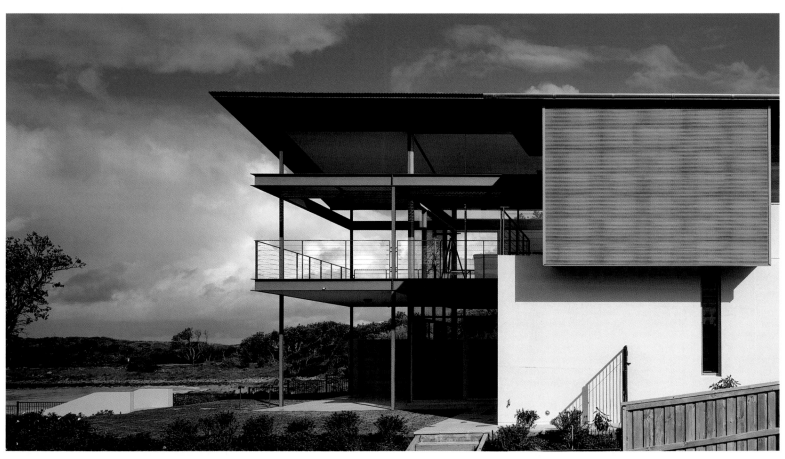

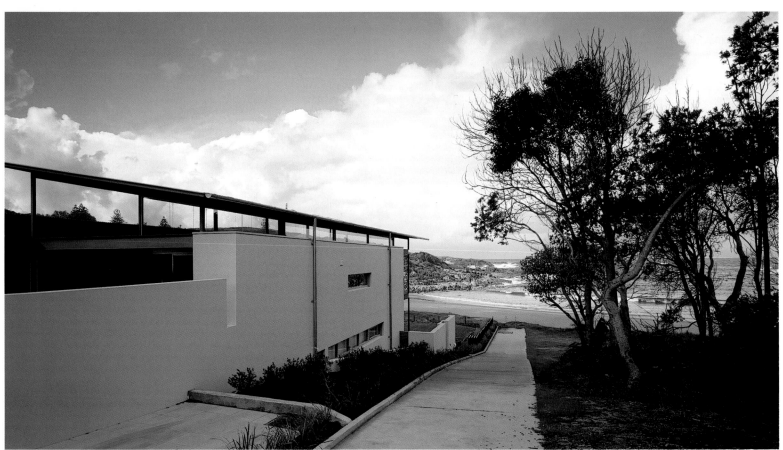

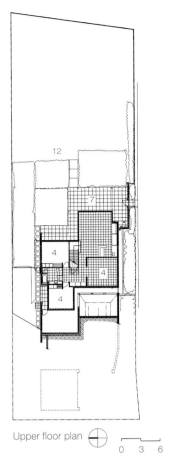

Upper floor plan

0 3 6

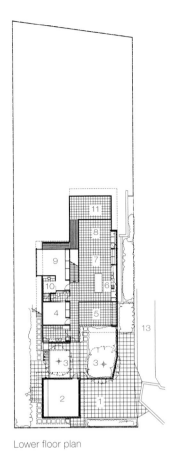

Lower floor plan

1. Driveway
2. Garage
3. Courtyard
4. Bedroom
5. Terrace
6. Kitchen
7. Dining room
8. Living room
9. Master bedroom
10. Master bathroom
11. Balcony
12. Lawn
13. Public footpath

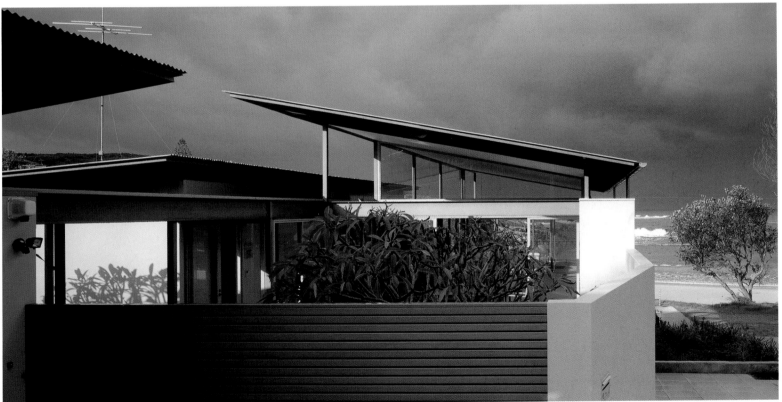

In order to protect against the corrosive effects of the ocean, steel sections were finished in micaceous iron oxide (MIO), aluminum doors and windows were powder-coated, and the roofs were made out of heavy gauge Zincalume, a watertight material that prevents corrosion.

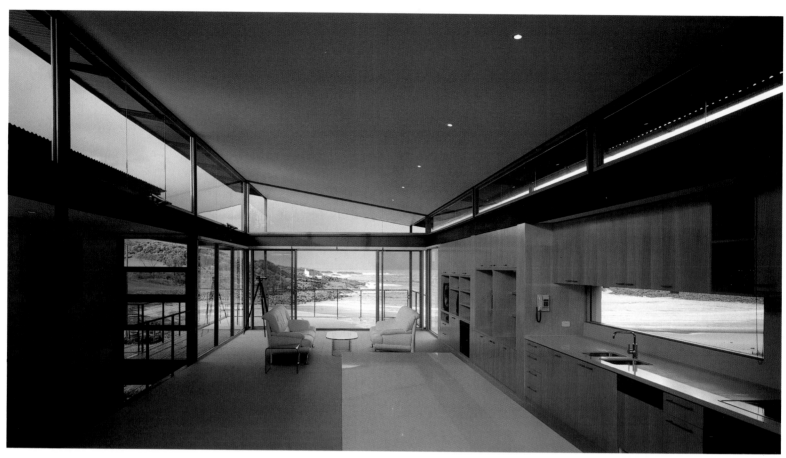

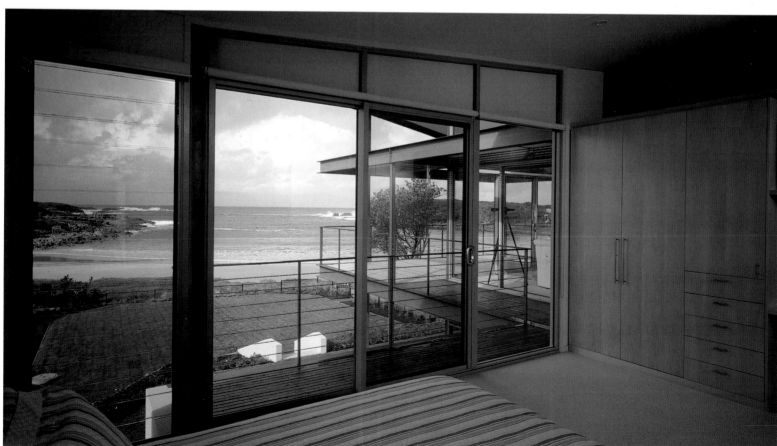

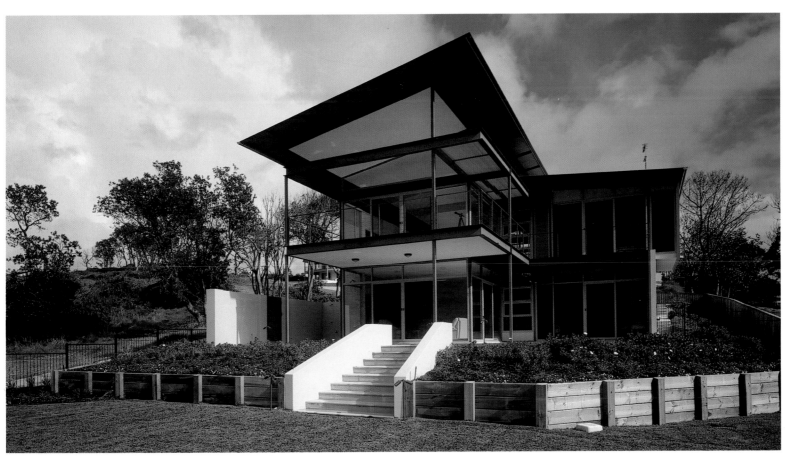

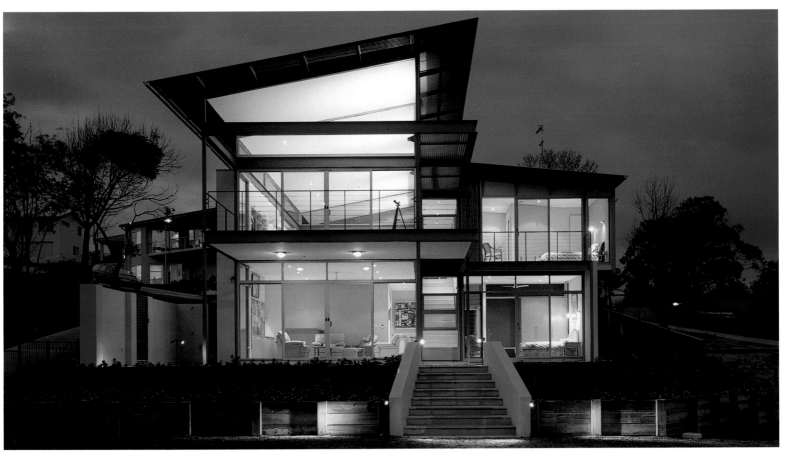

house on fire island	Bromley Caldari Architects, Jorge Rangel (interior designer)
Photos © Jose Luis Hausmann	Fire Island, New York, USA 2002

Fire Island, literally a sandbar, is just a 30-minute ferry ride across the Great South Bay from New York City. This residence is situated on the north side of the island, looking towards the continent, and safeguarded from the strong Atlantic winds. The island's fragile ecosystem prevents the presence of cars, and wooden walkways replace concrete streets out of respect for the environment and the constantly shifting sand dunes.

A small walkway leads to the guest pavilion, followed by a barbecue area, a swimming pool and the main entrance at the far end. The home is composed of two large masses: the main house and the guesthouse. The main house consists of two bedrooms and a large social area that includes the living, kitchen, and two-story dining area that looks out towards the bay through an expansive wood-framed glass panel. The panel opens in its entirety to merge the living and dining area with the terrace, making it the perfect place for eating, talking, reading, or viewing the ocean. A few steps down from the porch, a small rest area also acts as an embarcadero for incoming sailboats. The second building is a guest pavilion situated near the entrance beside the swimming pool. The structure, completely independent from the main house, also serves as a painting studio for the owner when the guesthouse is empty.

This unique construction uses materials not usually found in beach houses. The pavement was laid in brick, zinc panels were used in the wet areas, and cedar and pine panels were used with structural beams to create large, airy spaces within the home.

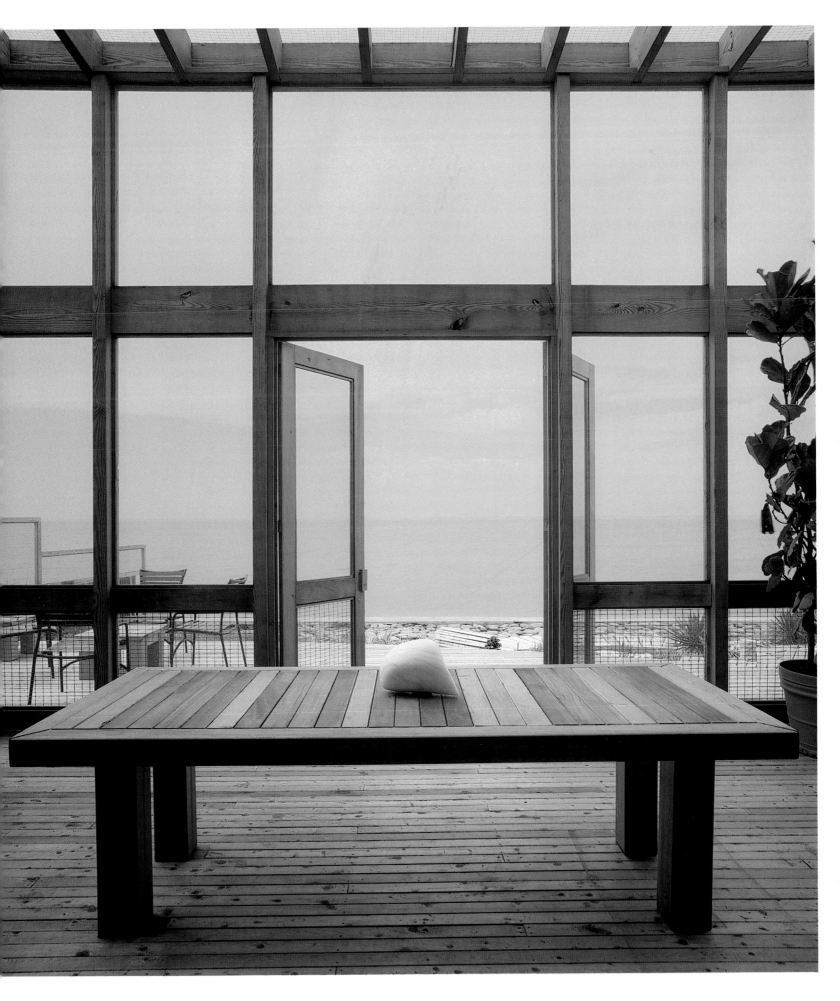

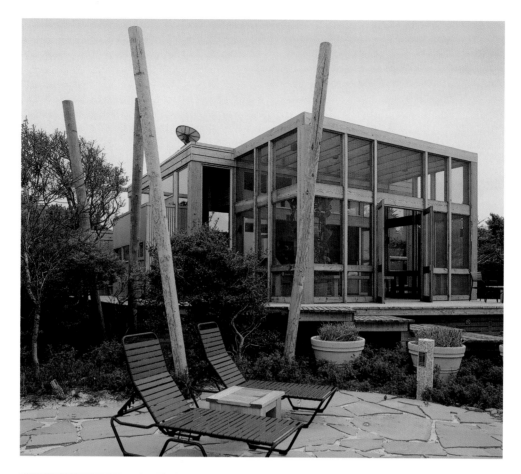

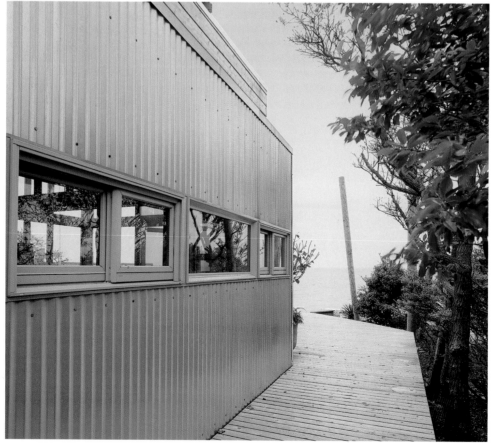

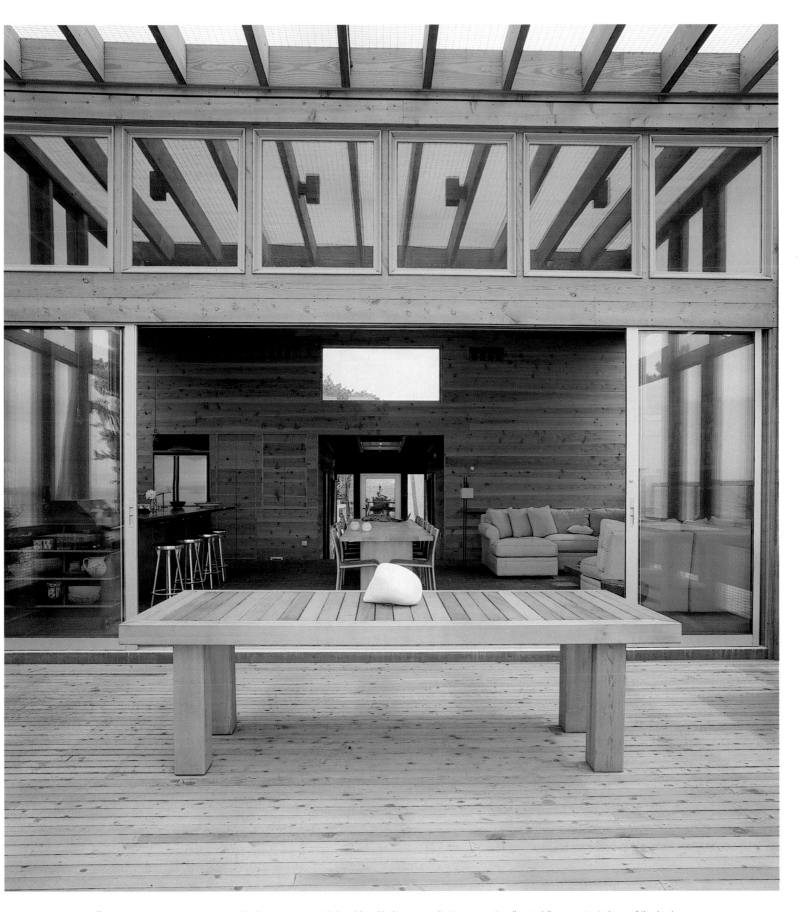

This wood and glass structure maintains a constant relationship with the ocean, its transparent walls providing constant views of the horizon.

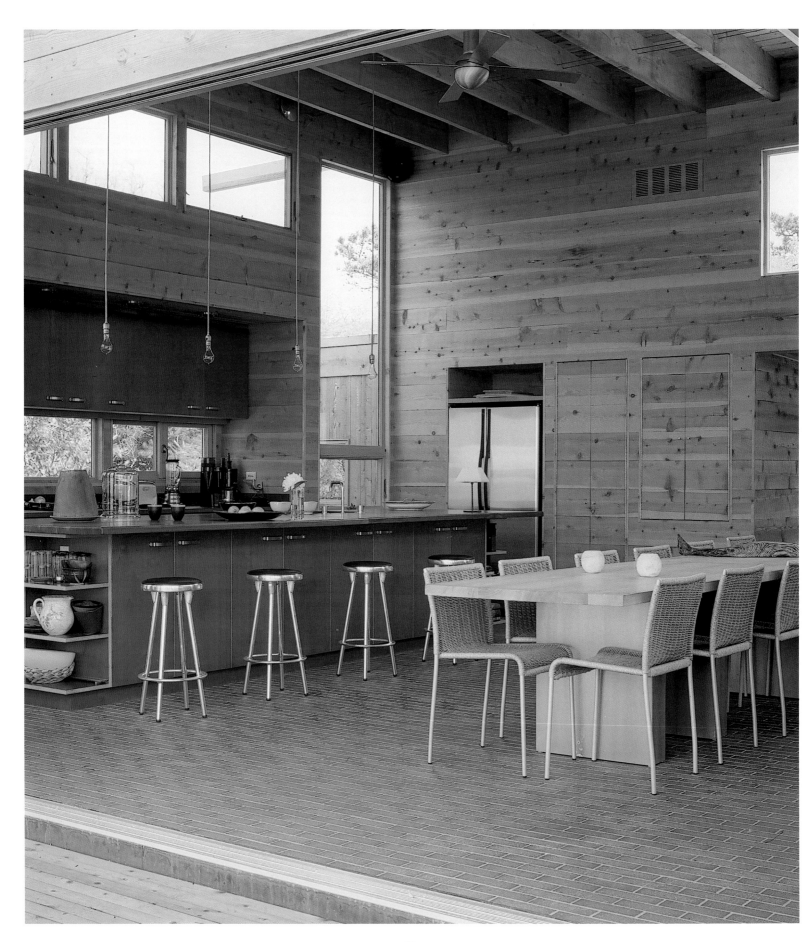

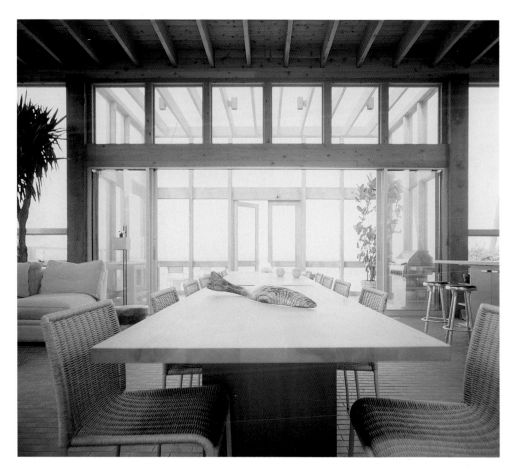

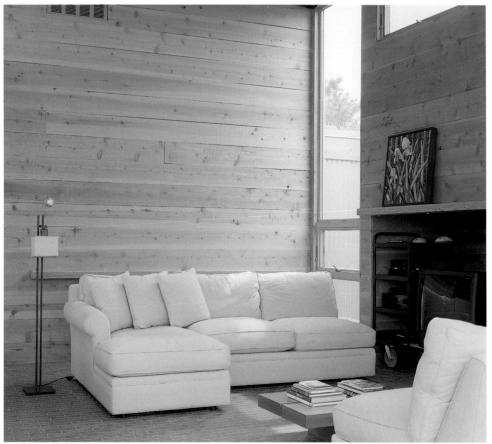

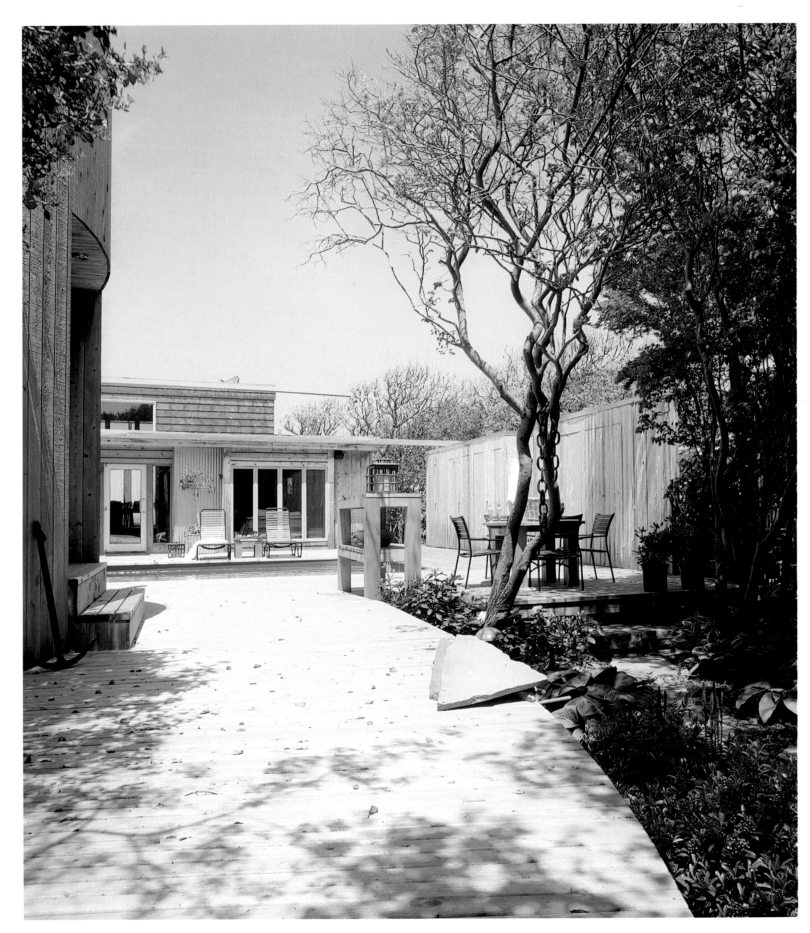

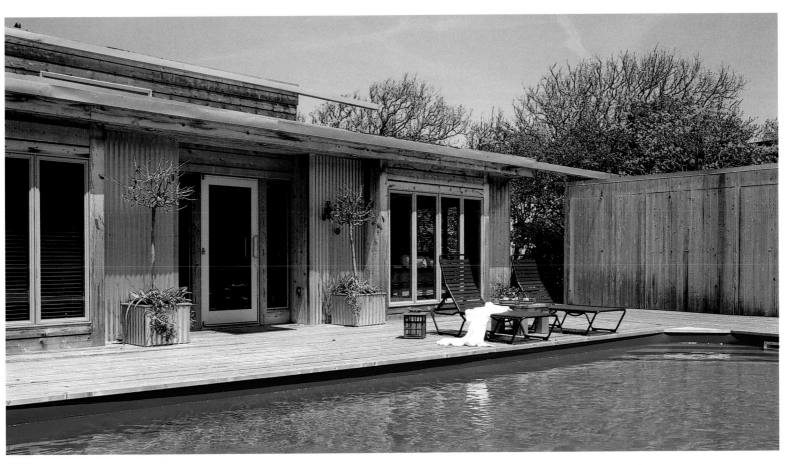

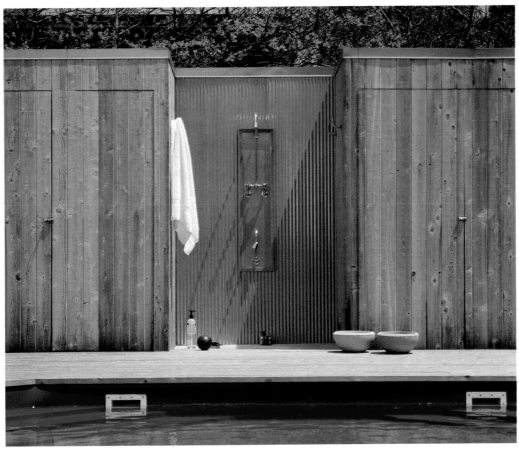

island house	Shim-Sutcliffe Architects
Photos © James Dow	St. Lawrence River, Ontario, CANADA 2002

This summer home, in a meadow that borders the St. Lawrence River, explores the element of water in the form of a man-made pond. The Island House, given its name for the body of water that surrounds the main living area, engages the existing landscape and creates its own. The river establishes a water theme that dominates the overall design of the home.

A long, low concrete wall is set into the gently sloping terrain that descends towards the river. The plan interlocks two linear flat-roofed rectangular 'bars' around a square living room pavilion. Both low roofs are planted with wild flowers, becoming abstract meadows themselves in a continuation of the surrounding landscape. On the west side, the kitchen and dining room lead onto a deck and gravel garden. On the east side are located the study, bathroom, and master bedroom and the north wall contains storage, the stairs, and another bathroom.

The entrance looks directly through the living room pavilion that seems to float like an island in a large reflecting pool, with views of the meadow and river beyond. The landscaping is a continuation of the meadow and reinforces the pastoral quality of the island. The pond is punctuated with clusters of bulrushes and scattered with water lilies to add detail, while a crushed limestone dry garden encloses the tranquil body of water.

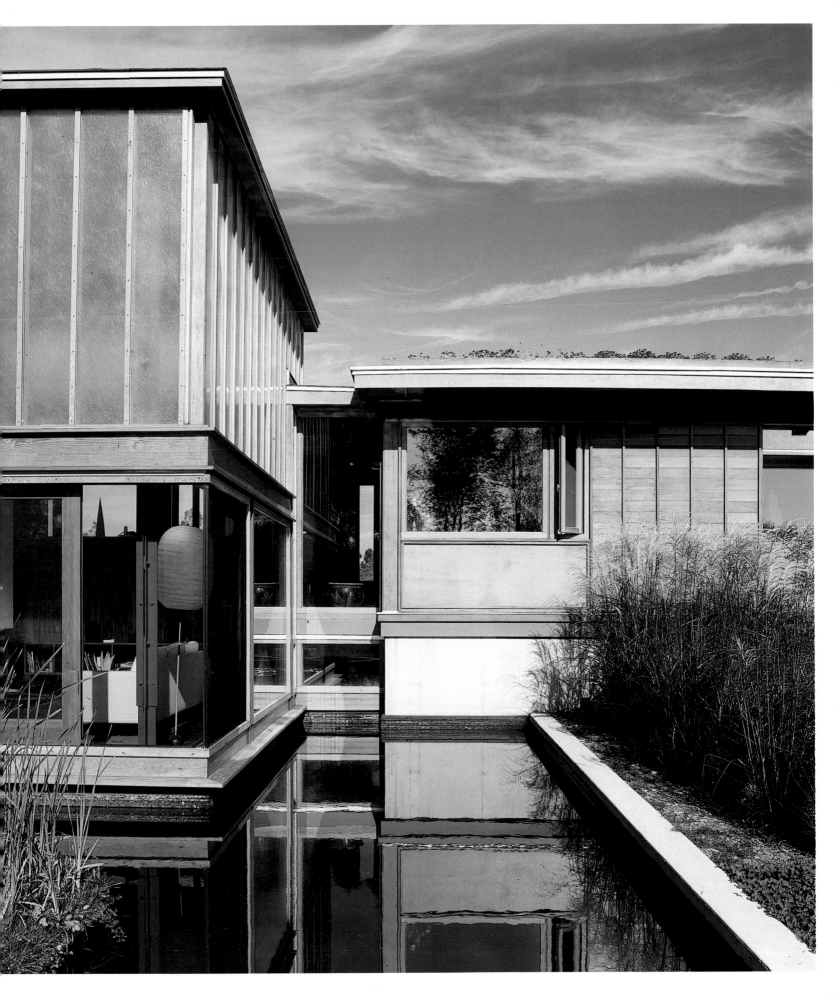

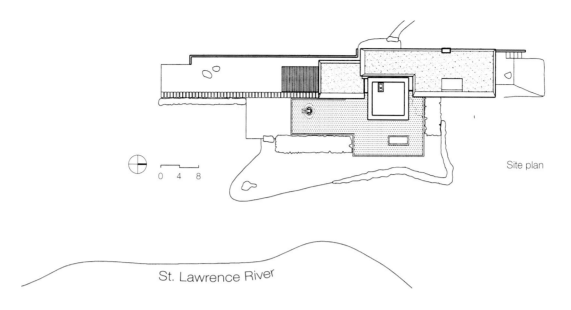
Site plan

0 4 8

St. Lawrence River

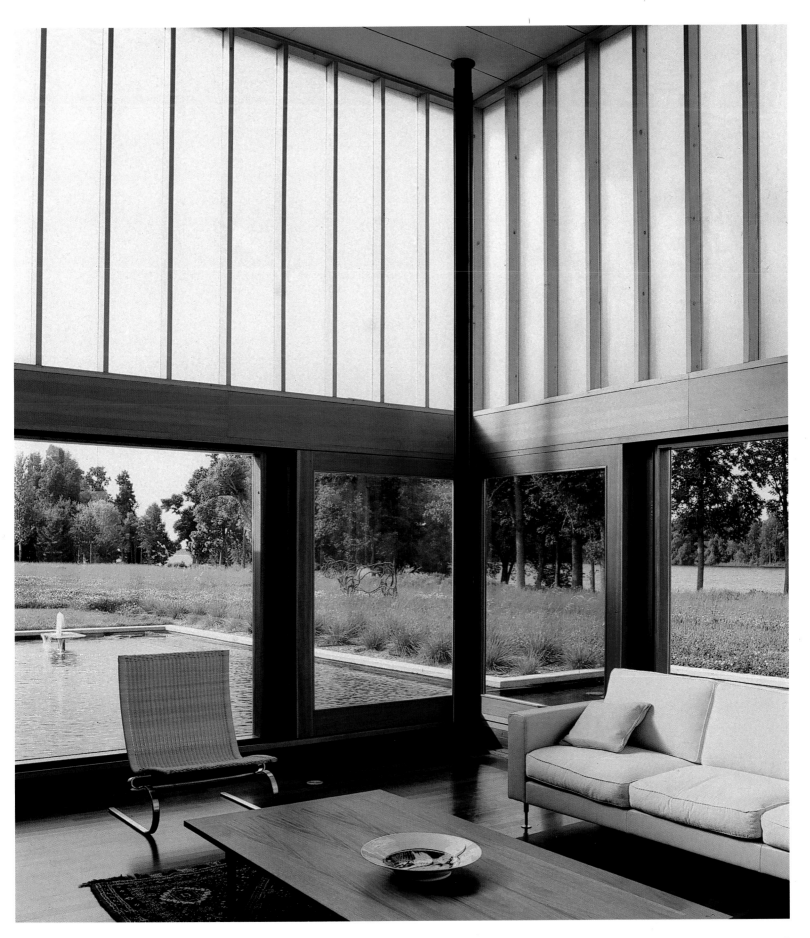

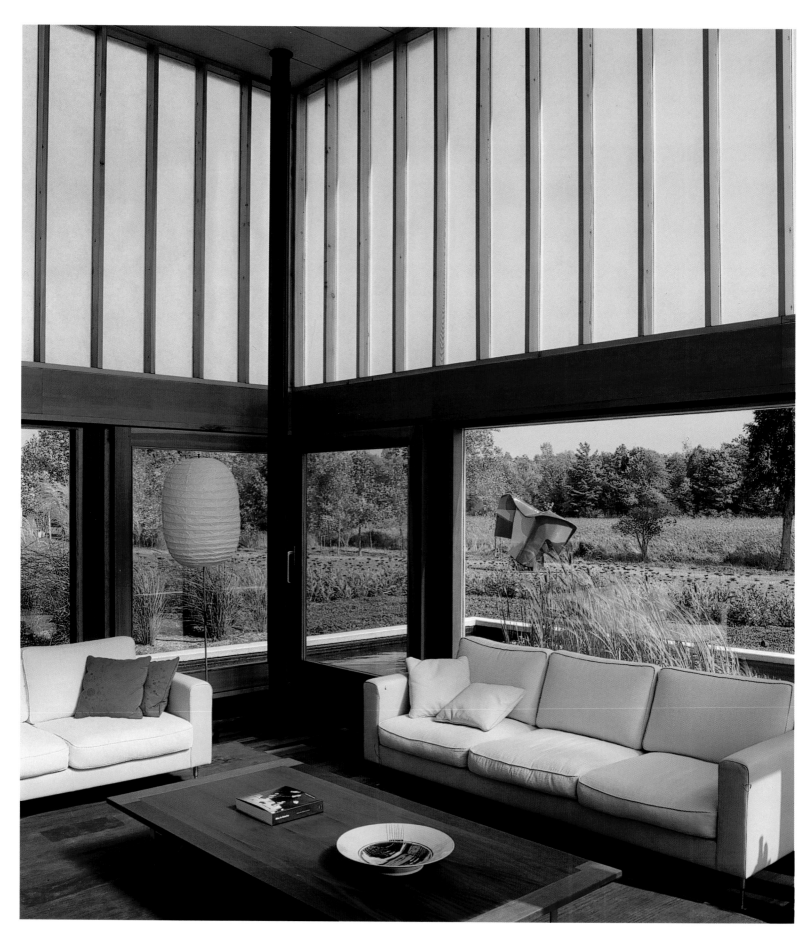

Floor plan

1. Entry
2. Dining room
3. Kitchen
4. Living room
5. Bedroom
6. Bathroom

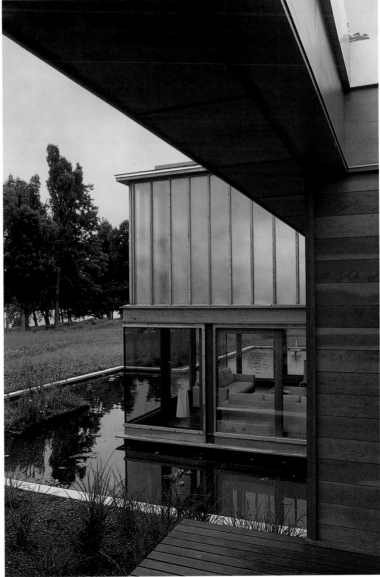

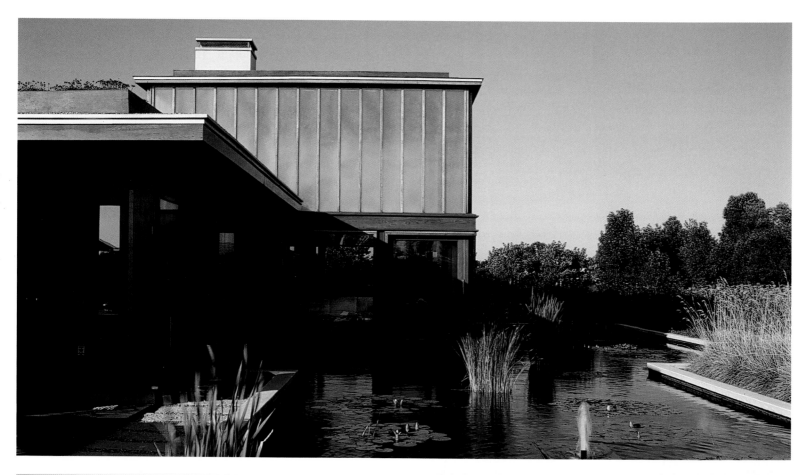

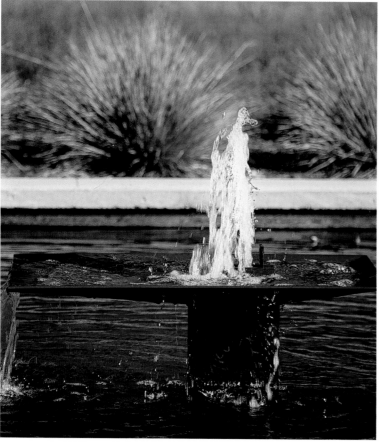

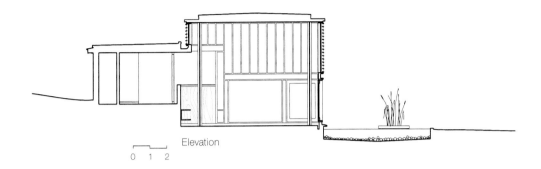

Elevation

0 1 2

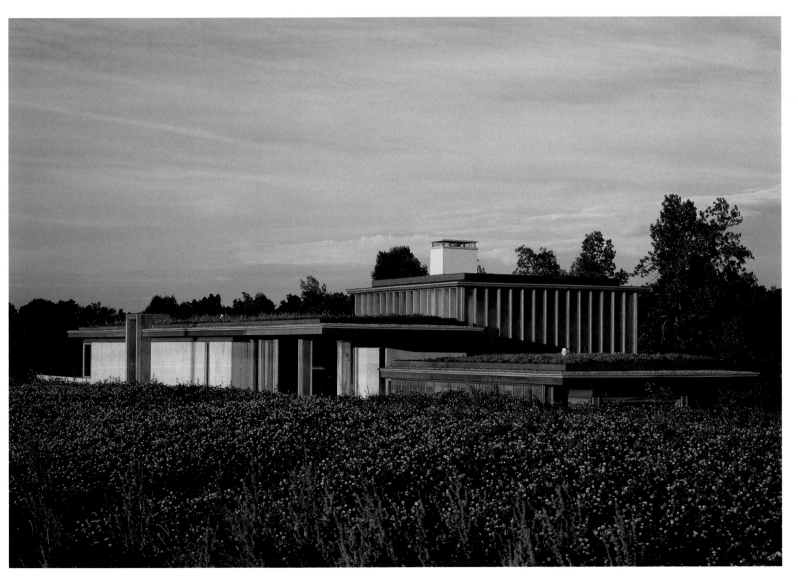

View of the house surrounded by a clover meadow and the St. Lawrence River beyond.

hodges place

Knox Bhavan Architects

Photos © Dennis Gilbert/View

Kent, UK 2000

A 17th century timber framed farm house in Offham, Kent, was refurbished and expanded in a marriage of traditional and contemporary style. The addition of a reflective pool serves as both an aesthetic and practical element.

The existing house is located within the Conservation Area of a small village on the edge of the Metropolitan Green Belt. It was decided that the new extension should be respectful of, but not necessarily the same style as, the existing house. The architects devised a contemporary design that would not compete with the old house, remain sensitive to its immediate surroundings, and be constructed from high quality natural materials. The project resulted in a single-story extension with an irrigated grass roof. Set almost a yard below the floor level of the existing house, the new structure takes advantage of the natural slope of the land to reduce its impact on the old house, landscape, and garden. The grass roof hovers a foot above the kitchen garden stone wall that measures 82 feet in length, and to which all internal partitions are set at right angles. These partitions, made of cherry veneered panels, are disengaged from the stone on each partition line by a slender, vertical strip of frameless glass so that the entire stone wall appears to be seamless.

Adjacent to the window seat, a 49-foot-long reflecting pool bounces the sunrays onto the ceiling and façade of the building. The pool also acts as a reservoir for rainwater, which is pumped twice a day to irrigate the roof. The pool and other new features contribute a contemporary feel to the long-established Kent garden.

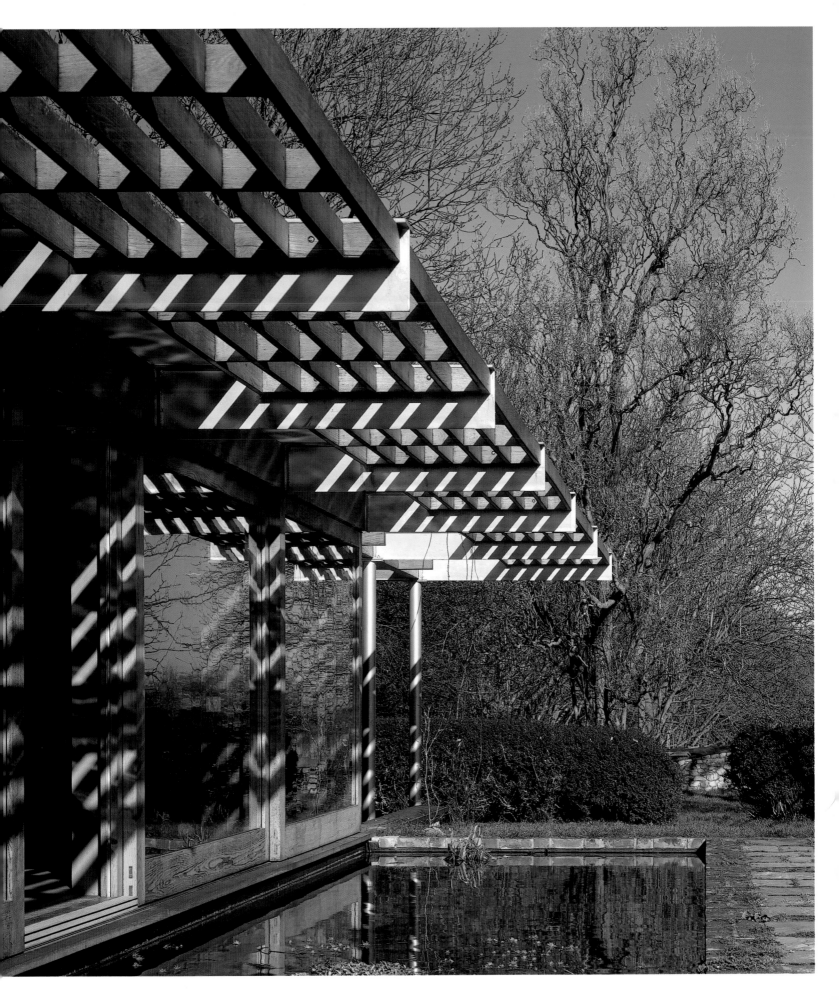

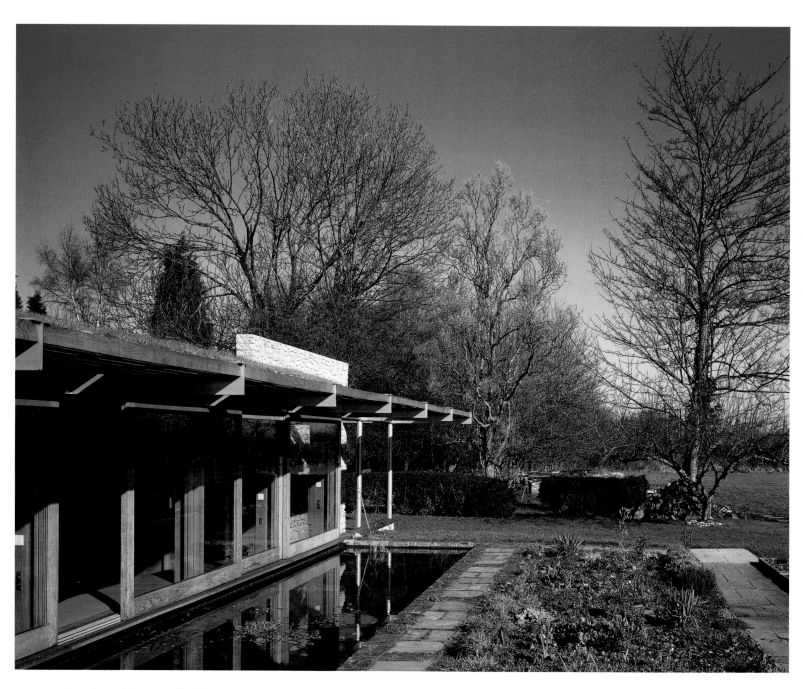

A cantilevered structure with oak slats provides shade in the living area, protecting the glass wall from glare and overheating and the fish from hovering herons.

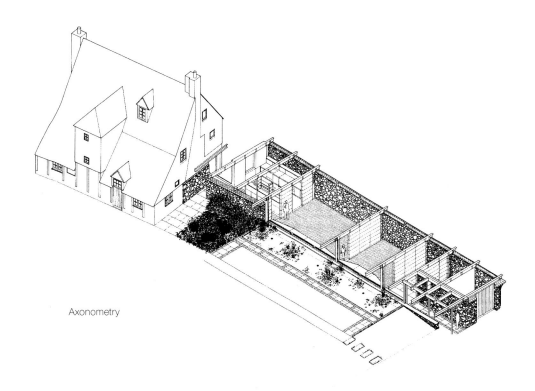

Axonometry

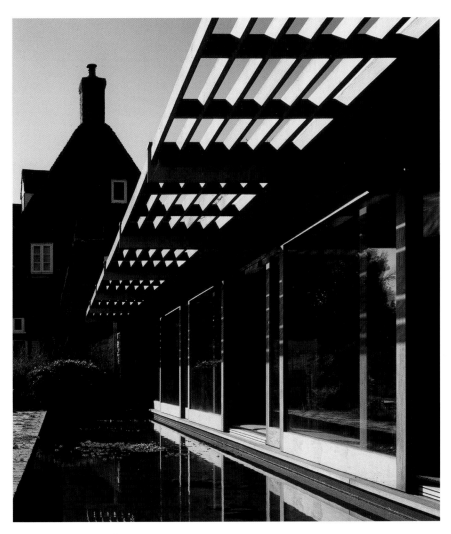

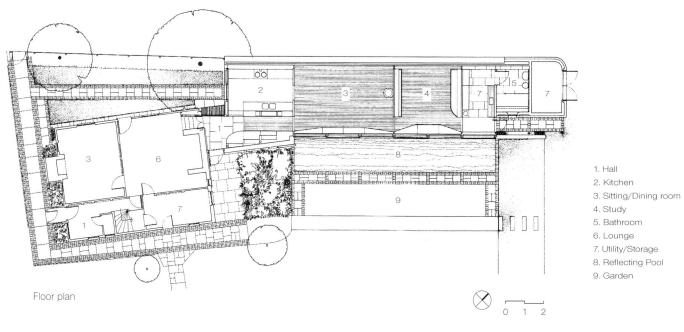

Floor plan

1. Hall
2. Kitchen
3. Sitting/Dining room
4. Study
5. Bathroom
6. Lounge
7. Utility/Storage
8. Reflecting Pool
9. Garden

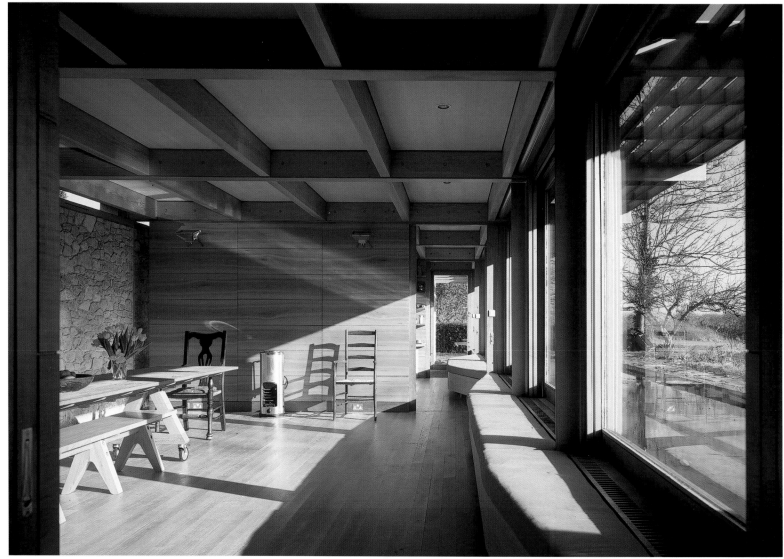

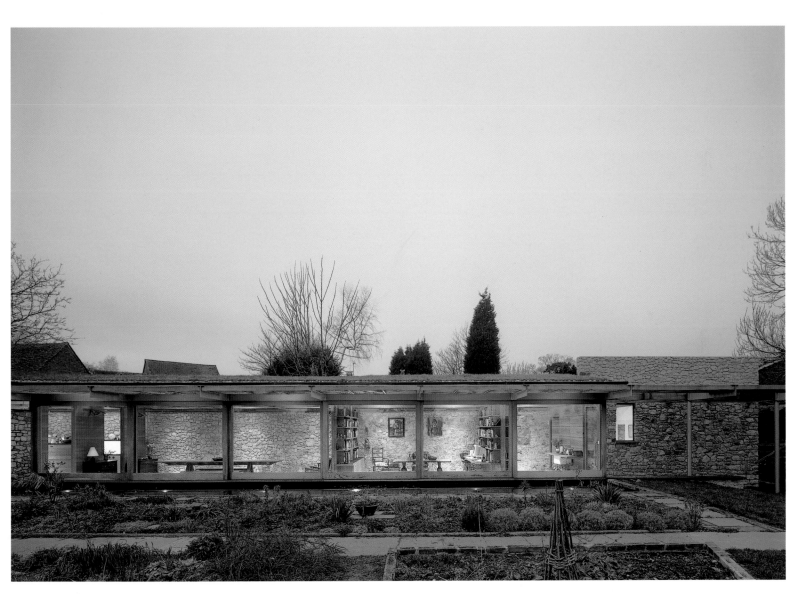

Seen through a seamless sequence of glass panels, the 82-foot wall can be best appreciated when illuminated at night.

JAMES VAN SWEDEN HOUSE	SORG Architects
Photos © Robert Lautman & Steven Ahlgren	Sherwood, Maryland, USA 2000

In a small rural town like Sherwood, set against Chesapeake Bay's Ferry Cove, modern architecture is an unexpected sight amidst the farms, antique shops and ice cream parlors. Despite local resistance to Suman Sorg's house for landscape architect James van Sweden, the project has been acclaimed internationally. An unpretentious interpretation of Modernist elegance, it establishes an inspired and cohesive relationship with the surrounding landscape.

Influenced by her childhood in India and her experience as a Peace Corps volunteer, Sorg considers herself an imperfectionist, opting for a rough kind of architecture that benefits from the weathering of time and use.

The town, characterized by chicken coops, clapboard houses, and utilitarian sheds, was an important source of inspiration for the project, designed as a country retreat for her friend van Sweden. The combination of Sorg's warehouse aesthetic and van Sweden's affinity for the land-scape resulted in an extraordinary residence reminiscent of an industrial New York loft, sprinkled with Indian flavors and completely integrated with the surrounding meadow and water.

The two came up with the idea of using a 140-foot cinder block garden wall as the defining feature of the house. This wall edges the courtyard and undulates through the interior, forming the spine of the complex and punctuating its outer edges, extending it towards the landscape. Painted light grey on the outside and left exposed inside, it contrasts with the plywood panels that sheath the remaining walls. These walls enclose the two pavilions containing the main residence and guesthouse, converting the garden wall into a group of garden sheds with a utilitarian feel. The west façade—housing the modestly scaled kitchen, den, and bathroom—faces van Sweden's meadow, an informal garden of grasses, shrubs, and a swampy pond that overlooks the bay.

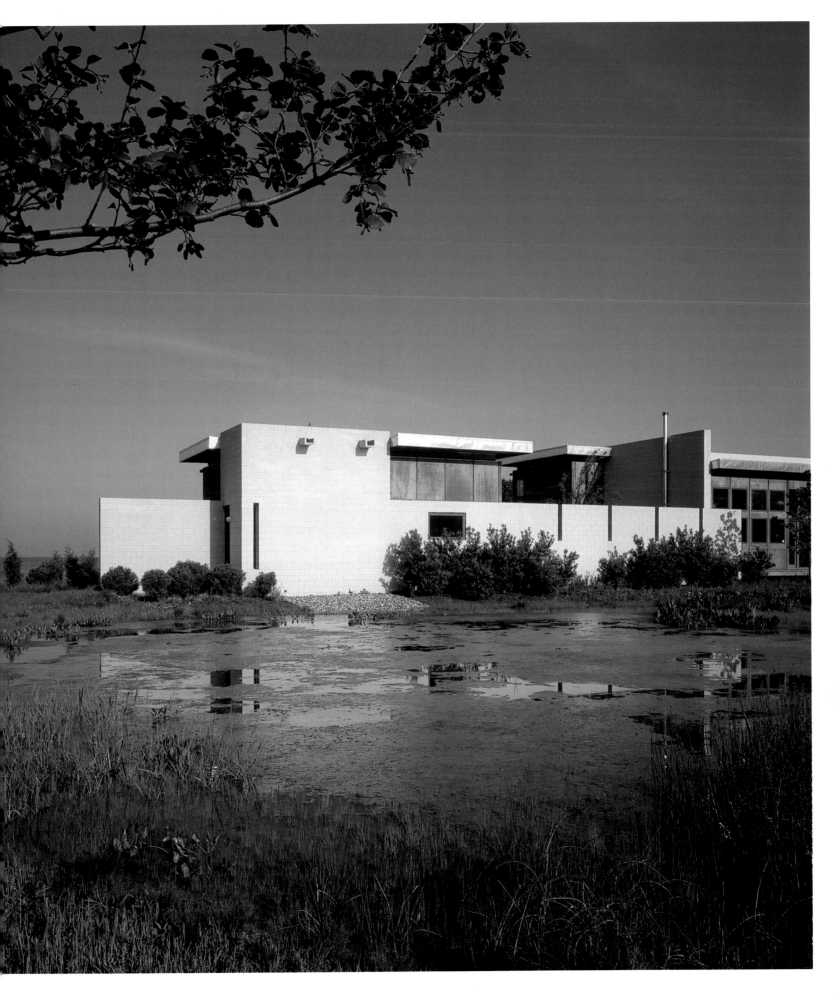

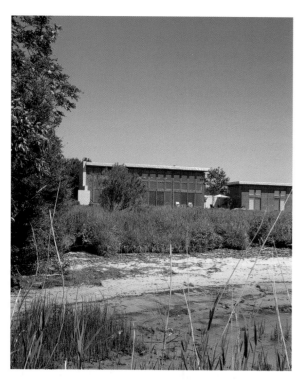

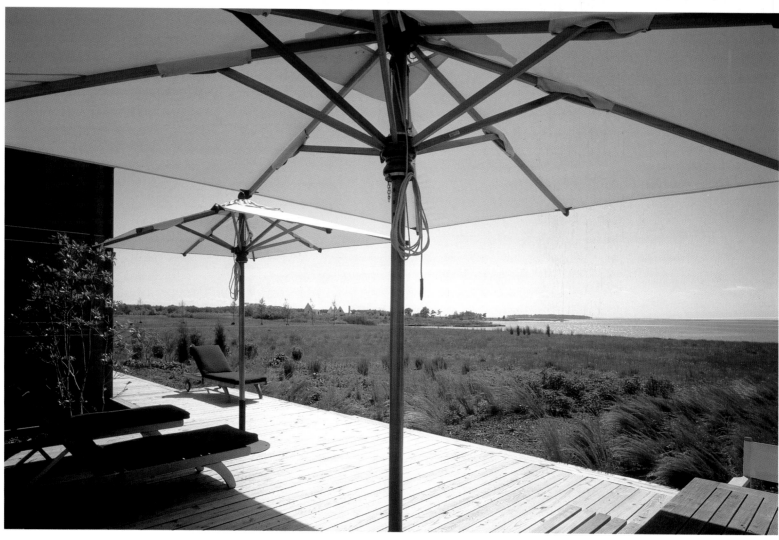

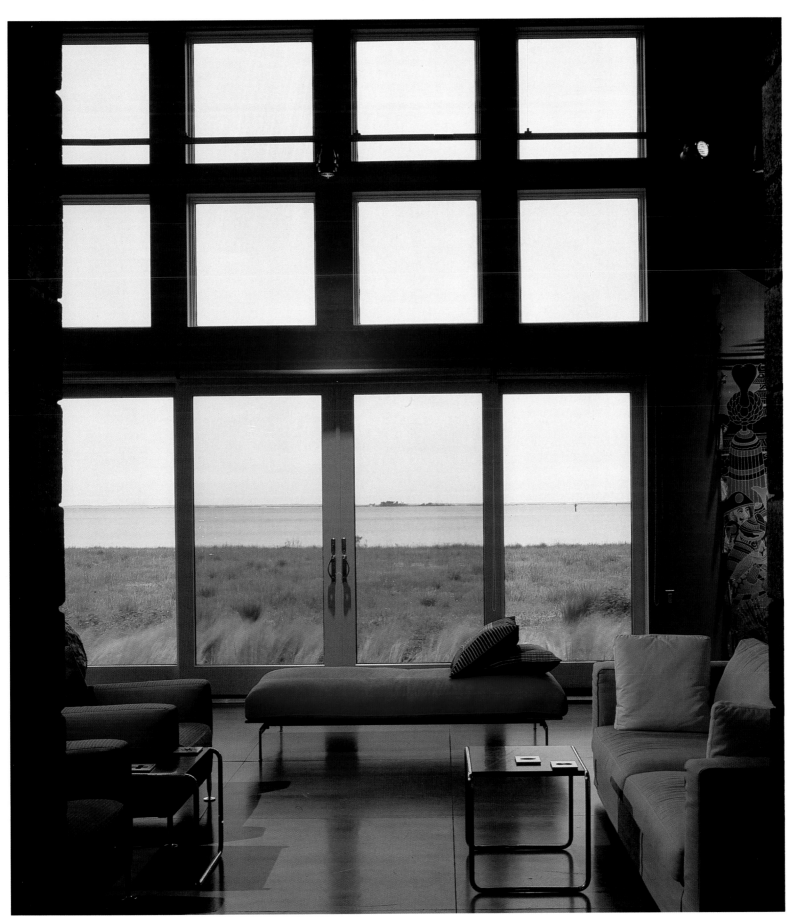

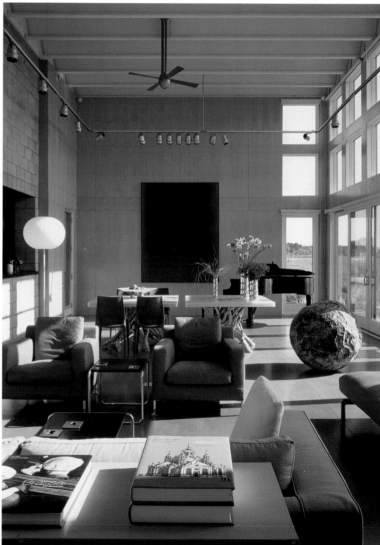

The architect draws upon a variety of architectural styles and makes advantageous use of color; the interior flooring is finished with a blue-green wash that evokes the sky and sea.

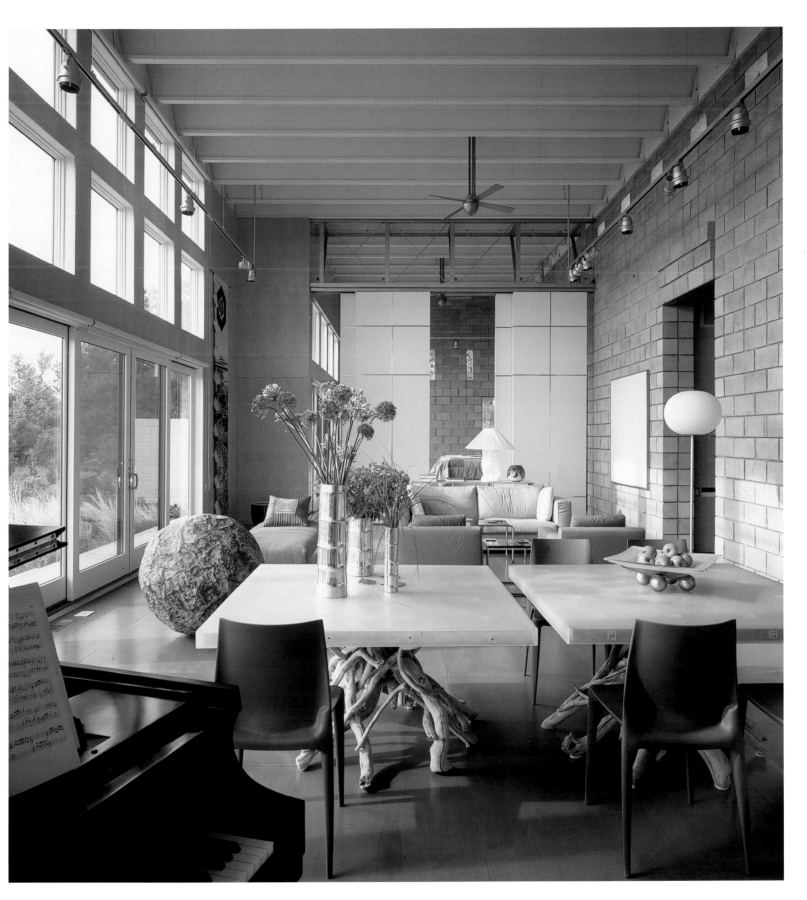

The living room, dining area, and bedroom face the bay in an open, loft-like space where furniture and art mix modern and country metaphors in a sensitively designed arrangement of color and form.

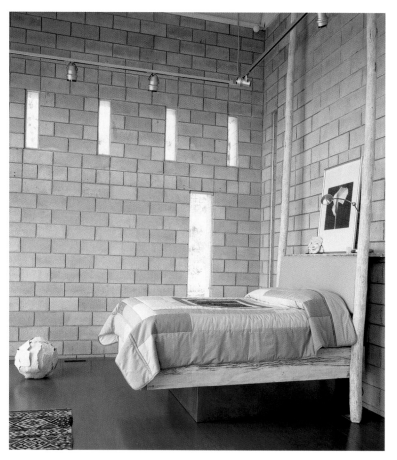

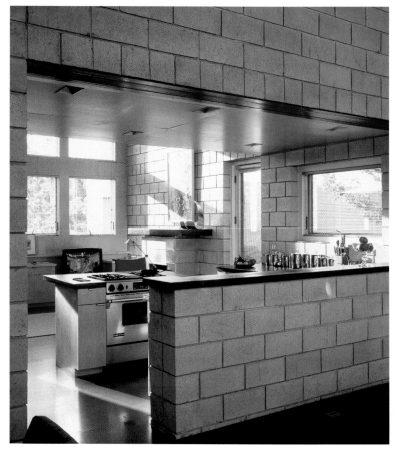

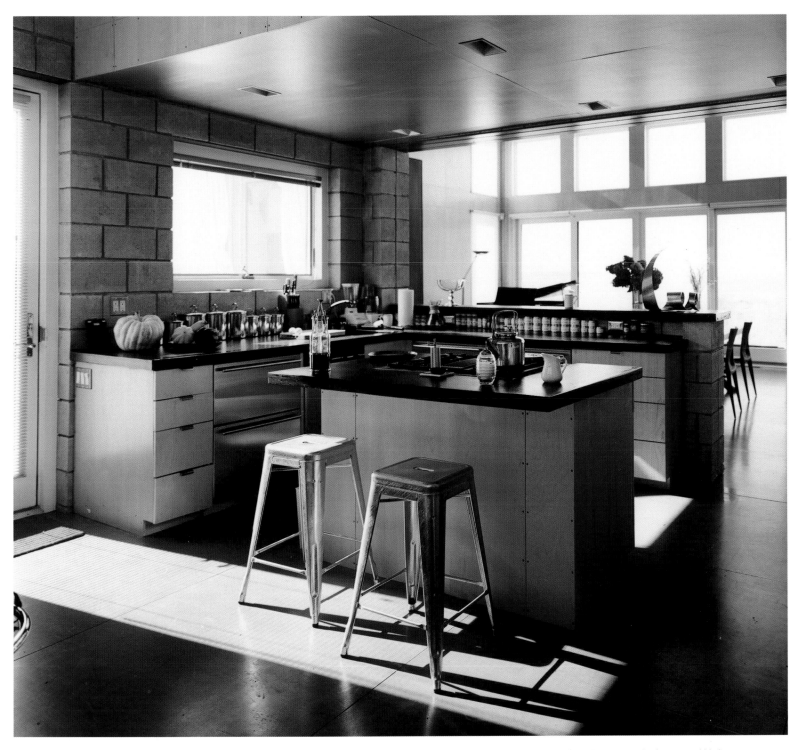

The garden wall that zigzags through the main residence, guesthouse, and courtyard reveals itself in the interior walls of the living room, bedroom, and kitchen.

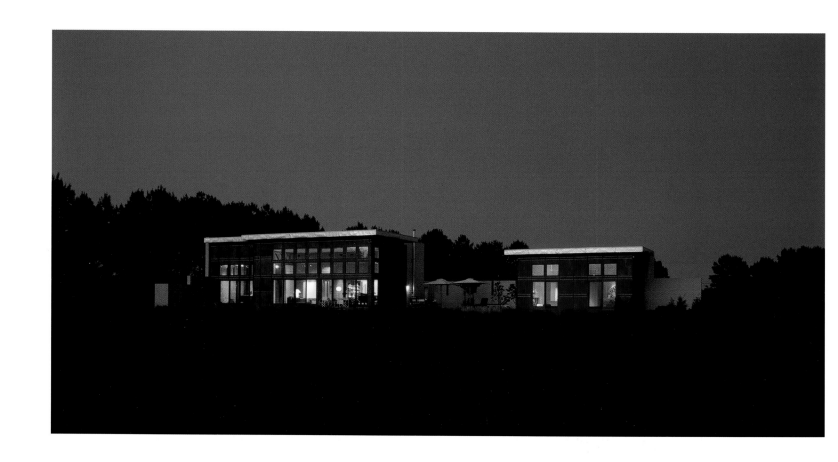

Site plan

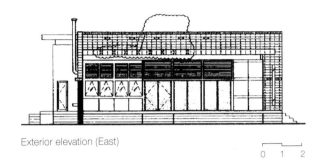

Exterior elevation (East)

0 1 2

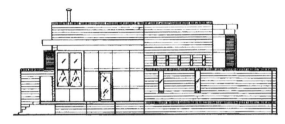

Exterior elevation (North)

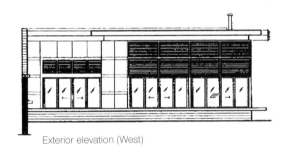

Exterior elevation (West)

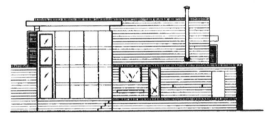

Exterior elevation (South)

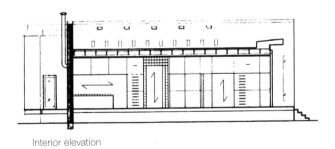

Interior elevation

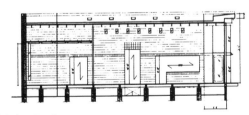

Interior elevation

cookson smith house

Edward Cullinan Architects

Photos © Dennis Gilbert/VIEW

Twickenham, UK 2002

On their return from a 15-year stay in Hong Kong, the clients wanted a quiet home for two. The house, on the banks of the River Thames, was expected to provide a variety of spaces for study, relaxation, entertainment, and common domestic requirements. It was particularly important to exploit the views of the river to the north and to capture enough sunlight without sacrificing privacy. A significant design factor was the local authority's requirement to respect the existing trees within the site.

The challenge was to provide a clear series of interrelated spaces linking the southern edge of the site, related to civic aspects, and the northern edge, related to the natural aspects of the quietly flowing river. Composed of London stock brick and Western Red Cedar, the buildings were set back from the road to allow for a two-car garage. The garage's asymmetrically curved roof marks the gateway to the site and incorporates a small studio within the roof space. The house is comprised of three sequential pavilions varying in height, position, and function. The curvilinear roof structures produce a series of canopies that continue the theme established by the garage/studio. An elevated entrance extends through the entrance hall to an exterior timber deck set back to retain the existing trees, and provides a clear and uninterrupted view of the river from the entrance.

The interior plan is ordered around a curved wall that incorporates stairs, storage, and display cases while offering vantage points from which to contemplate framed views across the river. The private garden on the riverside of the house features a raised timber deck that overlooks the existing floodwall with a view of both London and the Thames.

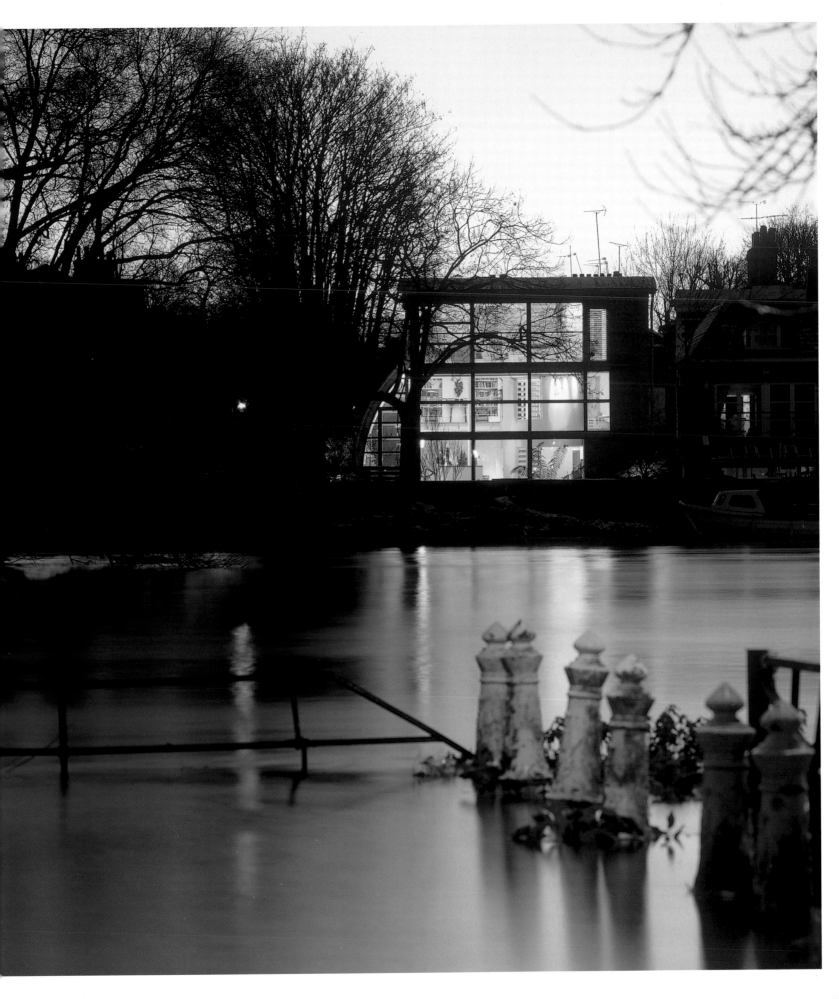

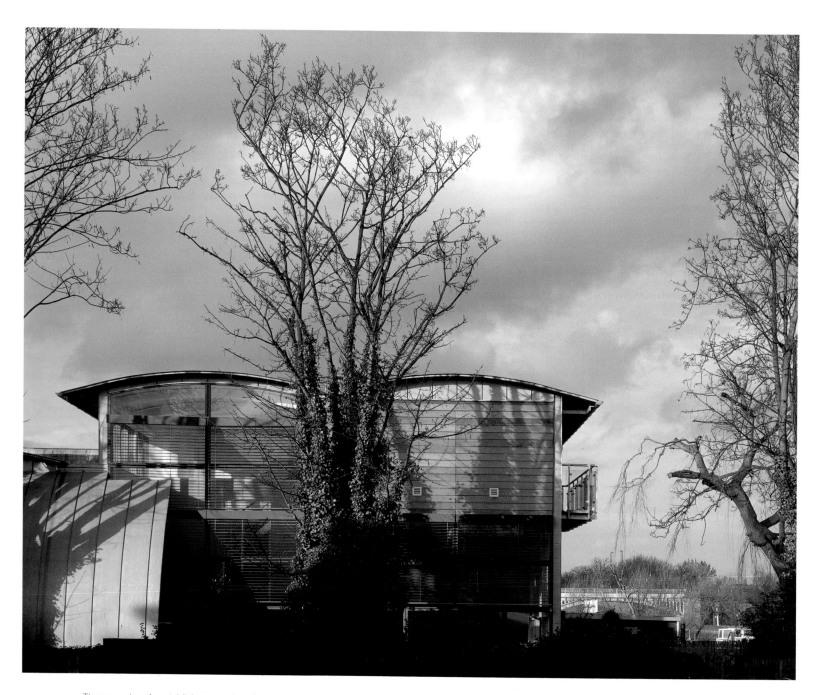

The curved roofs establish a recurring theme, the unifying element of the entire structure. The subtle curves reduce its visual impact on the surrounding traditional houses.

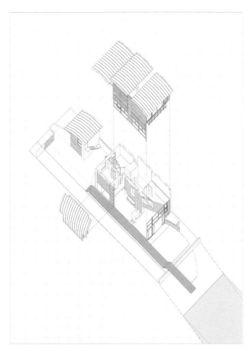

Axonometry

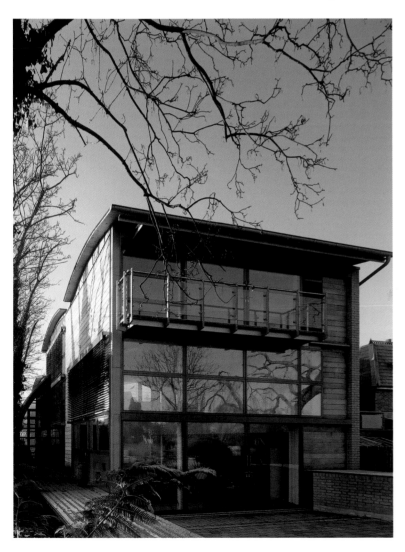

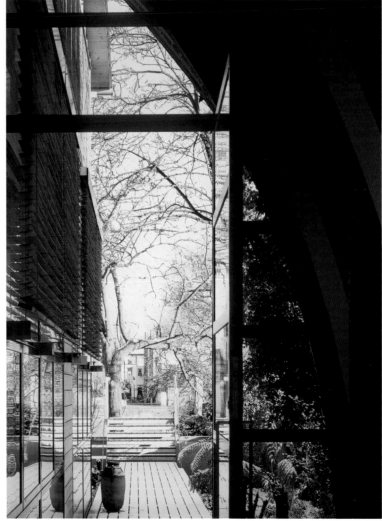

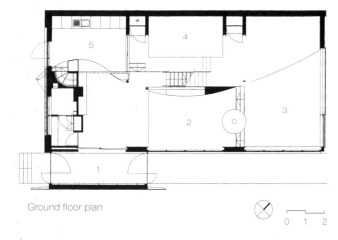

Ground floor plan

1. Entry
2. Upper living room
3. Lower living room
4. Dining room
5. Kitchen
6. Open space
7. Bedroom
8. Study
9. Open Space
10. Bedroom
11. Bathroom
12. Dressing room

0 1 2

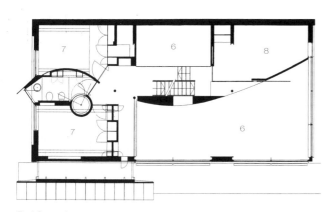

First floor plan

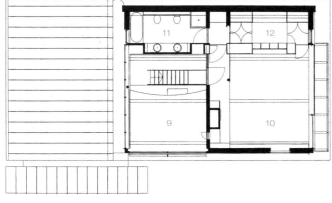

Second floor plan

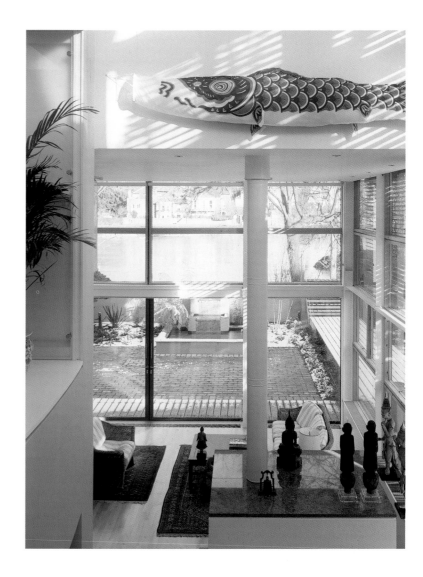

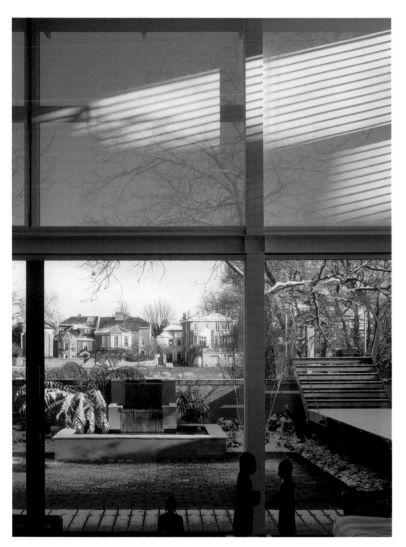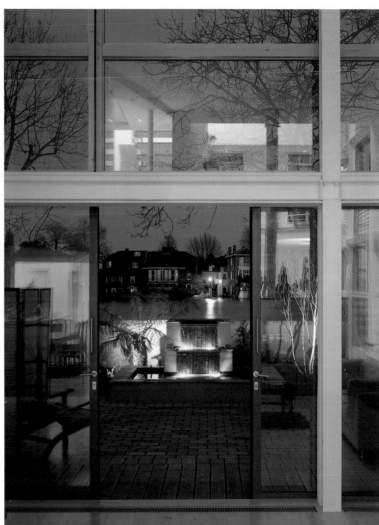

In an expressive design that brings the river into the home, a fountain on the timber deck steps water down from the floodwall.

CARDY NET FACTORY	Mike Rolland
Photos © Peter Cook/VIEW	Lower Large Fife, Scotland, UK 2000

A fishing net factory built in the late 1800s was converted into a home and vacation rental for the architects in charge of the renovation. Their goal was to preserve the special qualities of this unusual Victorian construction whilst creating a large single level floor area that would optimize the views of the beach and sea. The concept involved the implementation of a reflective glass wall overlooking the sea; a large modern living space protected by an enclosed timber terrace, and a generous number of bedrooms, bathrooms, and storage rooms.

Inspired by the simplicity of the original structure, the architects wished to integrate a strikingly modern interior within a space of 5000 square feet and to contrast and enhance the existing elaborate Victorian elements. Brightly colored bedrooms were placed opposite the original etched glass Victorian paneled doors. The cast iron columns were joined by a stainless steel kitchen; the sash and case windows were set off by the contemporary bronzed aluminum and oak glazed sliding screen, and the smooth polished concrete floor underneath worn brickwork. The glass windows across the length of the home provide framed views across Largo Bay.

Due to the extensive rot of the existing factory structure, the building was completely gutted and reduced to four walls, with the help of local tradesmen. Large storage spaces and cloakrooms provide practical solutions to modern living while the exterior shed offers a workshop space and storage for wine, logs, and coal. Though the home is well-suited for vacation rentals, it is currently a comfortable family home with spectacular views and an unexpectedly contemporary interior behind the rough-hewn Victorian walls.

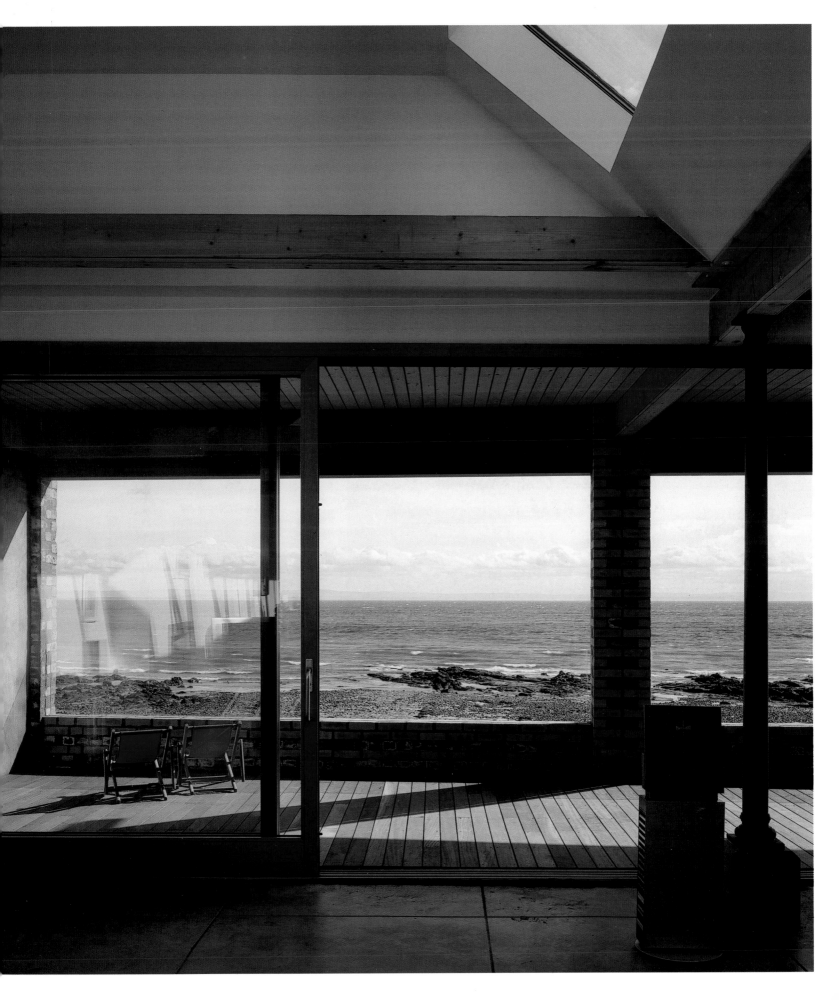

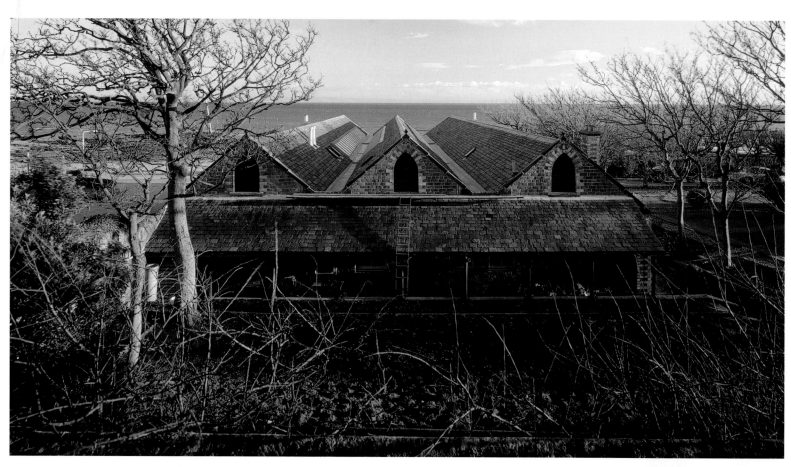

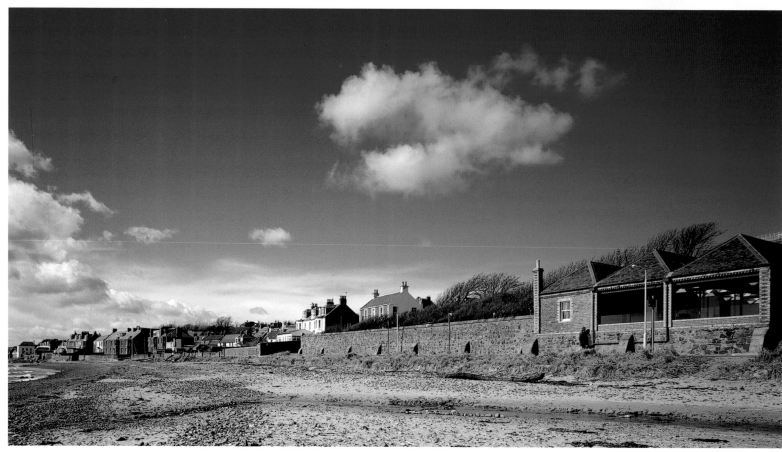

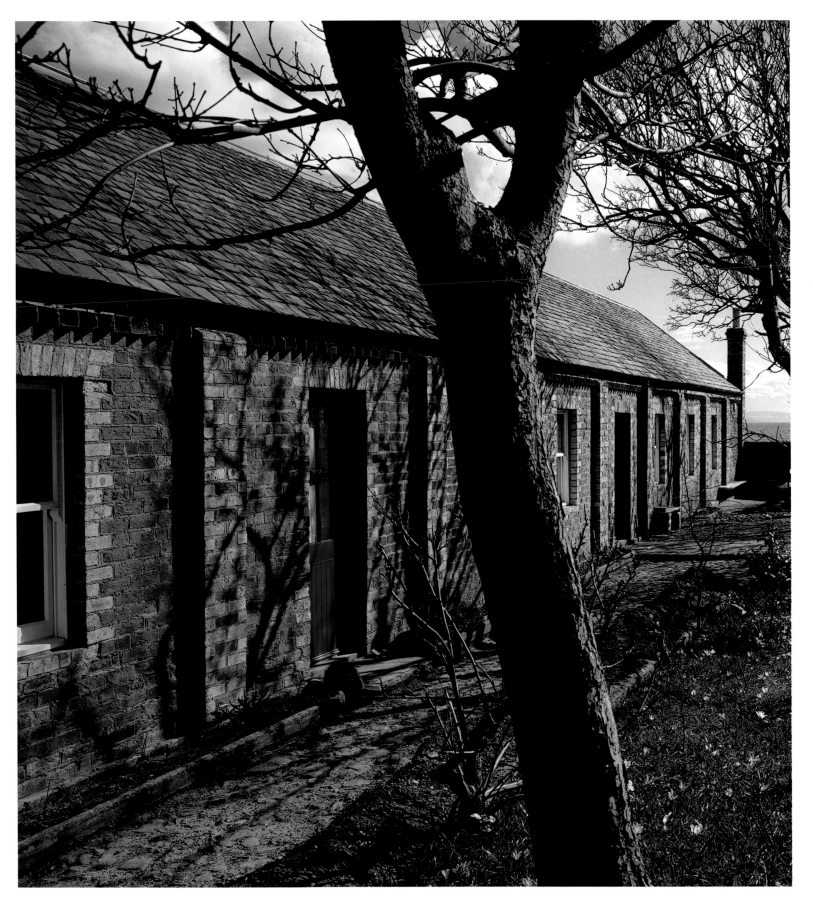

The preservation of the existing shell camouflages this reconverted factory amidst the surrounding period buildings.

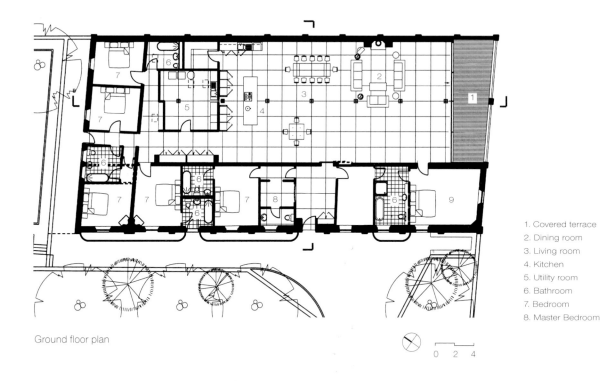

Ground floor plan

1. Covered terrace
2. Dining room
3. Living room
4. Kitchen
5. Utility room
6. Bathroom
7. Bedroom
8. Master Bedroom

0 2 4

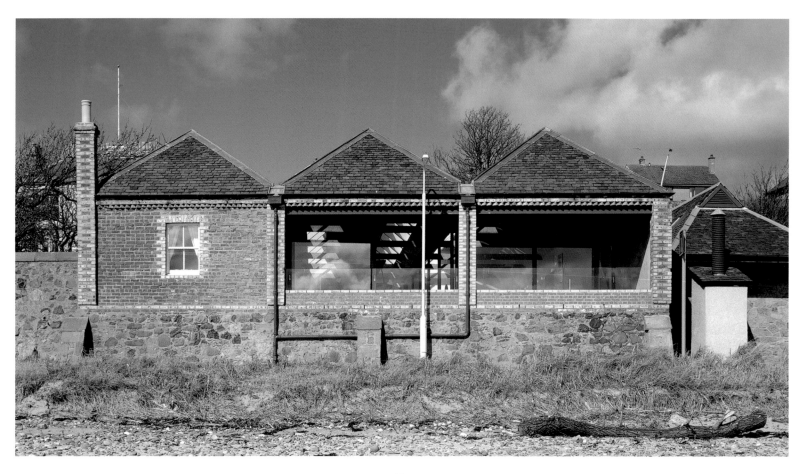

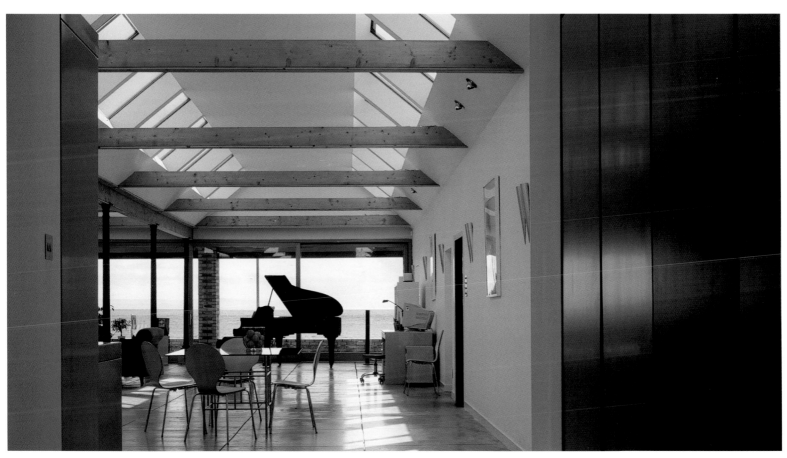

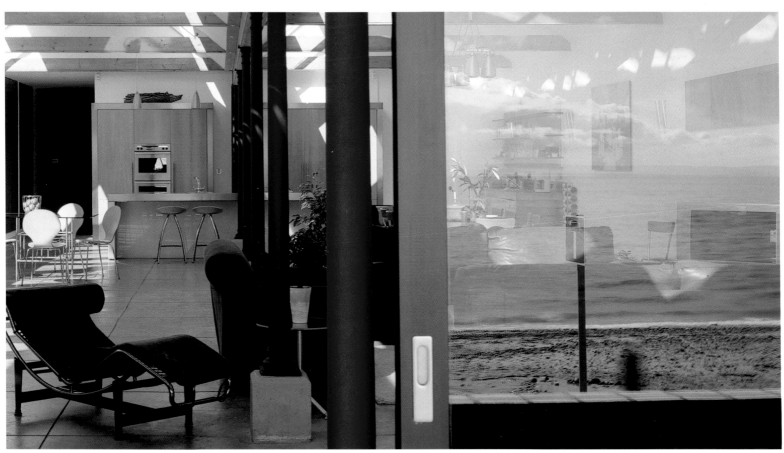

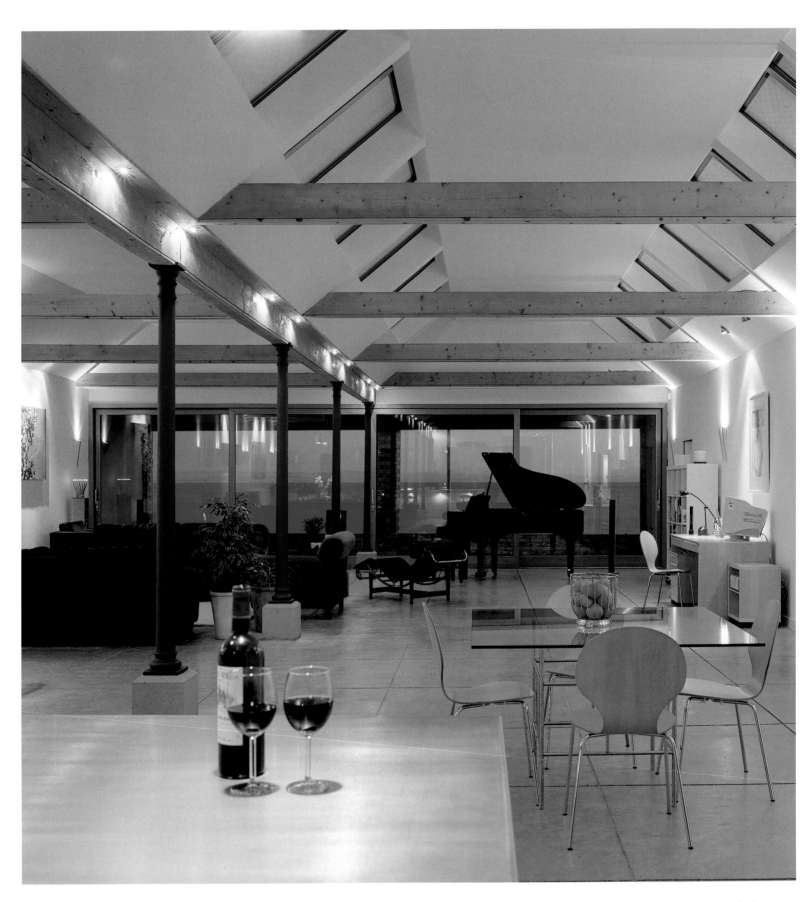

The contrastingly modern interiors offer a luminous, spacious, and comfortable living space that incorporates Victorian details into a predominantly contemporary design.

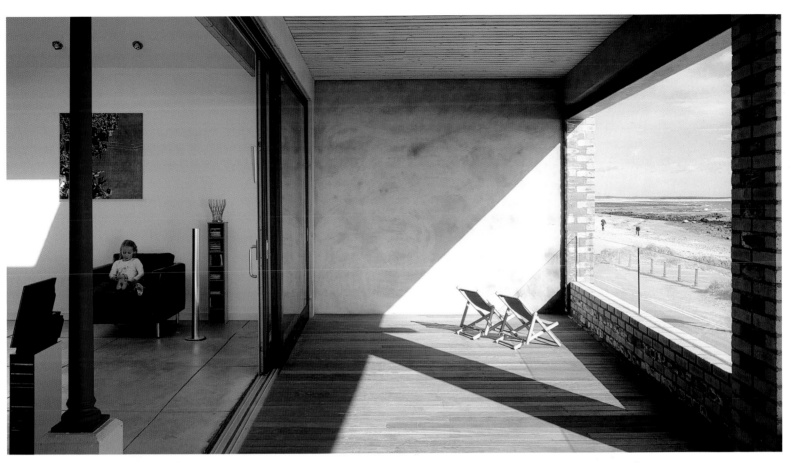

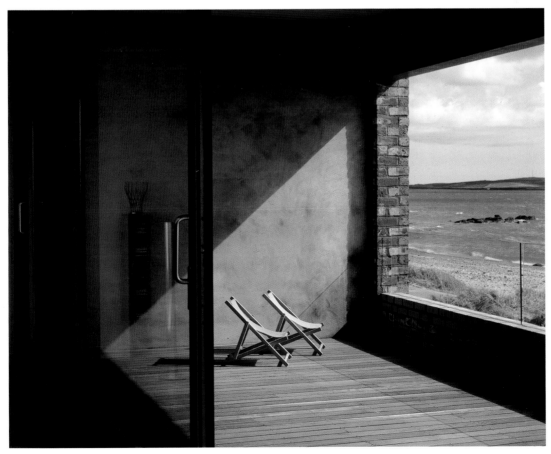

wedge house	Stutchbury & Pape
Photos © Julie Phipps/VIEW	Whale Beach, AUSTRALIA 2001

Situated on a steep site overlooking the rocky coastline of Sydney's northern beaches, the two wedge-shaped pieces that make up the home extend in opposite directions: the masonry descends into the earth and the lightweight timber extends toward the sky and ocean.

The entry is defined at the wedges' junction, and inside, an open living area spills onto a shaded triangular deck that directs the gaze toward the sea. Lowered horizontal windows provide views of Whale Beach and the surrounding bush-land. The kitchen juts out of a timber batten wall and incorporates a viewing platform that faces south. Below the living area, the children's rooms, guest area, and bathroom open onto a landscaped earth terrace. The masonry wedge houses a study, an outdoor shower, and wash area.

The intersecting wedges create a juxtaposition of the elements that search for a balance between earth and sky. The earthbound portion, for example, favors protection and privacy. Its roof was designed as a lid so that the light is managed horizontally, unlike its adjacent partner that filters light from beneath the roof plane, creating a great sense of lightness and freedom. The architects conceived the house as a platform for observation, a dynamic addition to the landscape, and ultimately a place to be filled with memories and inspirational visions.

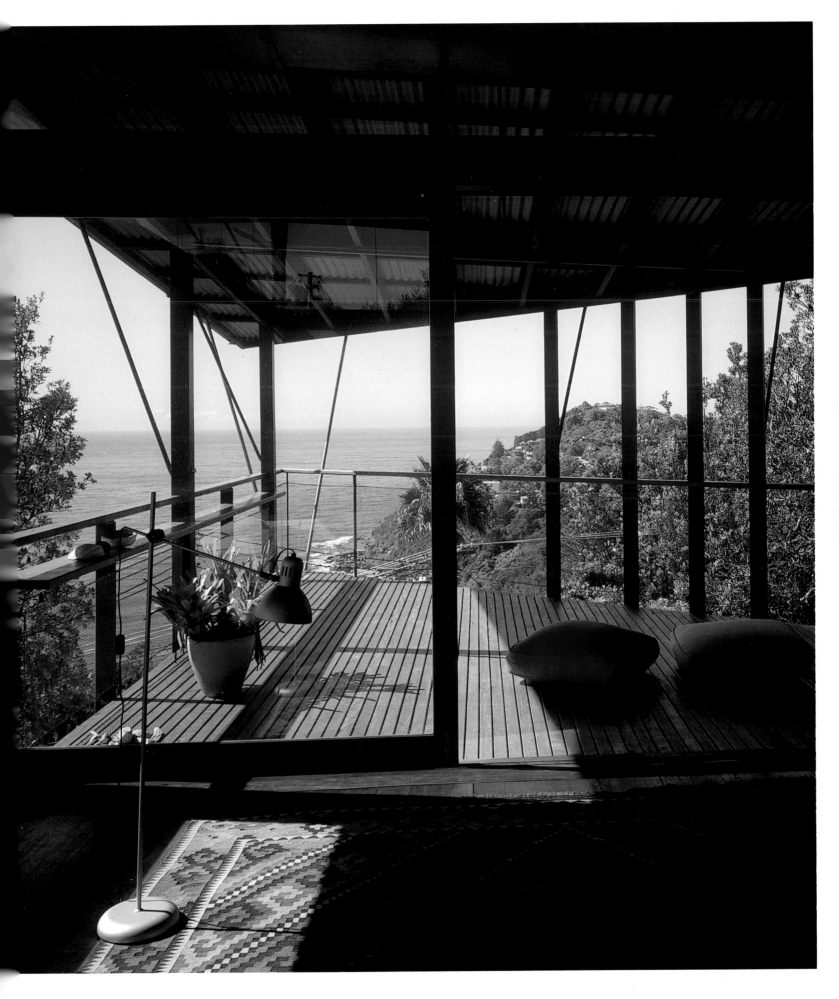

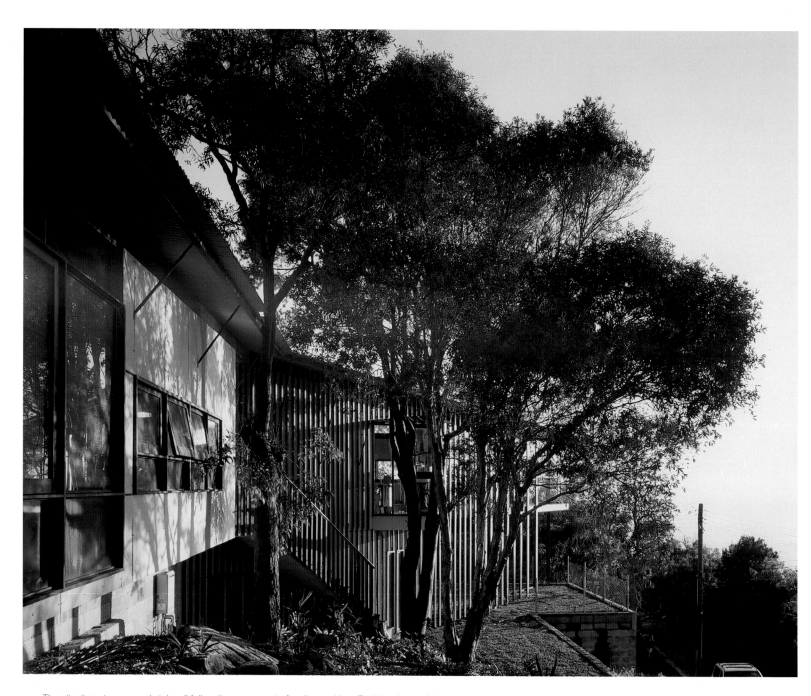

The site, its entrance, and stairwell follow the movement of a diagonal line. By tilting the roof plane toward the length and width of the triangle, the illusion is of a twisted plane.

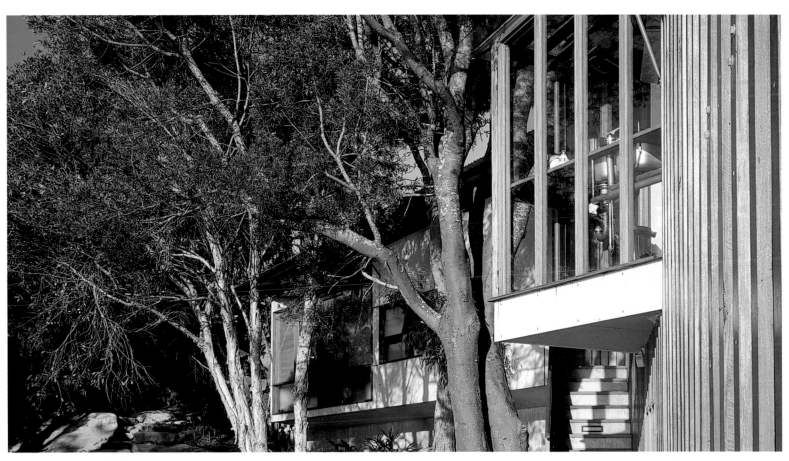

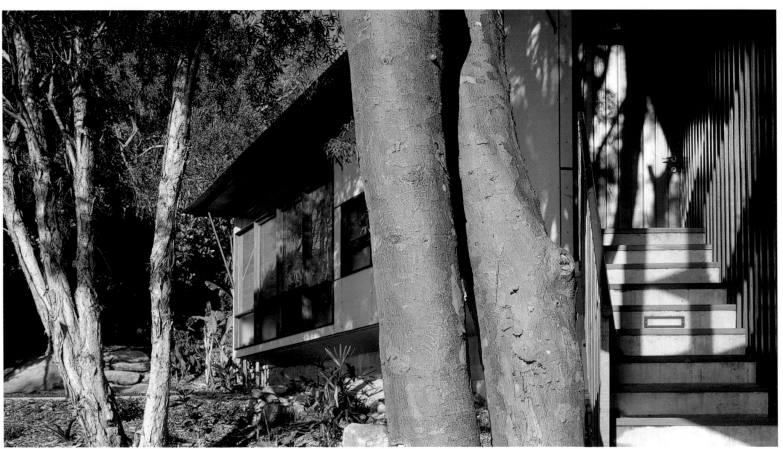

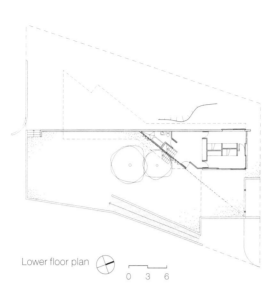

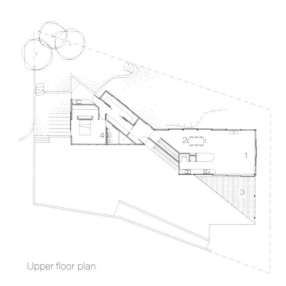

Lower floor plan

0 3 6

Upper floor plan

1. Living room
2. Kitchen/Dining room
3. Terrace
4. Bedroom

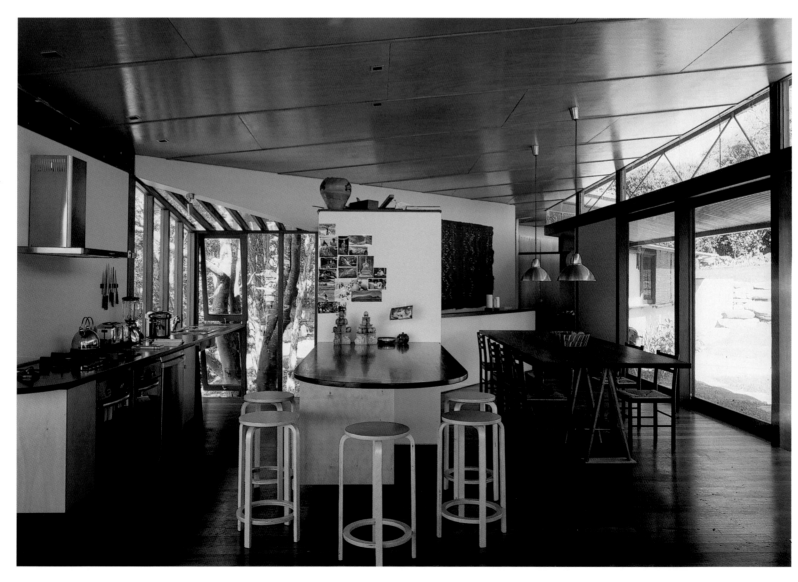

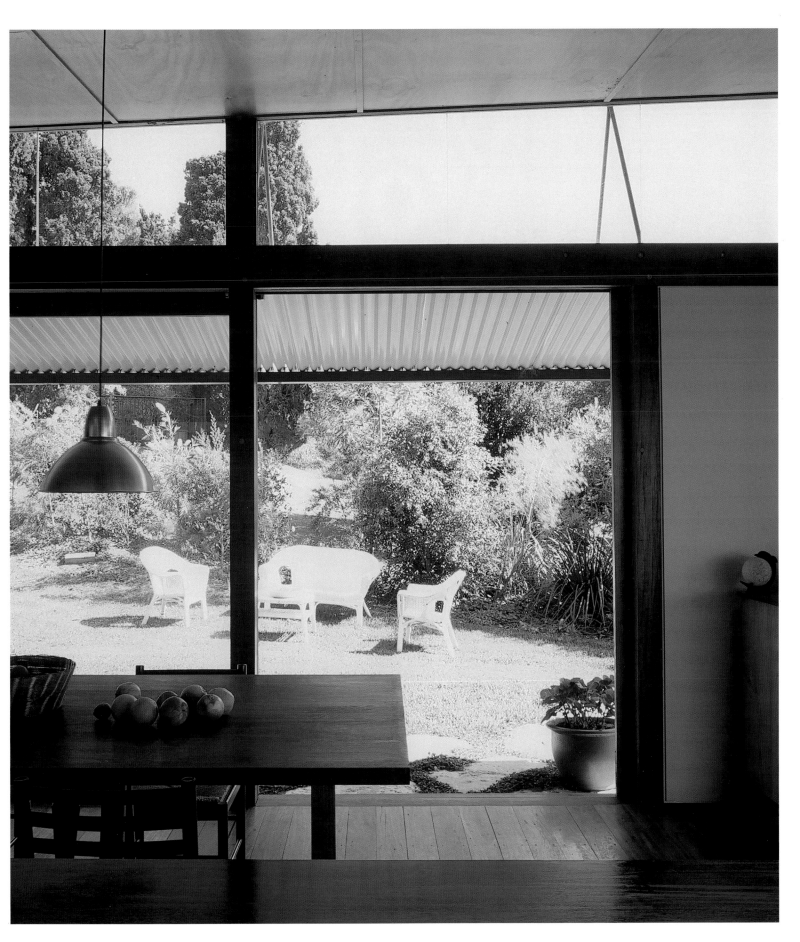

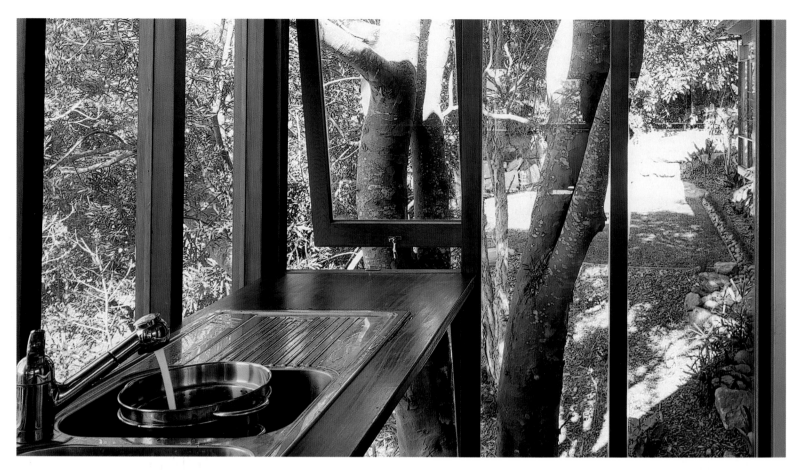

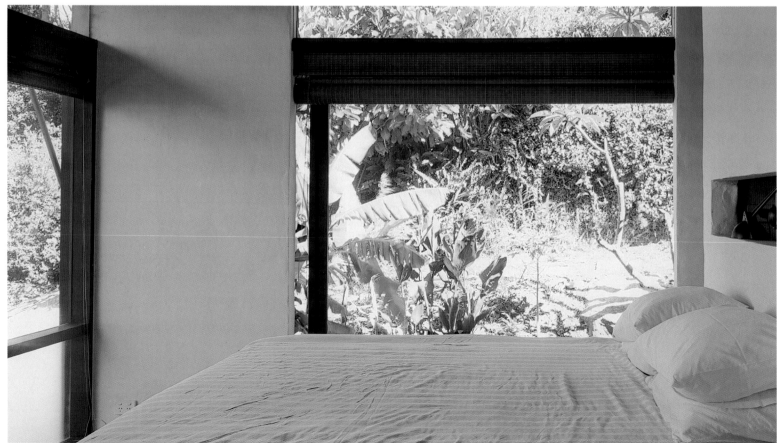

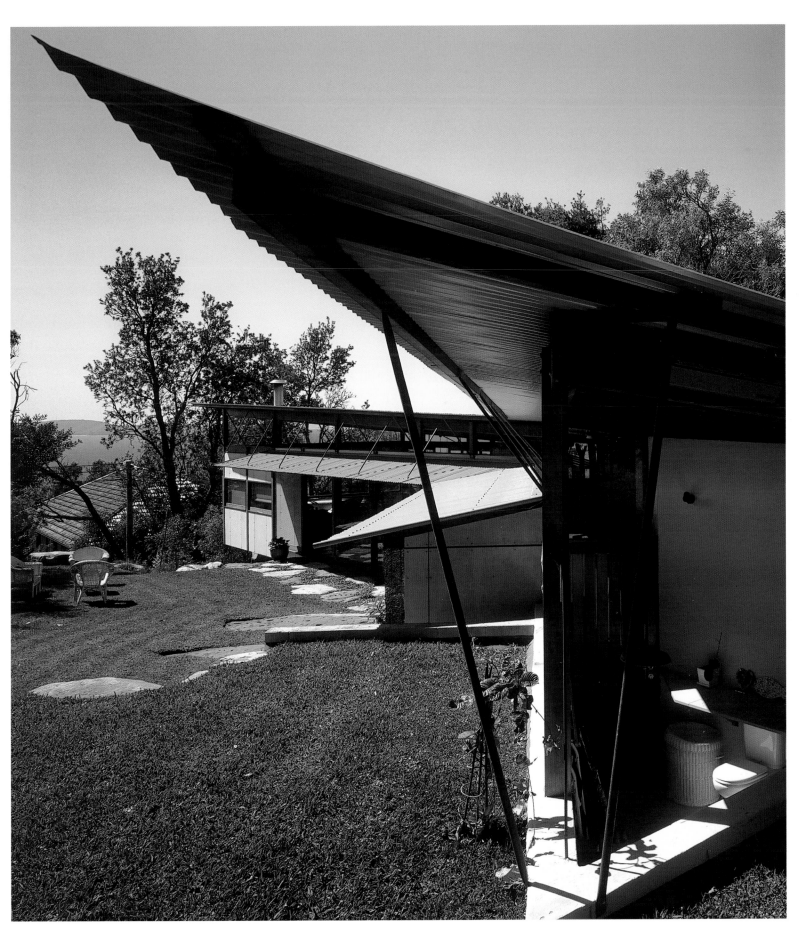

bruckner house	Eric Cobb
Photos © Paul Warchol	Whidbey Island, Washington, USA 2000

Situated near the edge of a 270-foot cliff overlooking Puget Sound and the Olympic Mountains to the west, this house looks out on the water on one side and an orchard on the other. The elements were configured in a jagged L-shaped structure, its two perpendicular bars set against a concrete wall. Around and above these walls, a wood and glass house was built.

The "domestic bar" contains the master bedroom, bath, laundry, utility, and kitchen. The "guest bar" houses the library, powder room, guest bedroom, and bath. The intersecting bars and overlapping roof planes create a shared living, dining, and studio area. Formal elements and a minimal set of materials are positioned to expose, contrast, and articulate differences. The separation of elements is key: a thin metal roof is supported by steel brackets above a thick concrete wall; a glass entry wall separates the two concrete walls; rough, concrete openings are flush-trimmed with smooth fir wood. In this loose assembly of elements, spaces constantly overlap, creating variations in light, exposure, material, and view.

Most of the structural elements of the house are exposed, such as the concrete walls, heated concrete slab floors, exposed timber framing, steel brackets, and a concrete block fireplace that separates the living room and library and extends through the roof. The enveloping glass walls enable the continuous contemplation of the expansive views over the water.

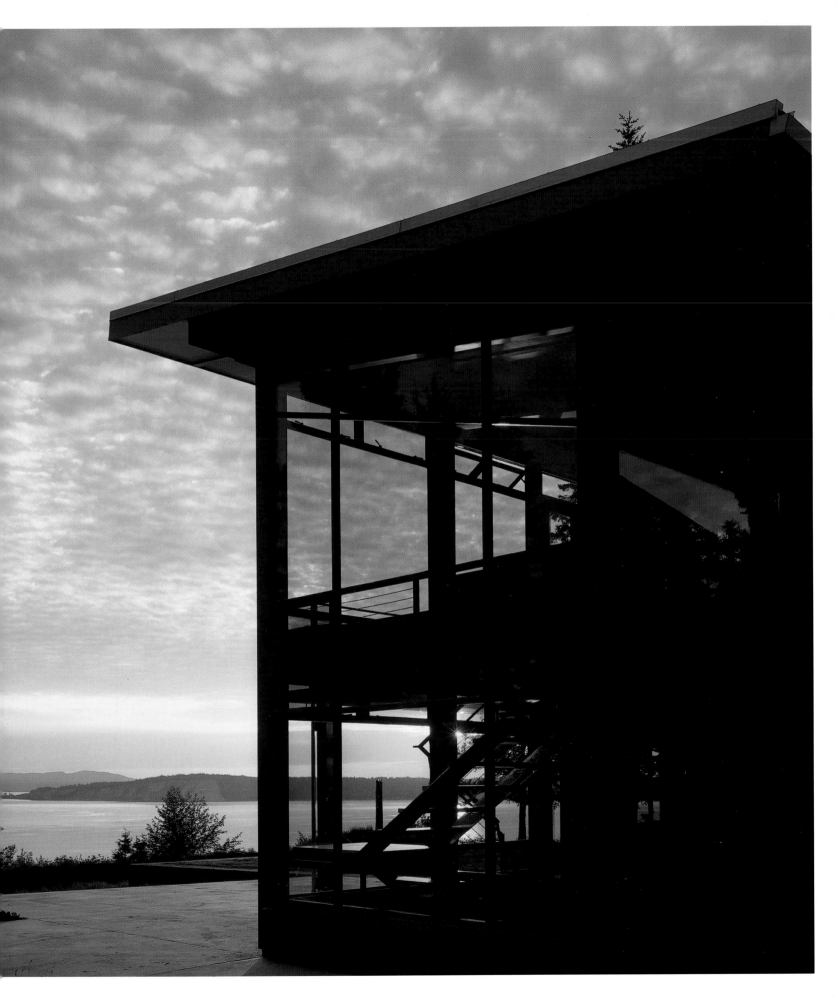

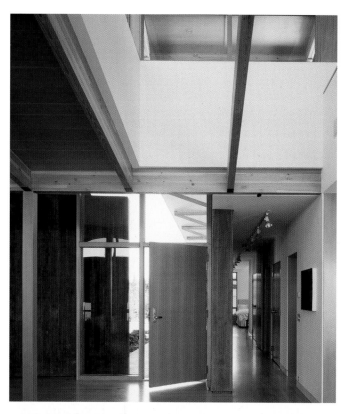

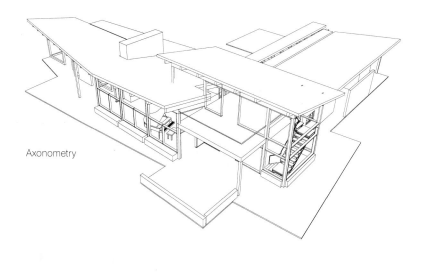

Axonometry

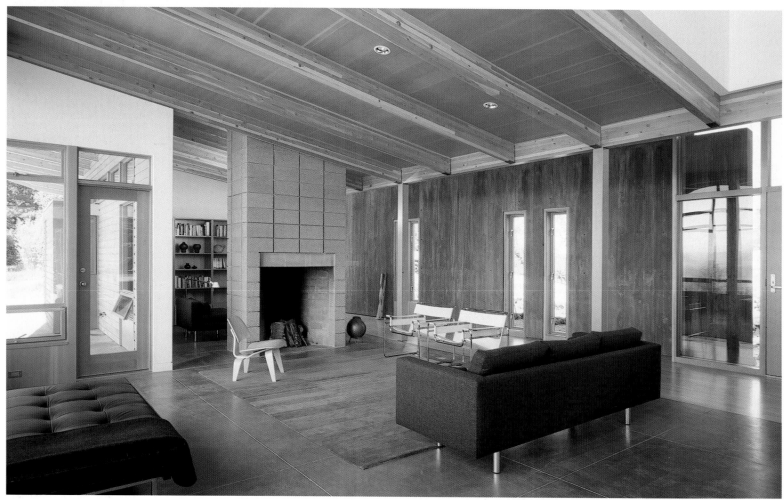

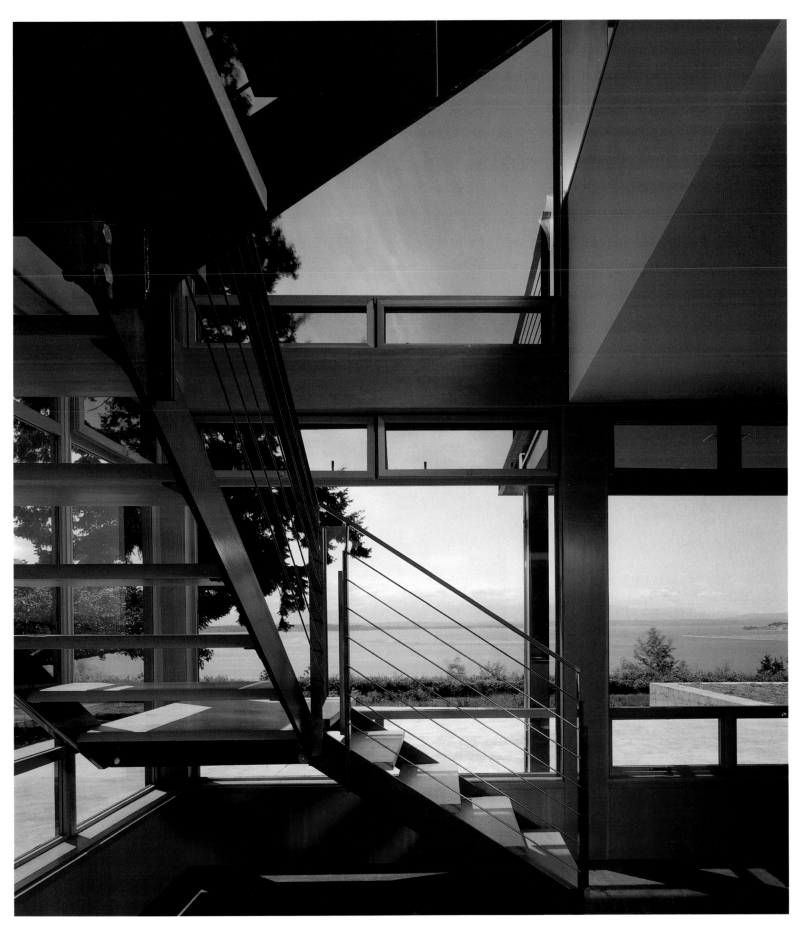

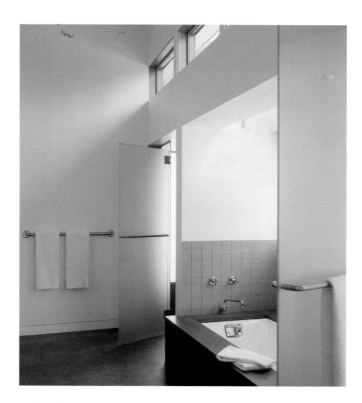

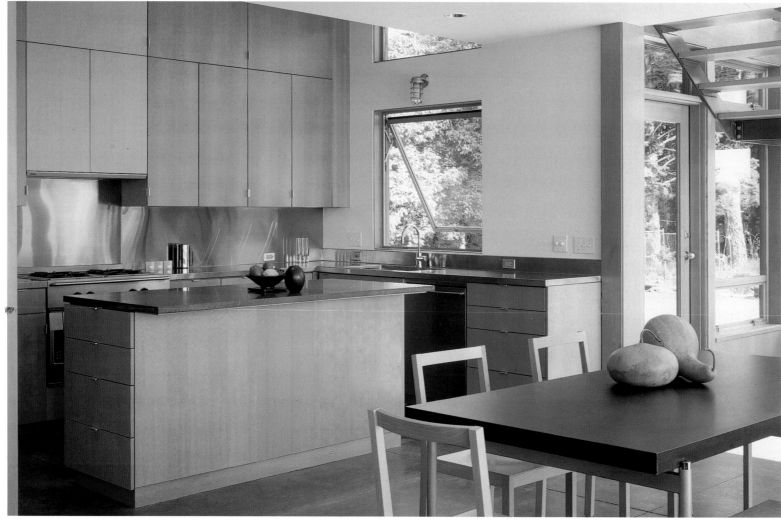

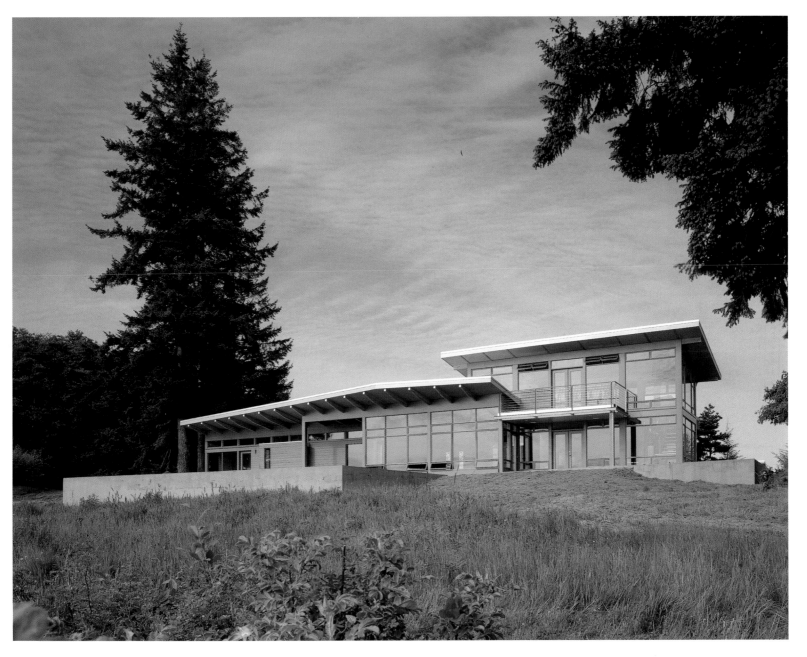

The home features beautiful views from either side: Puget Sound to the west and a wild orchard to the east.

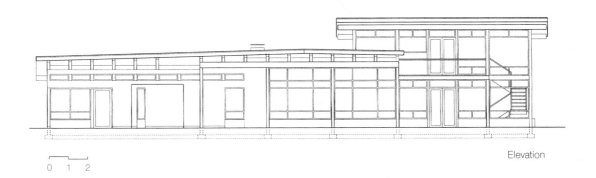

Elevation

0 1 2

MUSKOKA boathouse	Shim-Sutcliffe Architects
Photos © James Dow, Edward Burtynsky	Lake Muskoka, Ontario, CANADA 2001

Two hours north of Toronto, the Muskoka Boathouse floats along the chilled waters of the south western shore of Lake Muskoka. This hut in the wilderness seeks to find a balance between civilization and nature. Traditional building techniques and modernist concepts were integrated into a complex design that embellishes its rich and unique environment.

The project incorporates three local influences: the granite left exposed after the last Ice Age, the pioneer log cabins, ornate Victorian cottages, and custom wooden boats built by local craftsmen that define the region's cultural heritage, and finally, the mythological Canadian landscape; its wild, romantic and often hostile terrain as portrayed by the painters of the early 1900s. The boathouse consists of two indoor boat slips, one covered outdoor boat slip, storage for marine equipment, a sleeping cabin with kitchenette, shower, and bath area, and a sit-ting room. Several outdoor porches and terraces complete the picture and include a moss garden with indigenous plants.

Like all constructions on the water, an entire infrastructure lies hidden underneath. The architects employed traditional local building methods, which involved the construction of a series of heavy timber cribs to form the foundations for the overlying structure. To facilitate the building process, the plan was drawn out on ice during the winter, when the lake is frozen over.

The cabin was conceived as a sophisticated hut with a refined inner lining of mahogany, birch, and Douglas fir and a heavy protective overcoat composed of heavy recycled timbers. These interlocking elements and contrasting features create an almost indiscernible line between building and nature, land and water, and tradition and progress, yielding a sturdy yet multi-faceted residence.

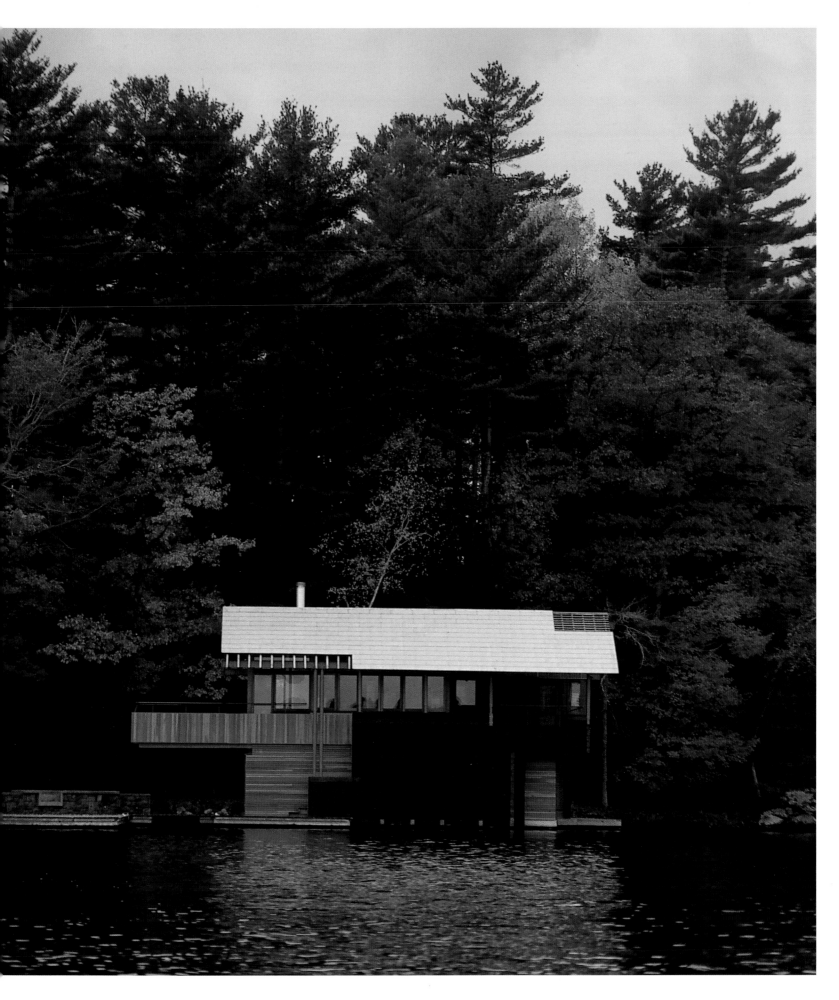

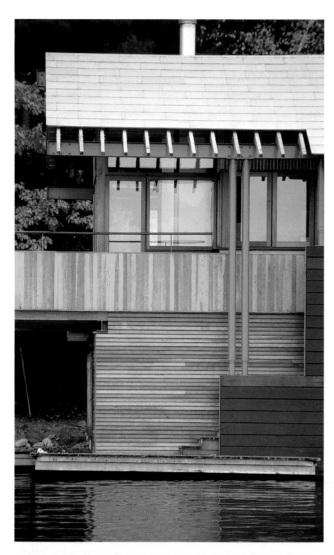

1. Entrance
2. Bedroom/Sitting room
3. Outdoor deck
4. Moss garden
5. Kitchenette
6. Shower
7. Bath
8. Covered porch

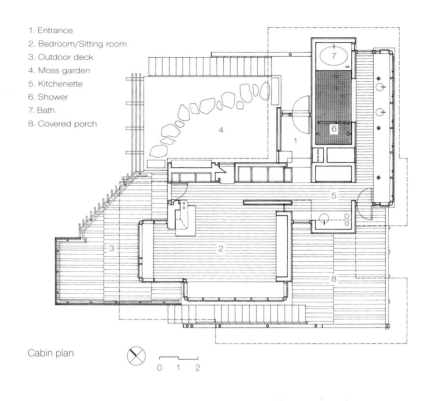

Cabin plan

0 1 2

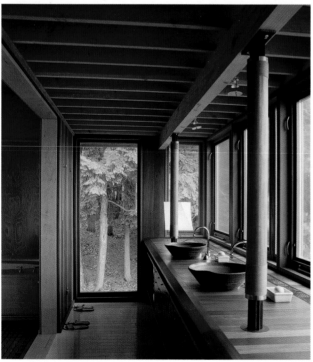

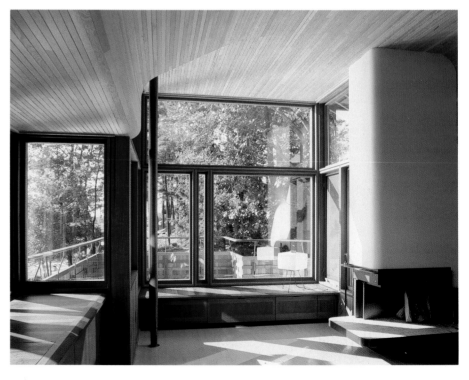

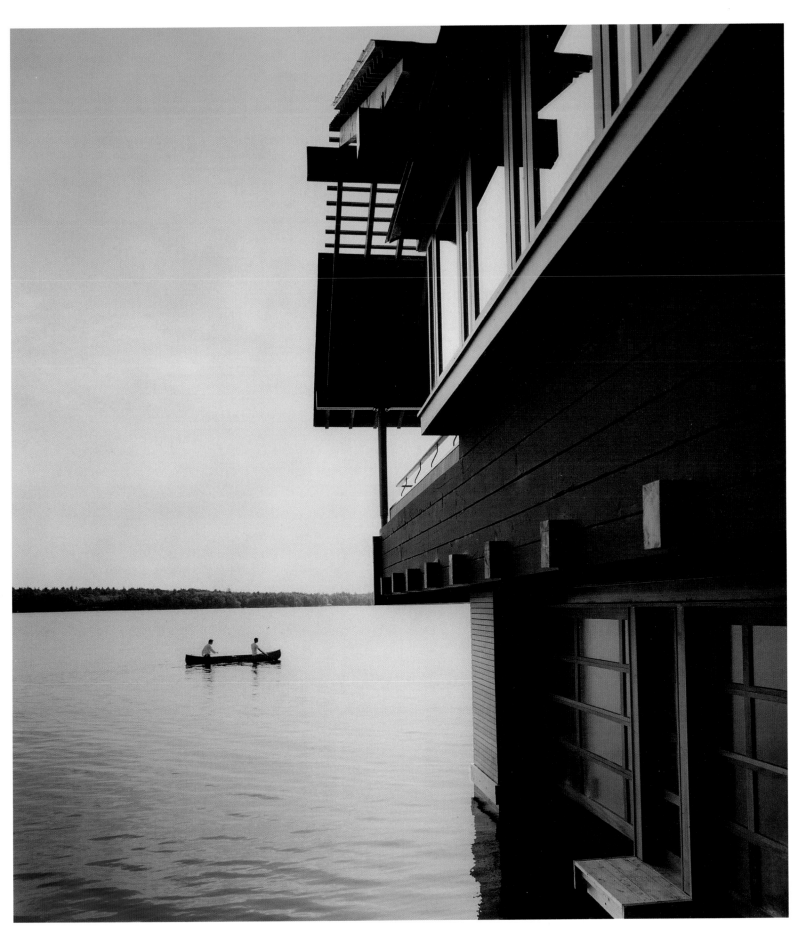

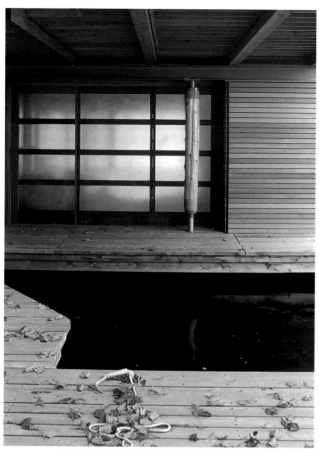

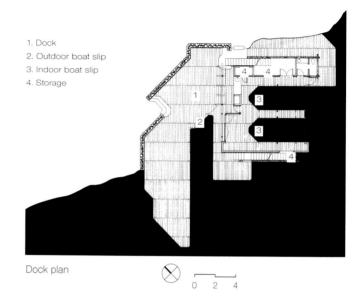

1. Dock
2. Outdoor boat slip
3. Indoor boat slip
4. Storage

Dock plan

0 2 4

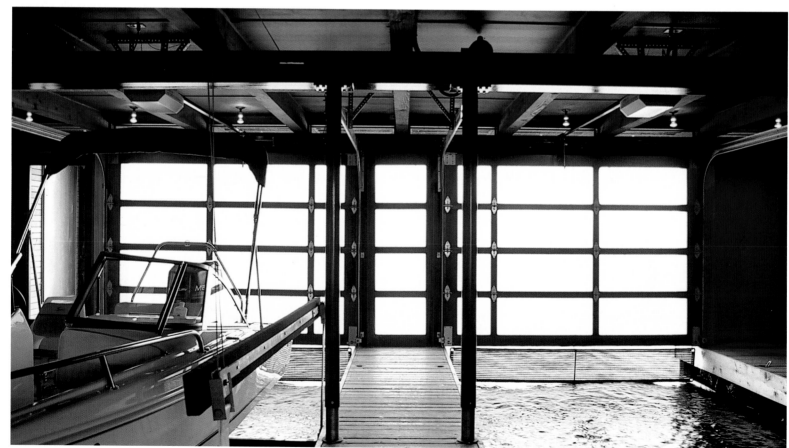

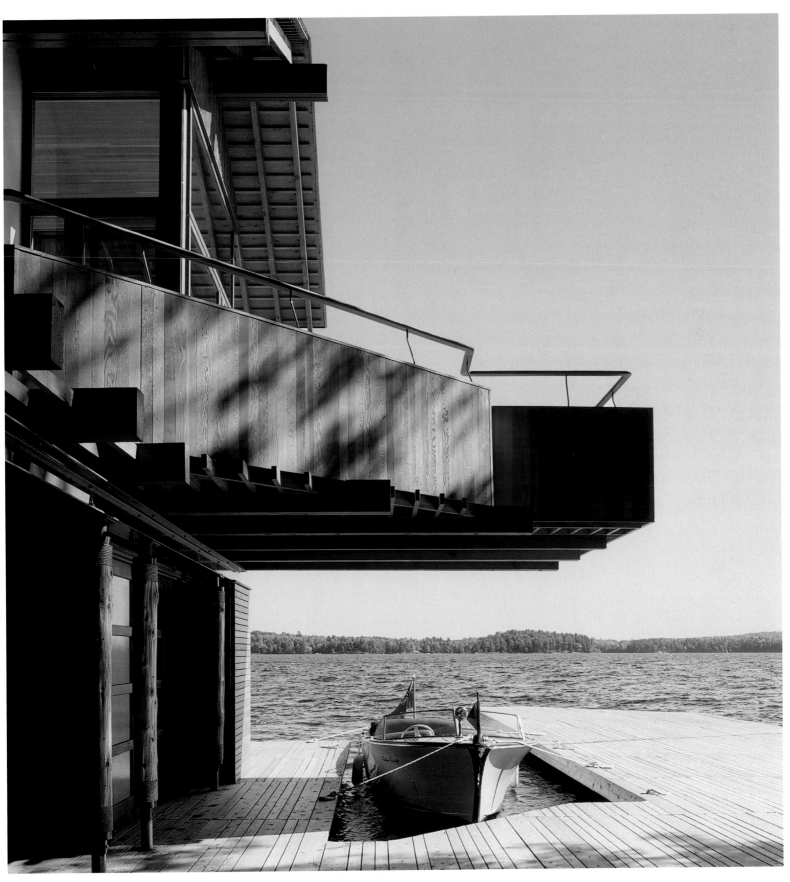

The construction team for this project waited until the lake was frozen to draw the plan that defines the building (and the detailed location of the cribs that will eventually support it) on the ice.

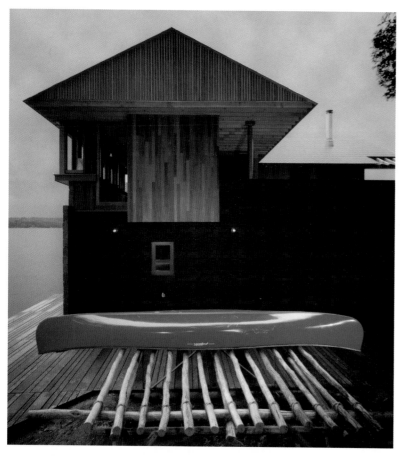

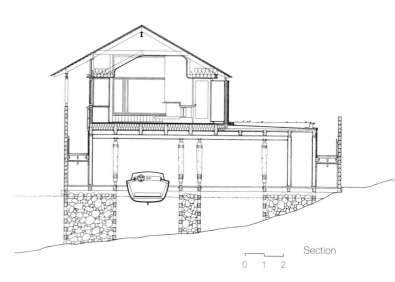

Section

0 1 2

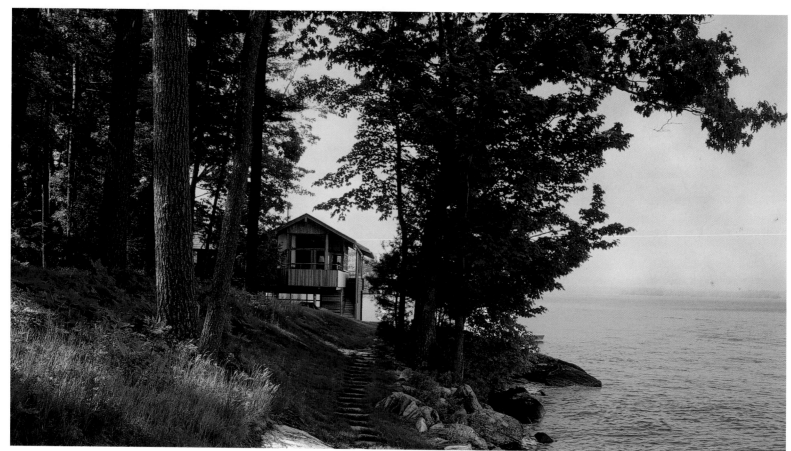

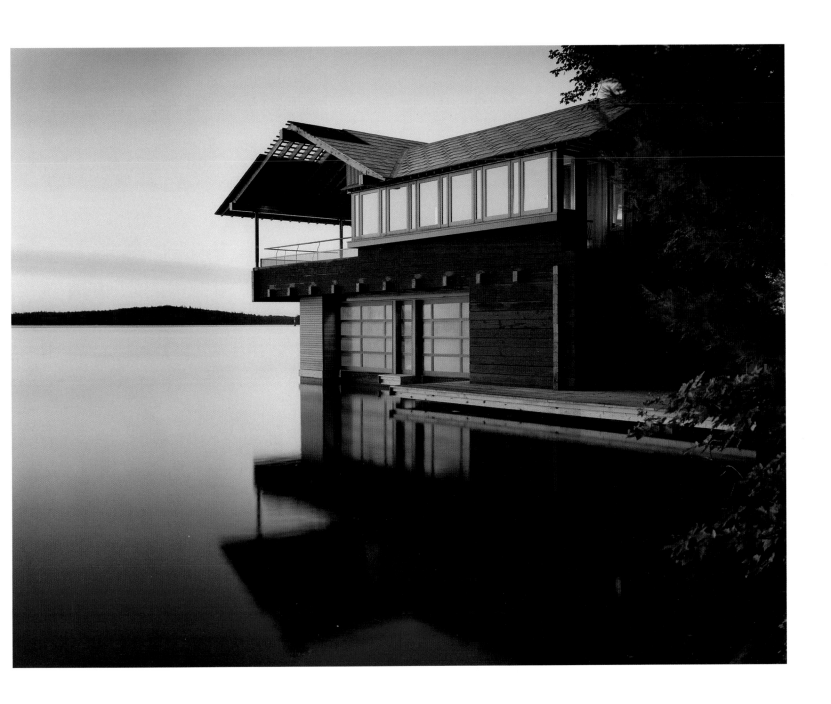

house on evening hill	Horden Cherry Lee Architects
Photos © Dennis Gilbert/VIEW	Dorset, UK 2002

Its owner acquired this site overlooking Poole Harbour in Dorset in 1994 with the aim of building a family home. Richard Horden, following the tradition of the 1950s Case Study House program in California, designed the 820-square-foot house. An exploration and reinterpretation of glass and steel construction pleasingly combines with the beautiful views over the harbor towards Brownsea Island, Sandbanks, and South Deep.

The building, designed to be extended at a later stage, features a series of structural bays that allow a step-by-step expansion if so desired. The upper ground floor living level is comprised of a light steel and glass frame structure, which rests on a highly insulated concrete lower ground floor. Since the home benefits from generous natural sunlight, the walls and floor of the con-

crete base were designed to absorb solar energy for use in the upper levels during winter. During the summer months, the balcony overhang works to minimize the heat. The white screen wall reflects sunlight into the north façade, balancing the light levels in the living space and avoiding energy losses on the land side. The flat roof is composed of a double layer with paving slabs that absorb solar energy and an air gap that prevents the summer heat from penetrating the living level.

The bedrooms are accessed along the south side of the house in order to avoid a dark internal corridor. Each room incorporates triple glazing to isolate the traffic noise.

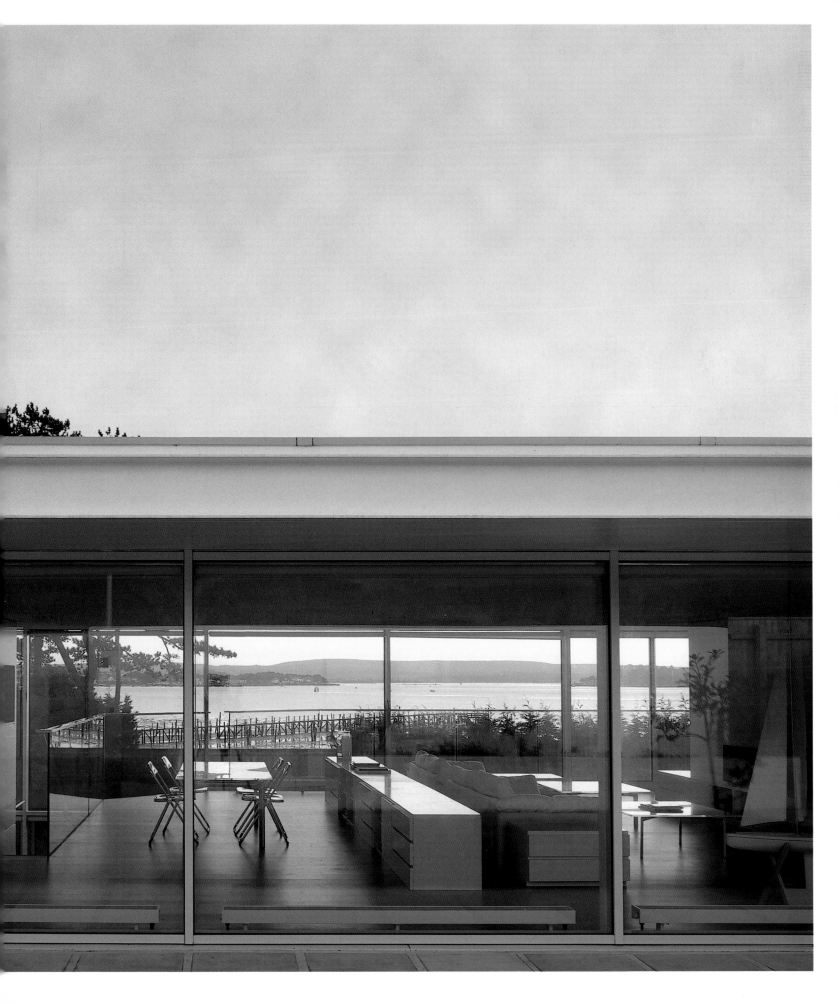

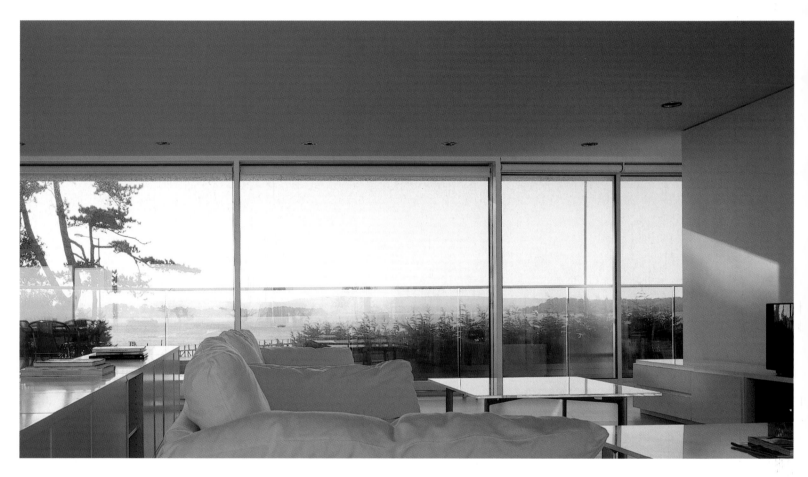

An extensive use of glass and steel provides countless views of the exterior along the interior surfaces of the home. White was used to emphasize the luminosity and underscore the sober qualities of the enveloping structure.

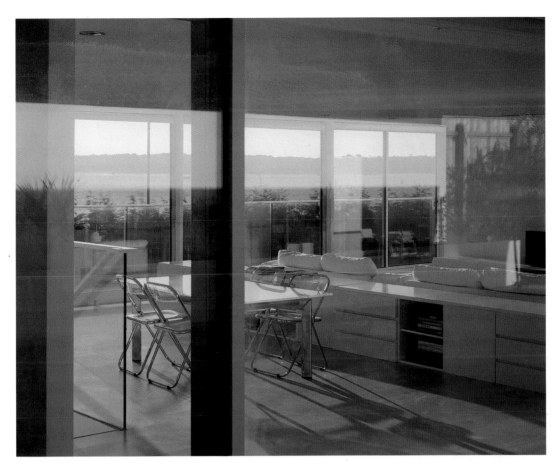

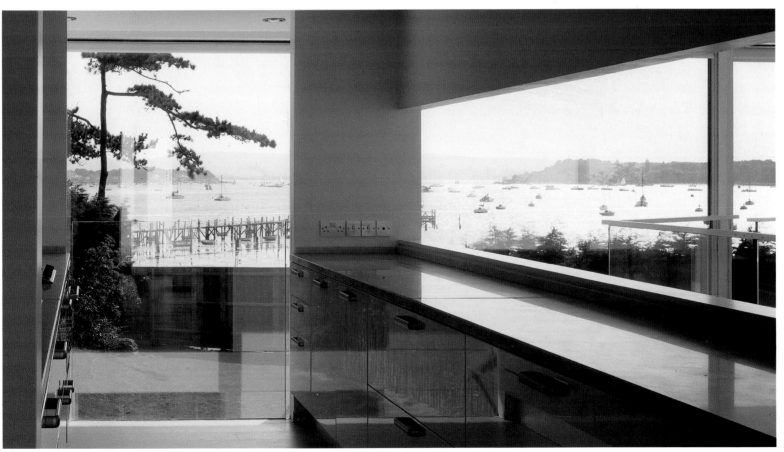

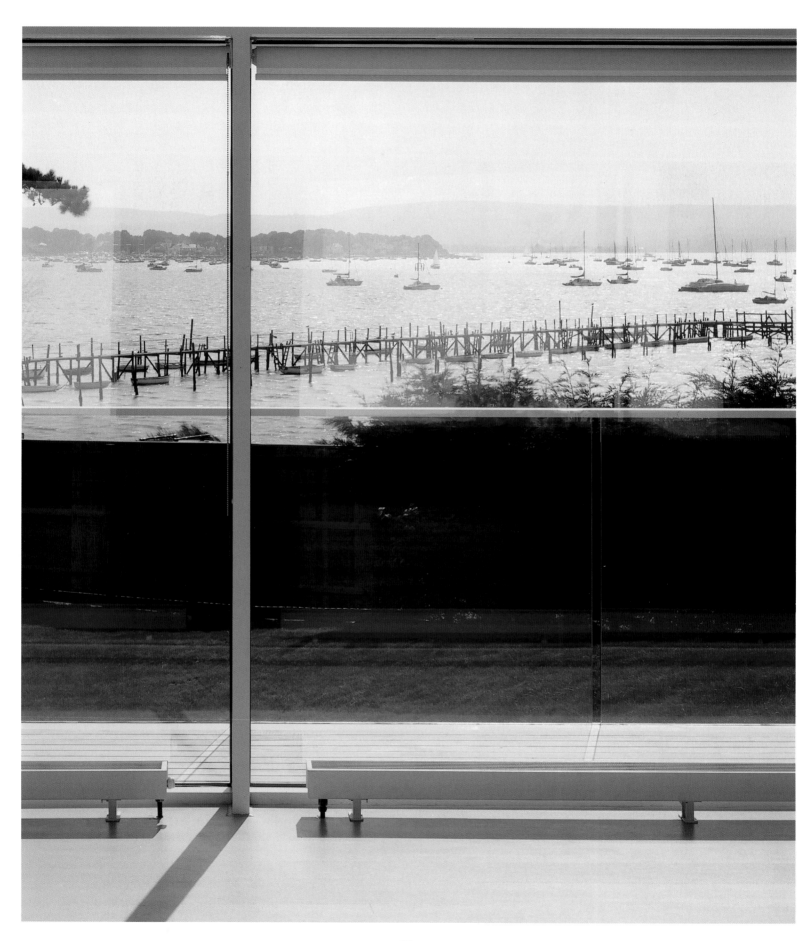

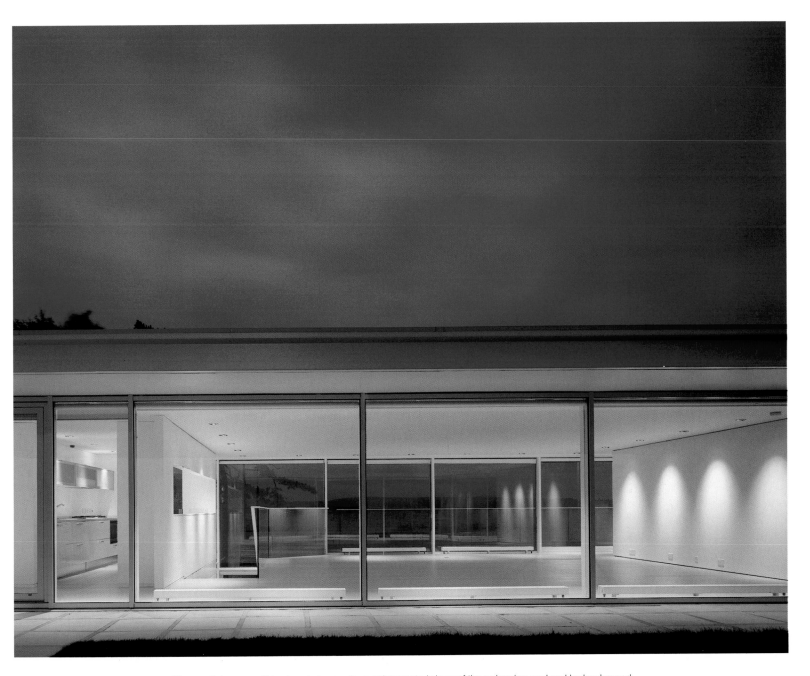

The nearly imperceptible glass balcony allows uninterrupted views of the swimming pool and harbor beyond.

house in miami	Jorge Rangel (interior designer)
Photos © Jose Luis Hausmann	Miami, Florida, USA 2003

This home for a Catalán family in Key Biscayne, Miami, was given a makeover in order to update it both functionally and aesthetically. The aim was to achieve a lighter space that would also allow a closer relationship with the bordering water.

Although no structural changes were made, the owners decided to remove certain elements. For example, the old carpets and tiles were removed, revealing the pavement beneath. The ground floor comprises the day area, which includes a spacious living/dining/service area, sauna, guest bathroom, swimming pool, and exterior dining terrace that link the two blocks that form the home. A steel structure on the terrace for hanging plants was designed to create shade during the summer months. The upper floor consists of three children's/guest bedrooms and a master bedroom. The master bedroom, with views of the ocean and pool, enjoys greater privacy and an integrated bathroom, walk-in closet, and terrace.

While surfaces were painted white to enhance the already luminous quality of the semi-tropical weather, glass was employed throughout many areas of the home to optimize natural light and views of the water. The living area, dining terrace, kitchen, bedroom, and even the bathroom now enjoy views of the ocean. In keeping with the outdoor/beach lifestyle for which Miami is known, sliding glass doors enable interior and exterior spaces to be merged.

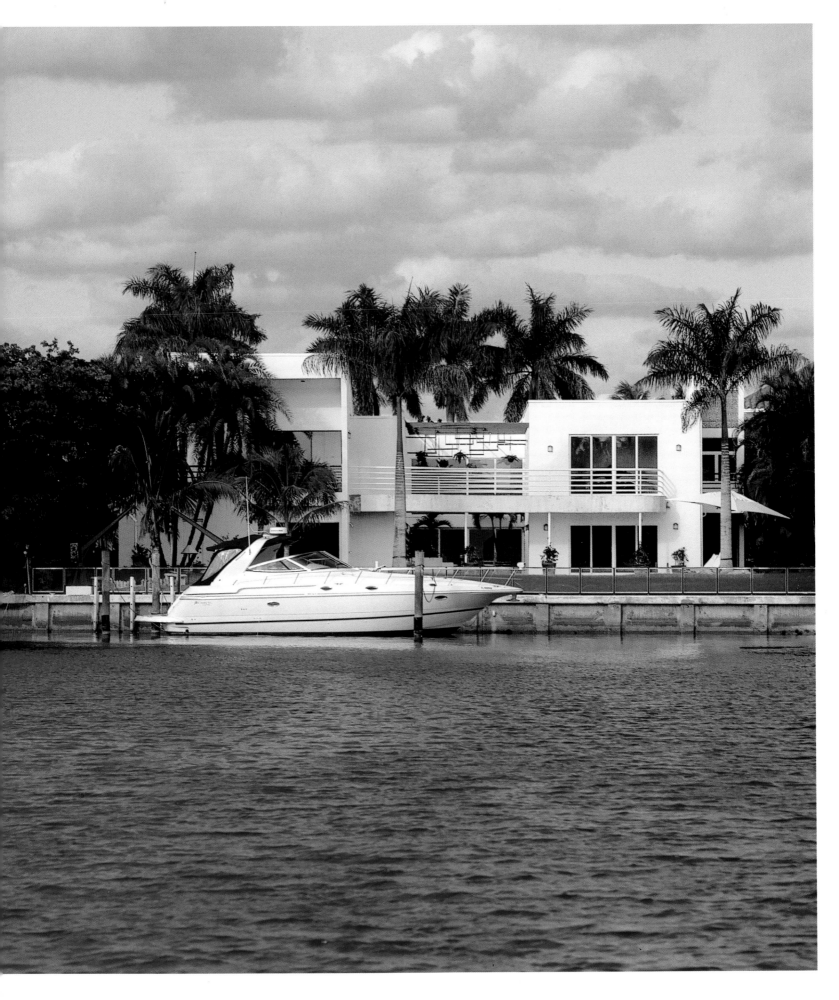

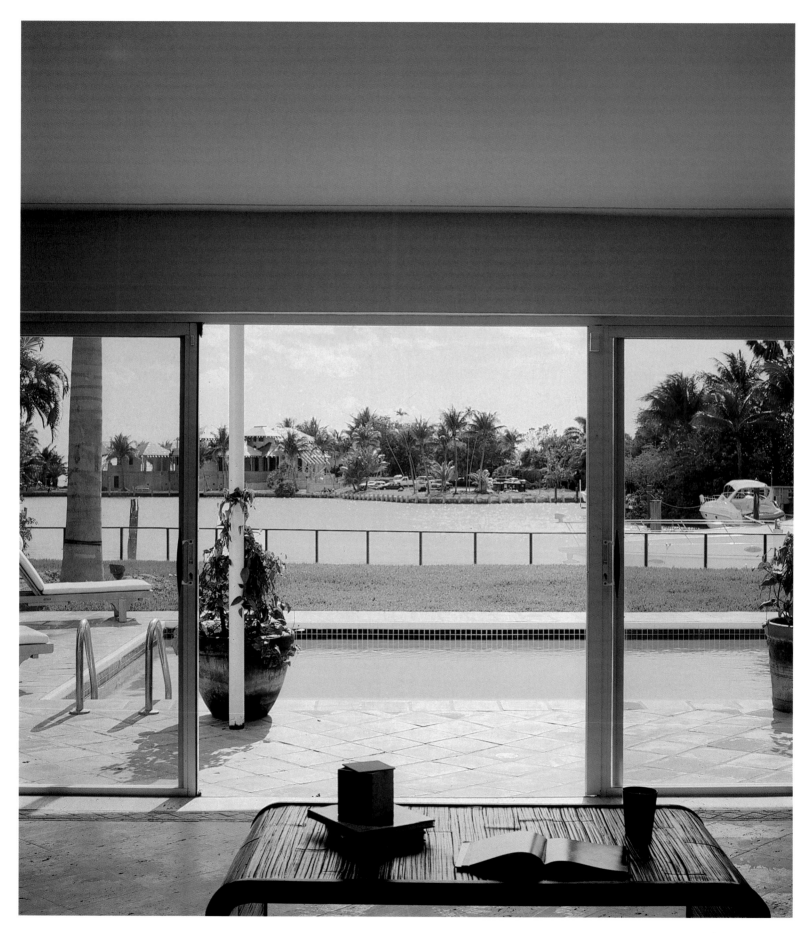

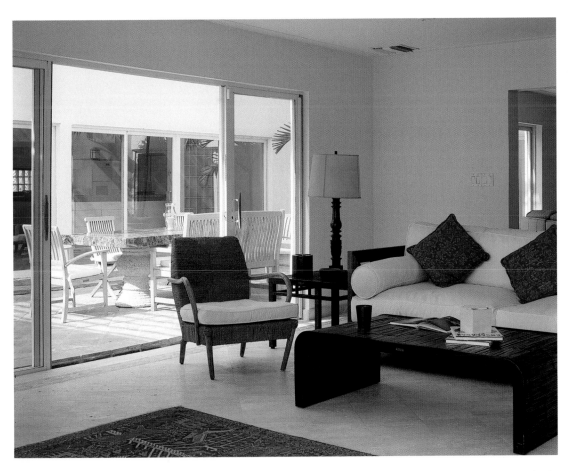

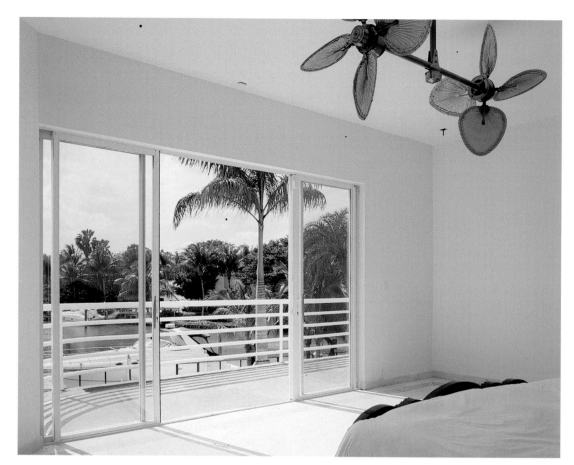

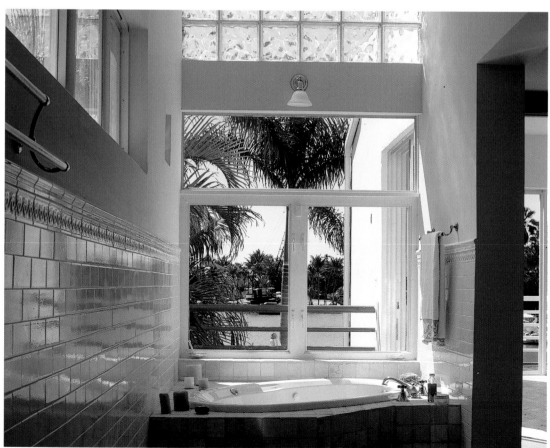

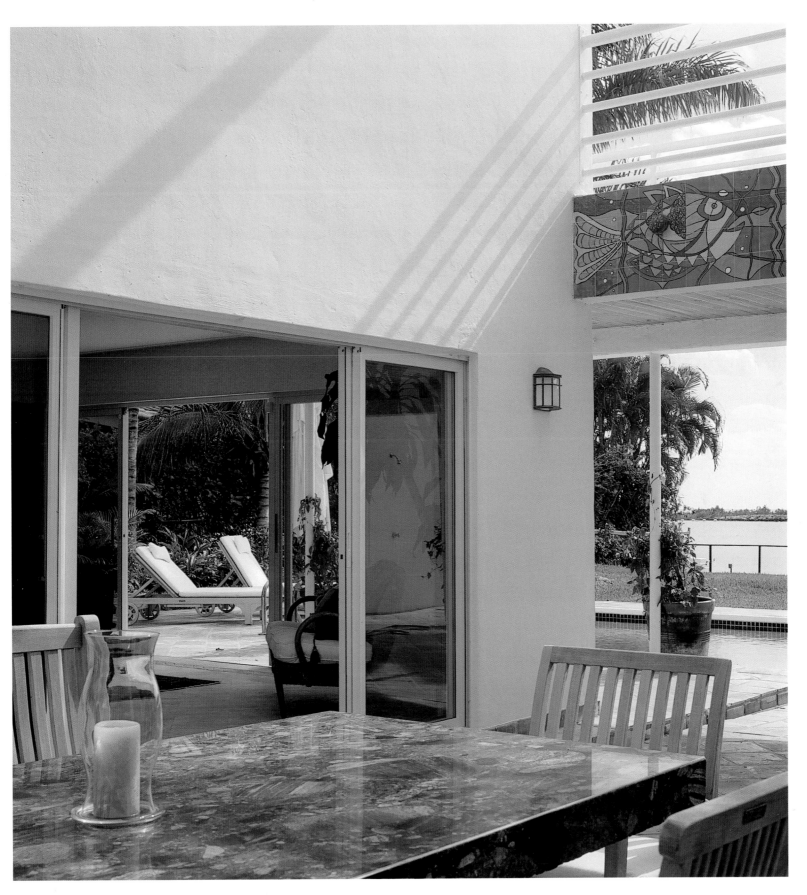

The exterior dining area is situated near the kitchen and connects to the living area through sliding glass doors. Tropical motifs adorn the white walls along the terrace.

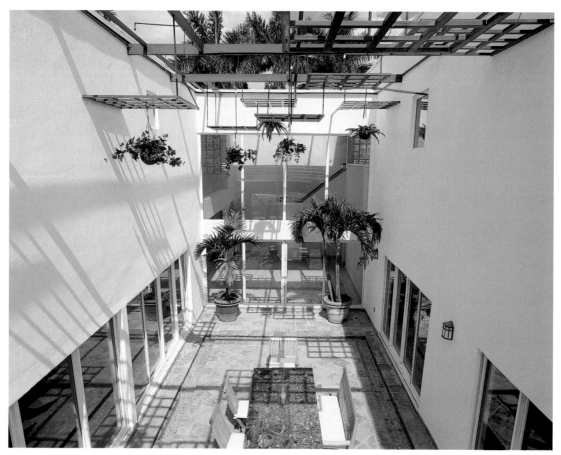

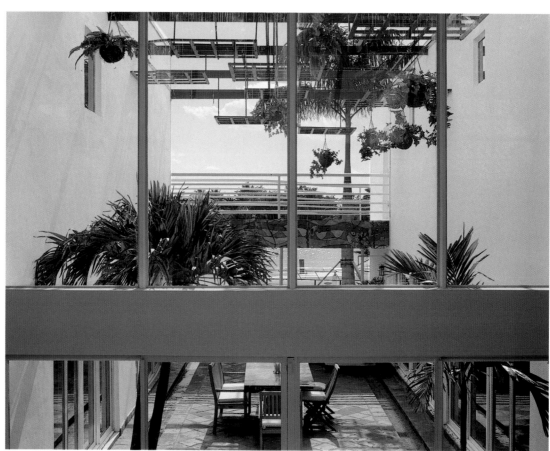

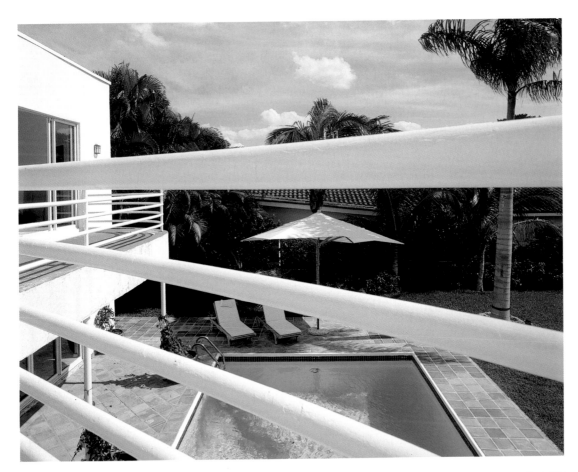

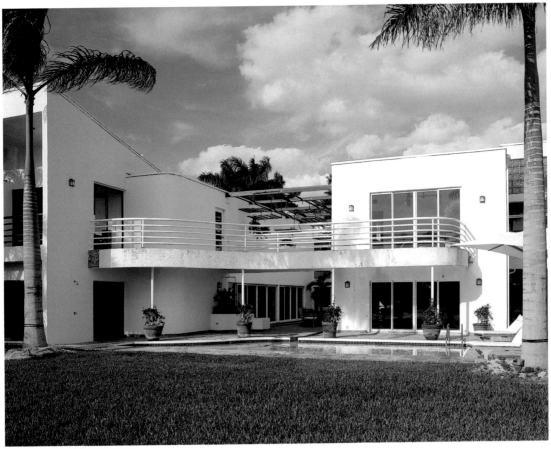

house #22	Brian MacKay-Lyons
Photos © Undine Pröhl	Oxner's Head, Nova Scotia, CANADA 1998

A pair of lantern-like buildings floats atop hills that overlook the juncture of the LaHave River and the sea. The main house and guesthouse are aligned on a north-south axis, facing the river or ocean. The natural wetland formed between the two mounds was conceived as a central garden. The mirrored buildings are set 450 feet apart and linked by concrete block walls that lead towards the garden.

Each building has its entry and service elements on the east side of the concrete wall. In the primary space, eight-foot-high glazing and horizontal sliding barn doors form the base, while the second floor receives natural light from enveloping glass panels. A concrete block hearth articulates a long block wall along which are situated a kitchen, stair, desk, seat, and a fountain that pours water from the roof out toward the wetland garden.

The construction of these spaces used two kinds of materials. The first comprised the heavy, grounded concrete elements such as the heated floor slab, block wall, and concrete hearth, which made use of the highly effective heating principle of thermal mass. The other consisted of wood framed elements like those within the home. The exposed timber frame channels much of the load into the center of the plan, creating a contrast between interior and exterior. These elements, finished off by flush metal barn doors, transform the house into a quiet box sheltered from the chilled temperatures. Butterfly trusses, energy-efficient materials, and the water fountain demonstrate the project's sensitivity to environmental building techniques and the surrounding landscape.

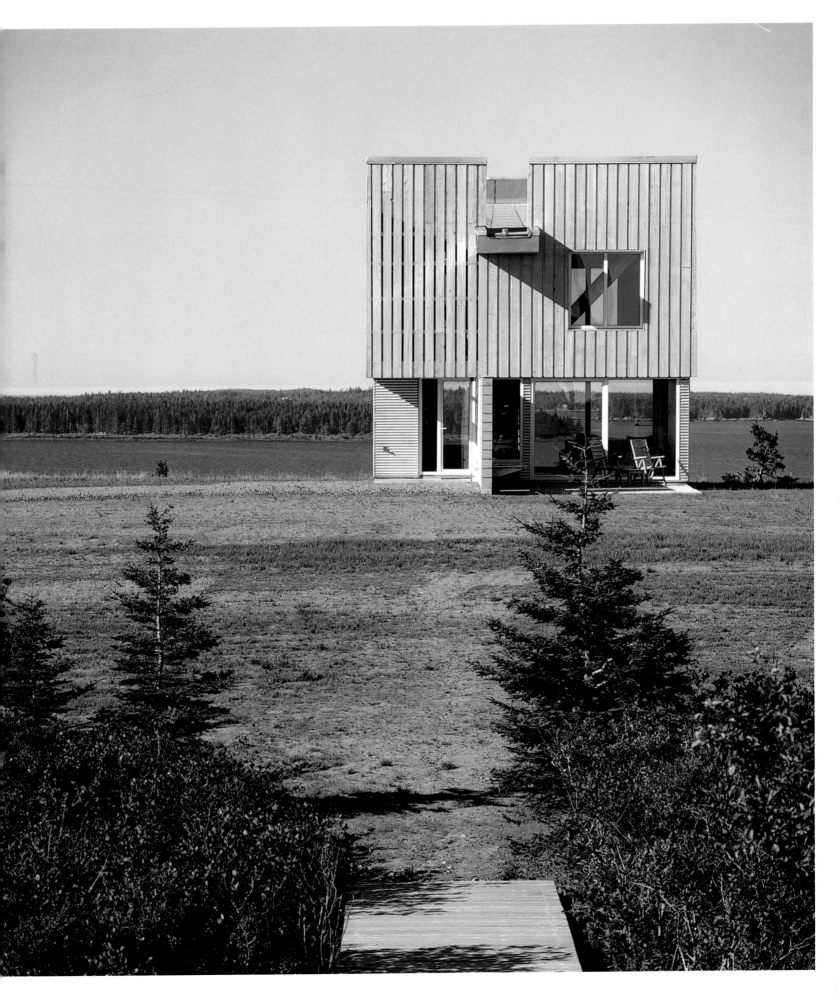

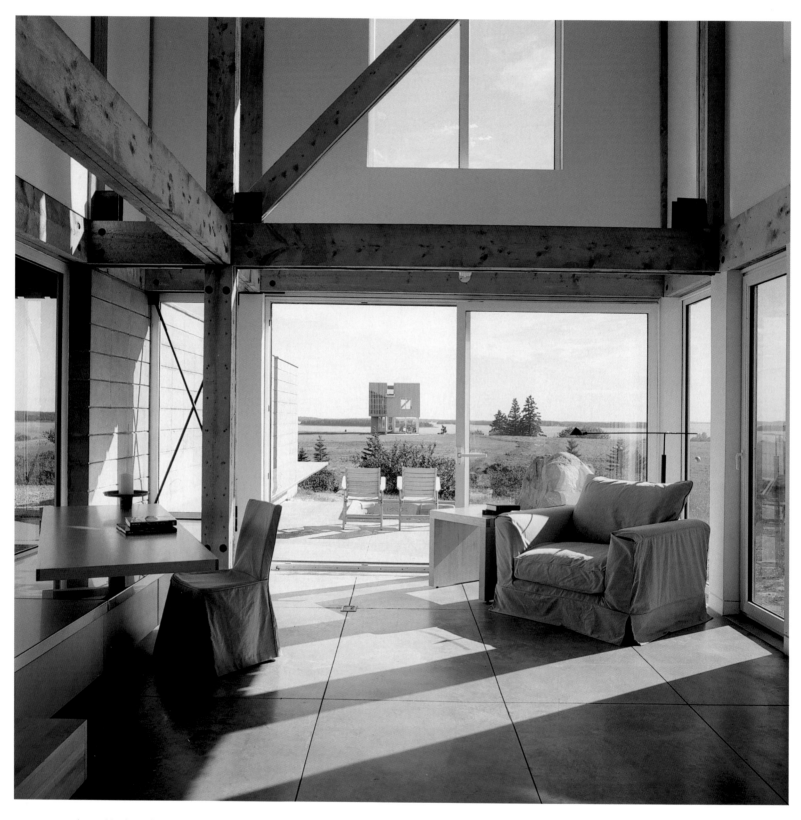

A repetitive field of windows punched into the upper portion of the house inundates the interior with natural light. The wooden plinth articulates a long block wall that defines the different functions of the home.

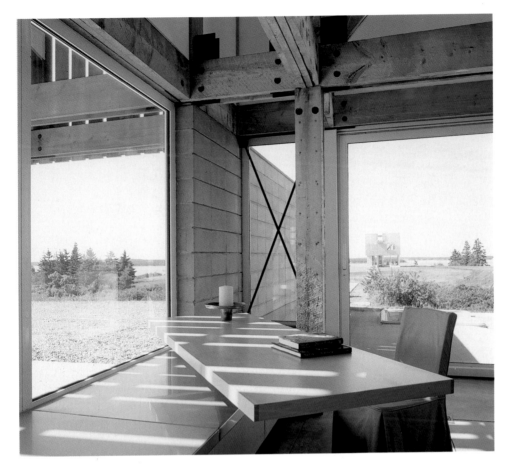

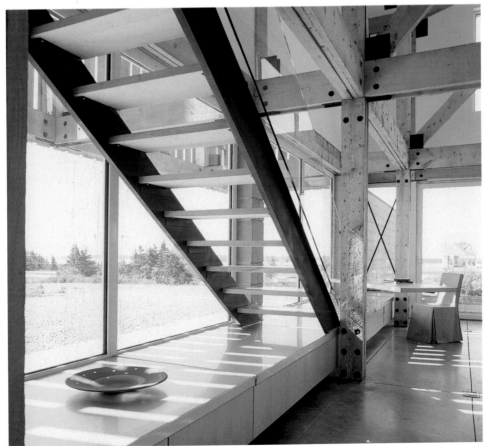

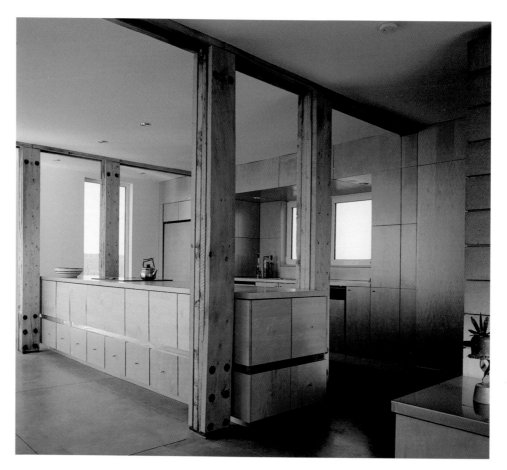

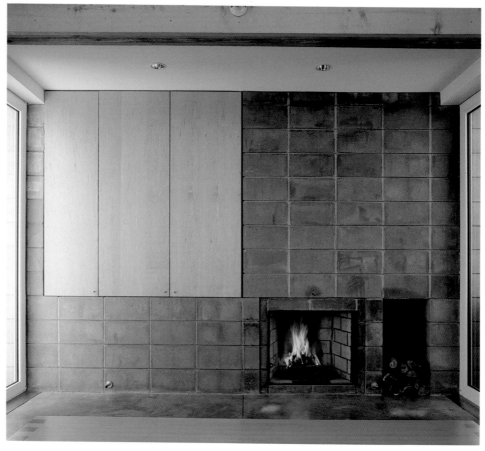

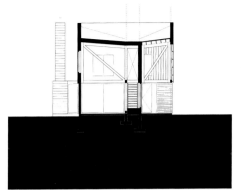

Section

0 1 2

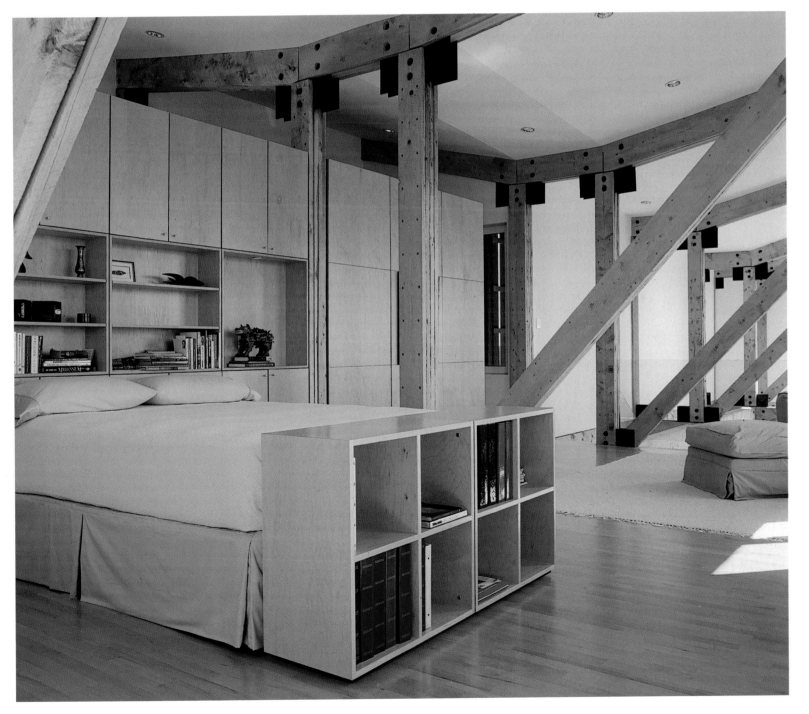

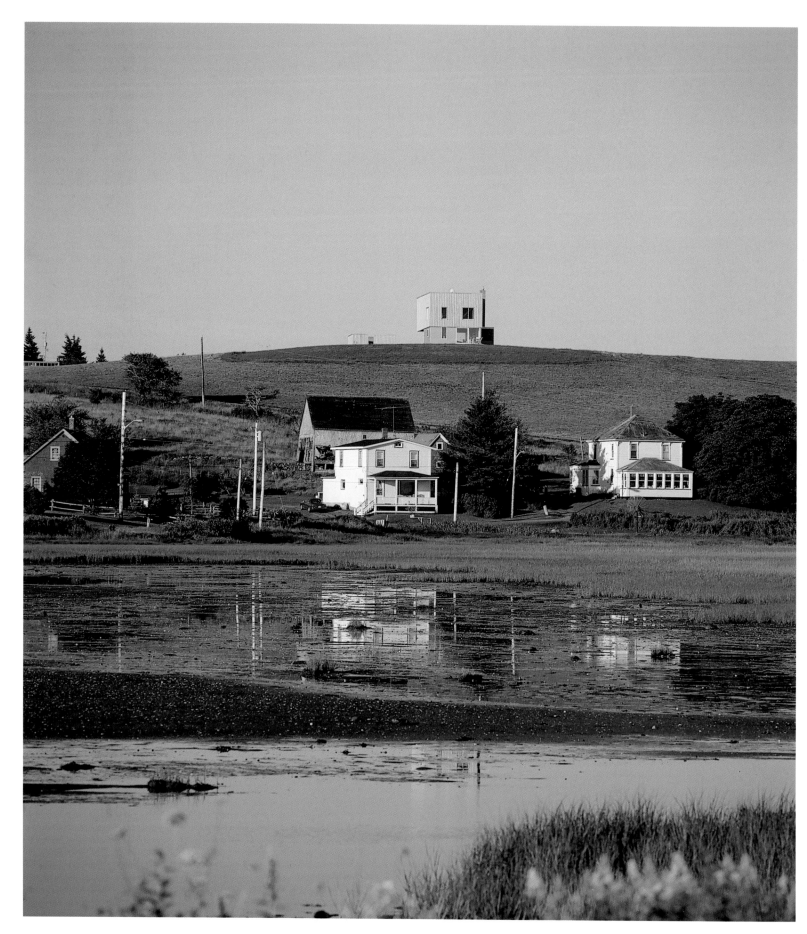

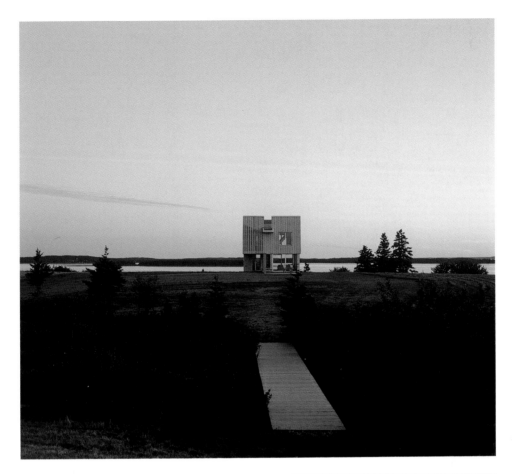

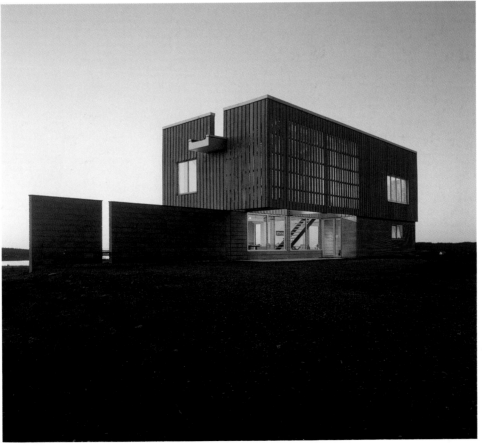

dunbar residence	Nick Milkovich and Arthur Erickson
Photos © Ron Dahlquist	Maui, Hawaii, USA 1998

Seeming to float among the lava rock formations of the western shores of Maui, this house in Makena is a spectacular vision of ordered civilization amidst chaotic nature. Surrounded by a green expanse of thick vegetation and practically submerged in the waters of the Pacific, the house features stunning views through seamless glass windows and appears ship-like from the ocean.

The three reefs that protect this portion of the shore allowed the architects to place the house very close to the surf. The site, however, is narrow and pointed, which required a steep ascent to be able see over the rocks. The steep grade and concern for security and privacy were factors in the design's evolution. In response, the site was divided down the center to create a linear progression of open spaces to the south and a string of enclosed spaces along a retaining wall to the north.

The main level contains a spacious living room with 11-foot-high unframed glass walls that slide open to join with the terrace. A tapered lap pool borders the entrance terrace; its water spills over the edges to create a seamless border with the big blue beyond. Post tensioned concrete and aluminum surfaces were employed to reduce maintenance and protect the house from the climate.

Inspired by Frank Lloyd Wright, the architects wanted to root the house in the ground and achieve a dynamic relationship with the landscape. Angular forms and cantilevered roofs are signature elements of the design. The pointed overhang above the living room allows the corner to remain completely open, and echoes the triangular shape of the lot. The angled rooms and sharp prow are suggestive of a ship or of an arrow that advances rapidly over the ocean. The forced perspective of the infinity-edge pool contributes to this effect. As Arthur Erickson explained it, the frozen energy of the lava and the kinetic energy of the surf had to be matched by a dynamic, forceful structure.

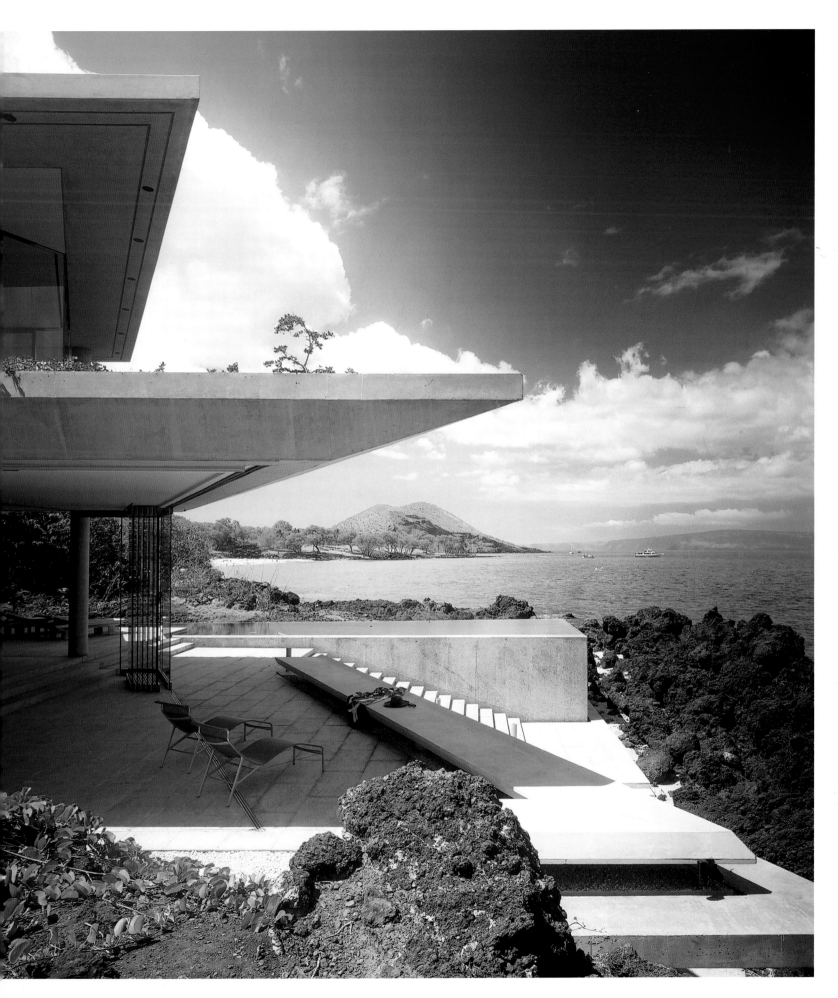

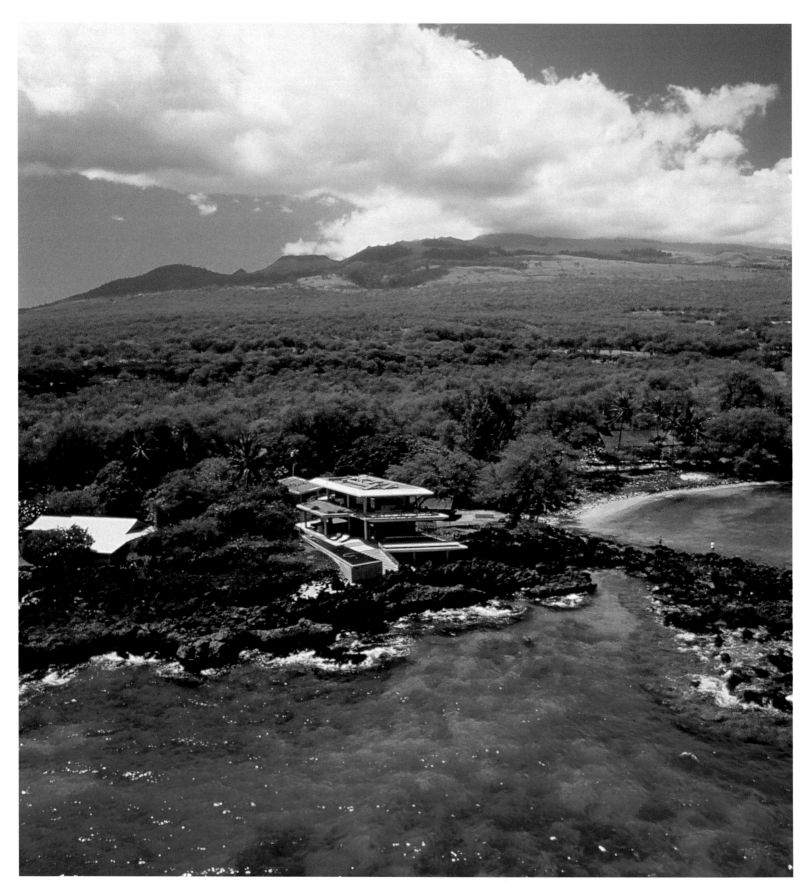

The 132-foot lap pool was tapered to follow the angle of the site. The home is a celebration of its stunning location, especially the quality of the light and the dramatic pounding of the surf against the rocks.

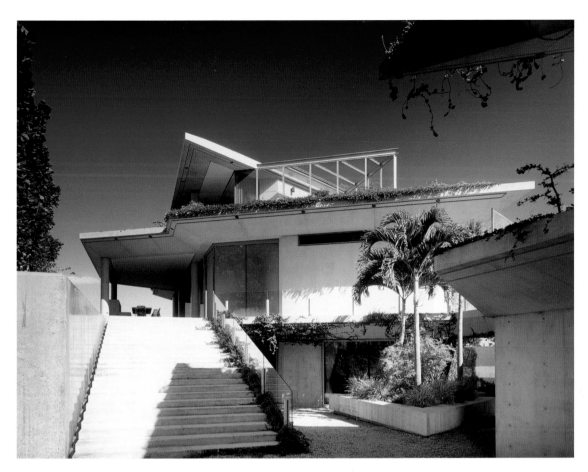

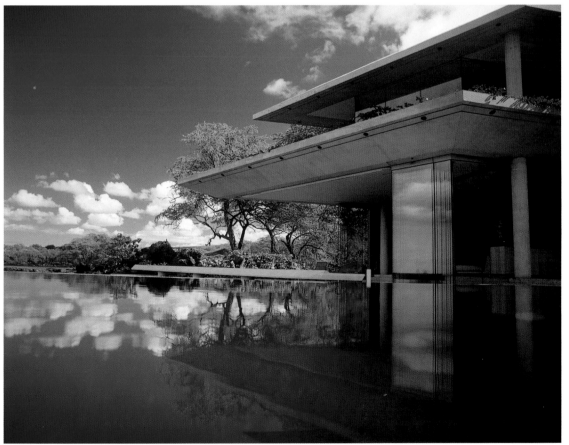

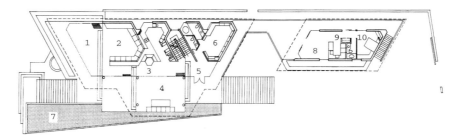

Ground floor plan

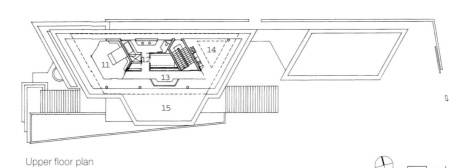

Upper floor plan

1. Lower living room
2. Upper living room
3. Dining room
4. Lanai
5. Entry
6. Library
7. Pool
8. Guest living/Dining room
9. Kitchen
10. Guest Bedroom
11. Master Bedroom
12. Master Bathroom
13. Study
14. Aviary
15. Landscaped Terrace

0 5 10

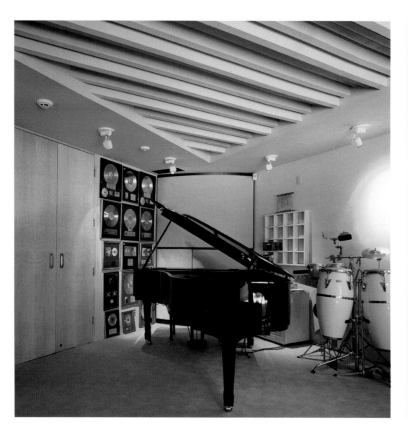

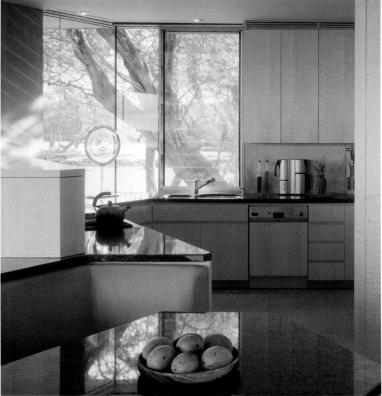

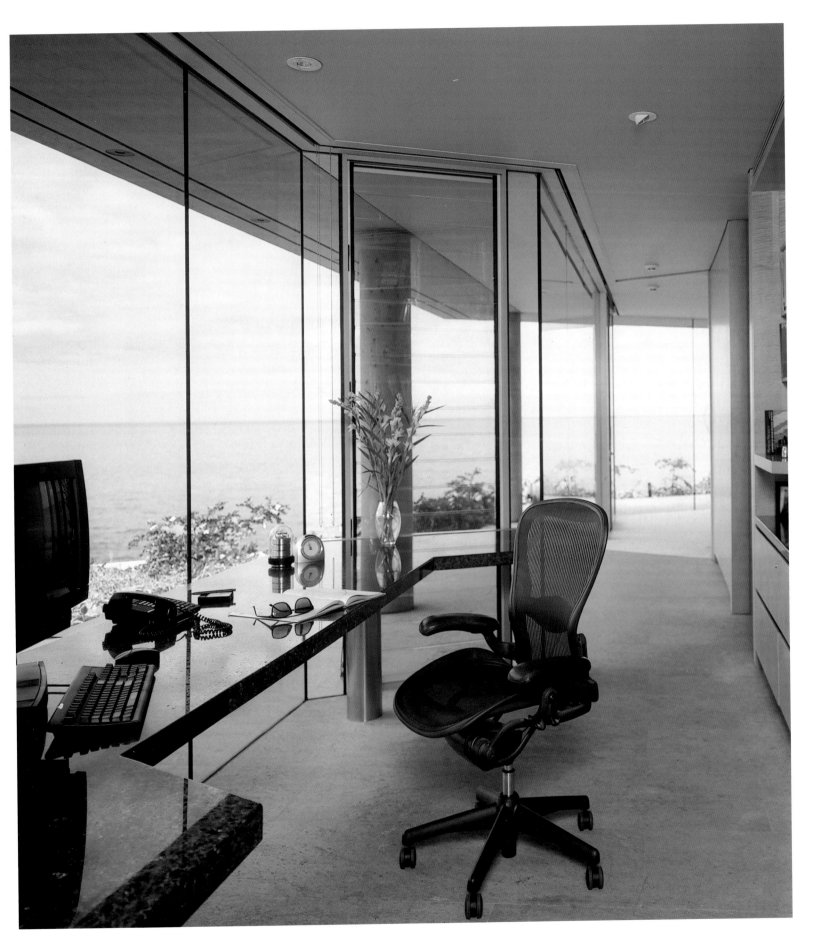

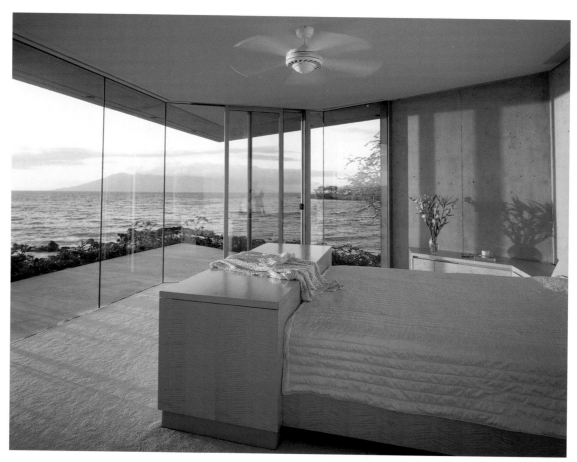

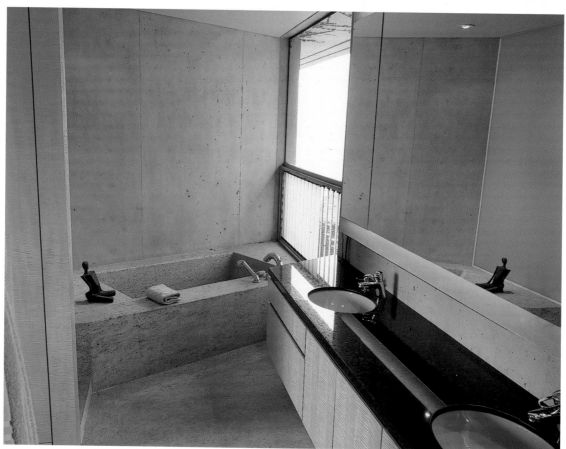

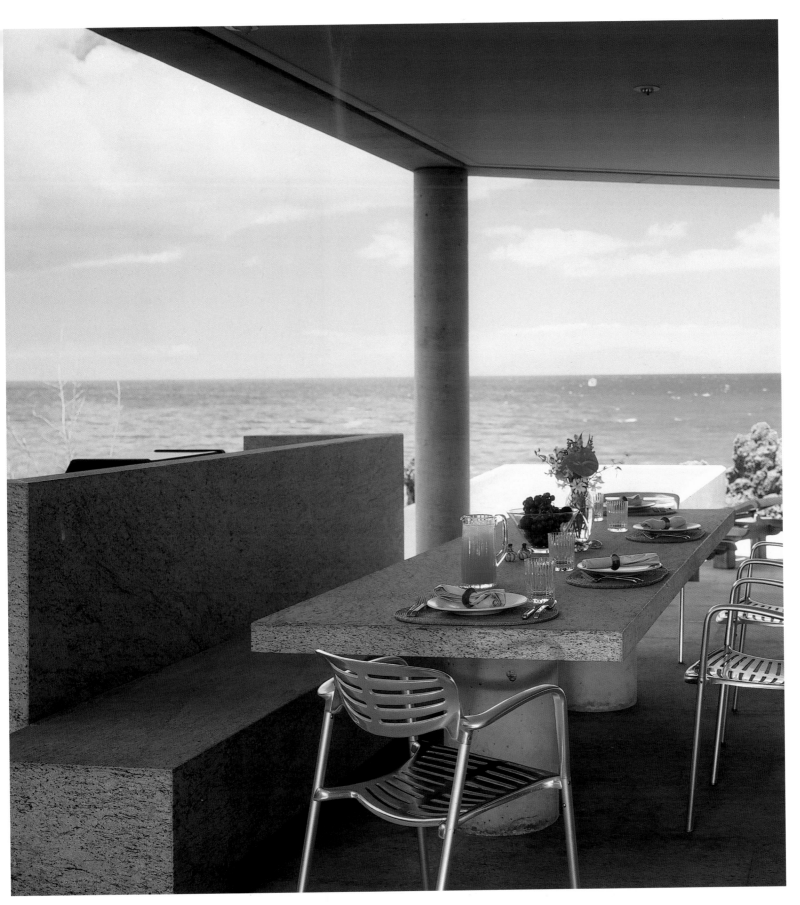

The open-sided lanai features a granite-and-concrete table accompanied by cast-aluminum chairs.

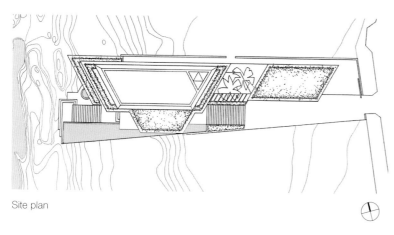

Site plan

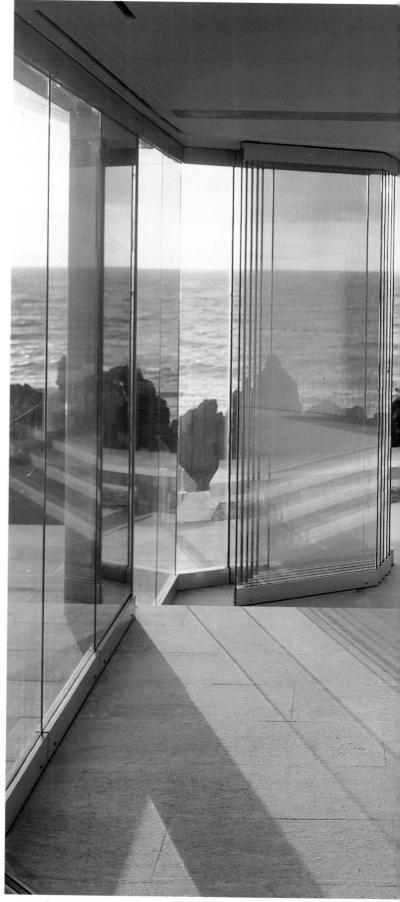

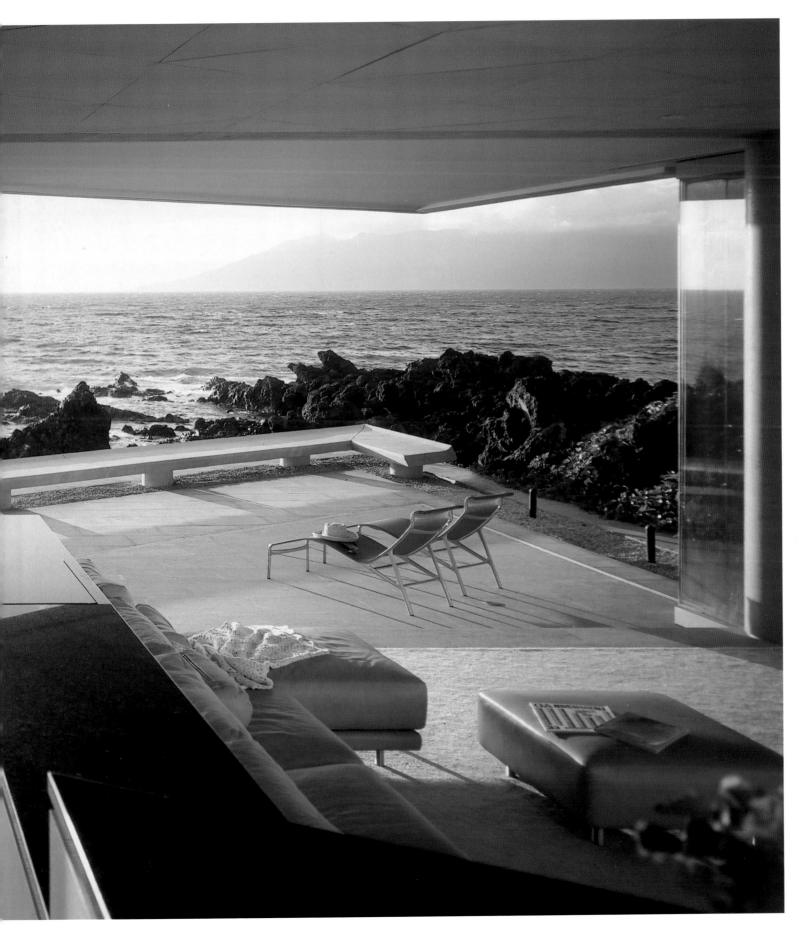

directory

Barclay + Crousse
38, Rue des Cascades
Paris 75020
France
t. +33 1 49 23 51 36
f. +33 1 40 21 69 14

Brian MacKay-Lyons
2042 Maynard Street
Halifax, Nova Scotia B3K 3T2
Canada
t. +1 902 429 1867
f. +1 902 4296276
info@bmlaud.ca
www.bmlaud.ca

Bromley Caldari Architects
242 West 27th Street
New York, NY 10001
USA
t. +1 212 620 4250
bcal@pipeline.com
www.bromleycaldari.com

Callas Shortridge Architects
3621 Hayden Avenue
Culver City, CA 90232
USA
t. +1 310 280 0404
f. +1 310 280 0414
mail@callas-shortridge.com
www.callas-shortridge.com

Edward Cullinan Architects
1 Baldwin Terrace
London N1 7RU
United Kingdom
t. +44 207 704 1975
f. +44 207 354 2739
eca@edwardcullinanarchitects.com
www.edwardcullinanarchitects.com

Eric Cobb Architects
911 Western Avenue
Suite 318
Seattle, WA 98104
USA
t. +1 206 287 0136
f. +1 206 233 9742
ecobb@cobbarch.com
www.cobbarch.com

Jean Bocabeille + Ignacio Prego
11 Passage Saint-Bernard
Paris 75011
France
t. +33 1 47 00 43 28
f. +33 1 47 00 59 16
agencebp@agencebp.com
www.agencebp.com

Jorge Rangel
La Font 22
Barcelona 08004
Spain
jorgerangel@terra.es

Knox Bhavan Architects
75 Bushey Hill Road
Camberwell, London SE5 8QQ
United Kingdom
t. +44 207 701 3108
f. +44 207 277 0751
mail@knoxbhavan.com
www.knoxbhavan.com

Mathias Klotz
Los Colonos 0411
Santiago de Chile
t. +56 2 2336613
f. +56 2 2322479
mathiasklotz@terra.cl

Mike and Liz Rolland
Hurd Rolland Partnership
Rossend Castle, Burntisland
Fife KY3 ODF
United Kingdom
t. +44 01592 873535
f. +44 01592 873503
mikerolland@hurdrolland.co.uk
www.hurdrolland.co.uk

Nick Milkovich Architects
1672 West First Avenue
Vancouver, British Columbia V6J IGI
Canada
t. +1 604 737 6061
f. +1 604 737 6091
nma@nmainc.ca

Patkau Architects
1564 West 6th Avenue
Vancouver, V6J 1R2
Canada
t. +1 604 683 7633
f. +1 604 683 7634
psuter@patkau.ca
www.patkau.ca

Richard Horden + Associates
34 Bruton Place
London W1J 6NR
United Kingdom
t. +44 207 495 4119
f. +44 207 493 7162
dwilliams@hcla.co.uk

Saunders & Wilhelmsen Arkitektur
Nygårdsgaten 2a
5025 Bergen
Norway
t./f. +47 5 536 8506
post@saunders-wilhelmsen.no
www.saunders-wilhelmsen.no

Shim Sutcliffe Architects
441 Queen St. East
Toronto, Ontario M5A 1T5
Canada
t. 416 368 3892
f. 416 368 9468
studio@shimsut.com

SORG Architects
2000 S Street, NW
Washington, DC 20009
USA
t. 202 393 6445
f. 202 393 6497
marilynnm@sorgandassociates.com

Steven Harris Architects
120 Chambers Street
New York, NY 10007
USA
t. +1 212-587-1108
f. +1 212-385-2932
vp@stevenharrisarchitects.com

Stutchbury and Pape
4/364 Barrenjoey Road
Newport, NSW 2106
Australia
t. +61 02 9979 5030
f. +61 02 9979 5367
snpala@ozemail.com.au

Tanner Architects
52 Albion Street
Surry Hills NSW 2010
Australia
t./f. +61 02 9281 4337
t&a@tannerarchitects.com.au
www.tannerarchitects.com.au